MW00610678

FABLES

THE COMPLETE COVERS BY

JAMES JEAN

VERTIGO/DC COMICS

Acknowledgments

I would like to express my gratitude to Bill Willingham for creating Fables, the framework upon which these covers are draped. Fables would also not exist without the dedication and synchronicity of Mark Buckingham, Steve Leialoha, and Todd Klein; we are all corralled and nurtured by Shelly Bond. I would also like to thank Mariah Huehner and Angela Rufino for their support, and Mark Chiarello for planting the sapling of my cover career at DC/Vertigo.

This book would not be possible without the archiving of Court Gebeau, the loyalty of the readers and collectors, and the invaluable studio assistance of Gary Musgrave. Last-minute rescue by Chris Pitzer. The cast of Fables was also brought to life by my models and friends, Esao Andrews, Joanna Mulder, Tomer Hanuka and Chris McDonnell.

FABLES

THE
COMPLETE
COVERS
BY
JAMES
JEAN

CONTENTS

PLATES & PROCESS

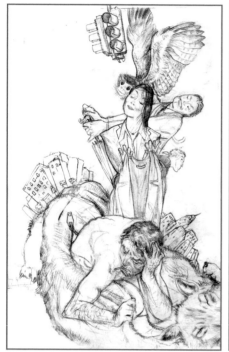
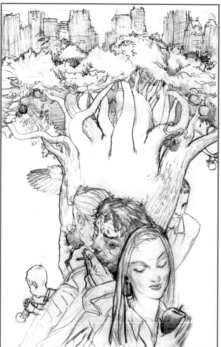
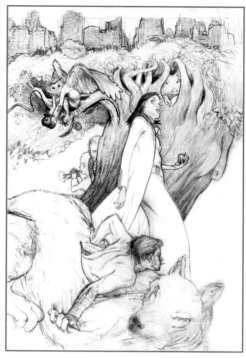

PRELIMINARY SKETCHES, GRAPHITE ON BOND, 8.5 X 11"

PRELIMINARY SKETCHES, GRAPHITE ON BOND, 8.5 X 11"

No. 01	LEGENDS IN EXILE	1/5

"There is an underground community in New York City made up of the living characters out of our most cherished fables and fairy tales. They are immortal, exactly as all good stories are immortal, but they are also reflections of our times, so these characters have changed. They no longer much resemble the beloved characters in the children's books. In New York they make up the secret Fable Community, with their own laws and customs, the most important of which is not to reveal themselves to the mundanes."

Excerpted from Fables: A Proposal, 2001.

MEDIA: OIL AND BALLPOINT PEN ON WOOD PANEL, 18 X 24".

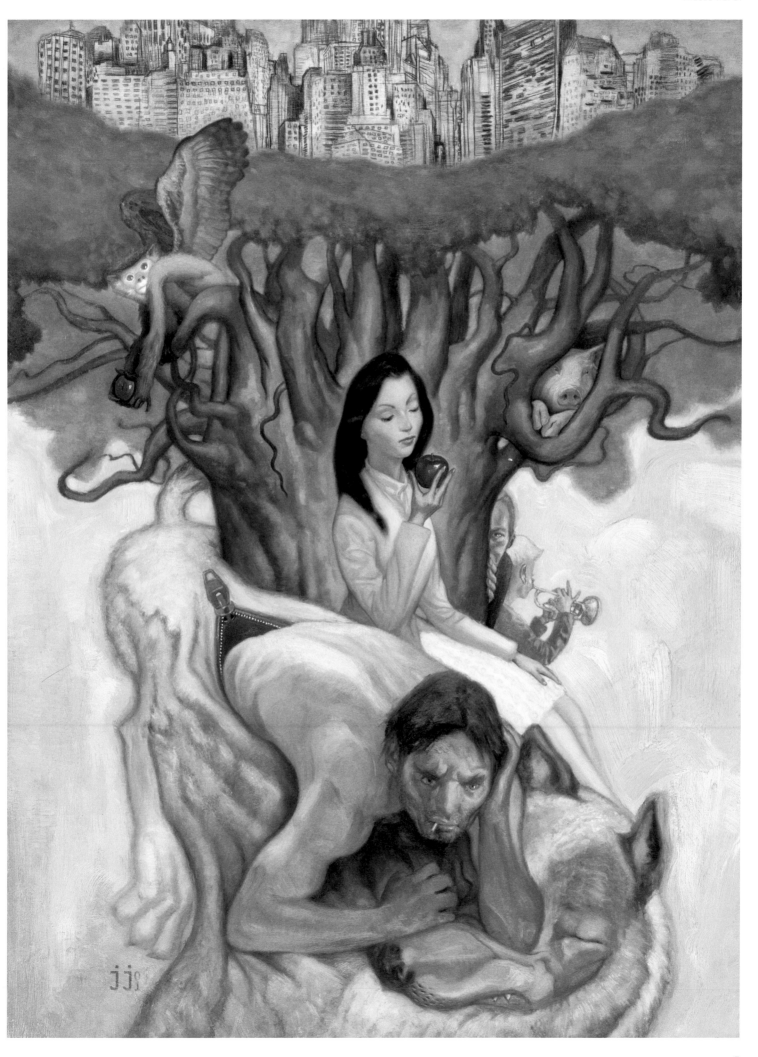

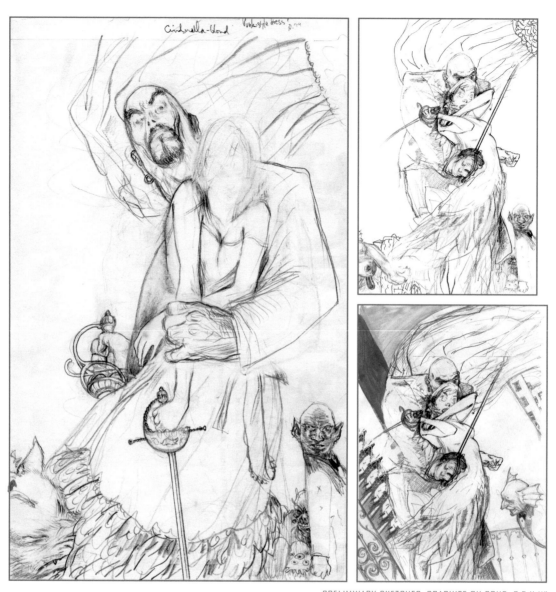

PRELIMINARY SKETCHES, GRAPHITE ON BOND, 8.5 X 11"

No. 02	LEGENDS IN EXILE	2/5

"<u>Bluebeard</u> – Back in the homelands he was the evil lord who married and killed all his wives. He also took advantage of the amnesty program to start over in exile. So far he seems to have changed his evil ways, but the truth remains to be seen."

Excerpted from Fables: A Proposal, 2001.

MEDIA: OIL AND MIXED MEDIA ON WOOD PANEL, 18 X 24".

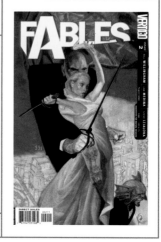

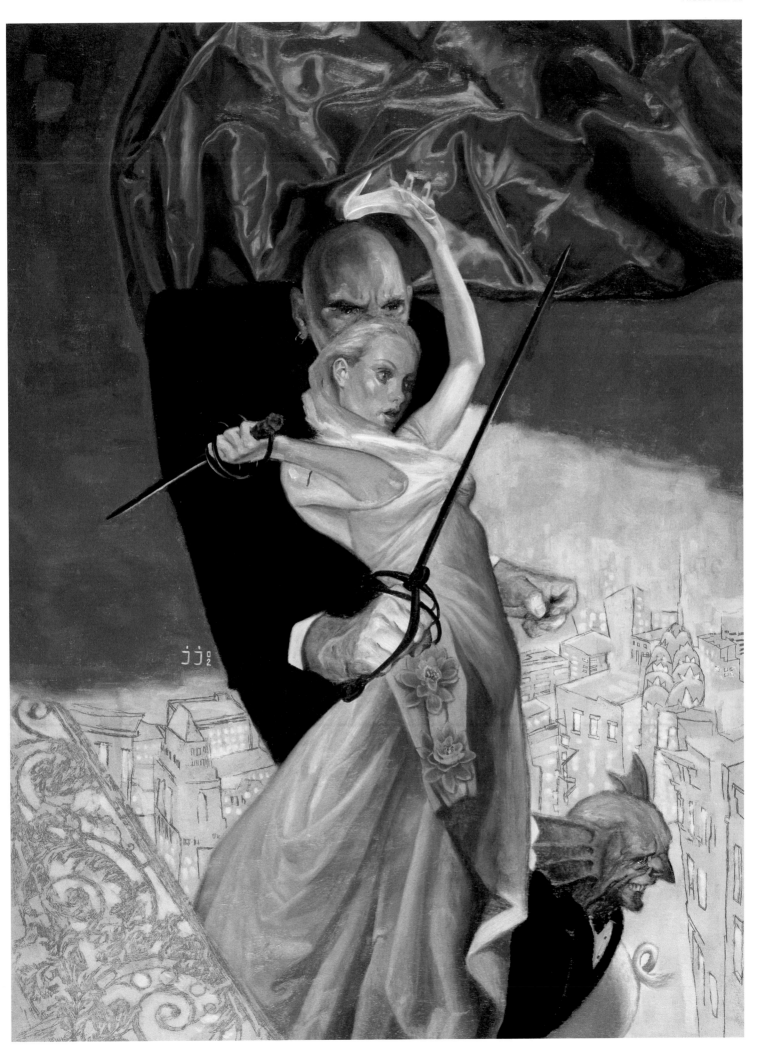

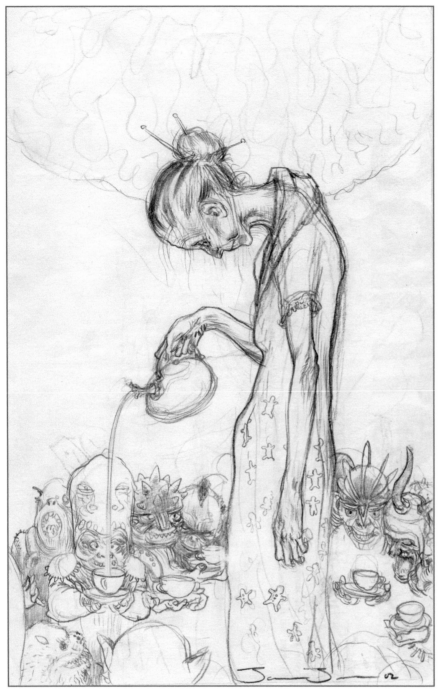

PRELIMINARY SKETCH, GRAPHITE ON BOND, 8.5 X 11"

DIGITAL COMP

No. 03	LEGENDS IN EXILE	3/5

"The Wicked Witch – True, there were many wicked witches in the fables. This one is the old meany who tried to eat Hansel and Gretel. In the investigation into Rose's disappearance (and possible murder) she will be one of the suspects; a red herring this time, but who knows in later stories."

Excerpted from Fables: A Proposal, 2001.

MEDIA: OIL ON WOOD PANEL, 18 X 24".

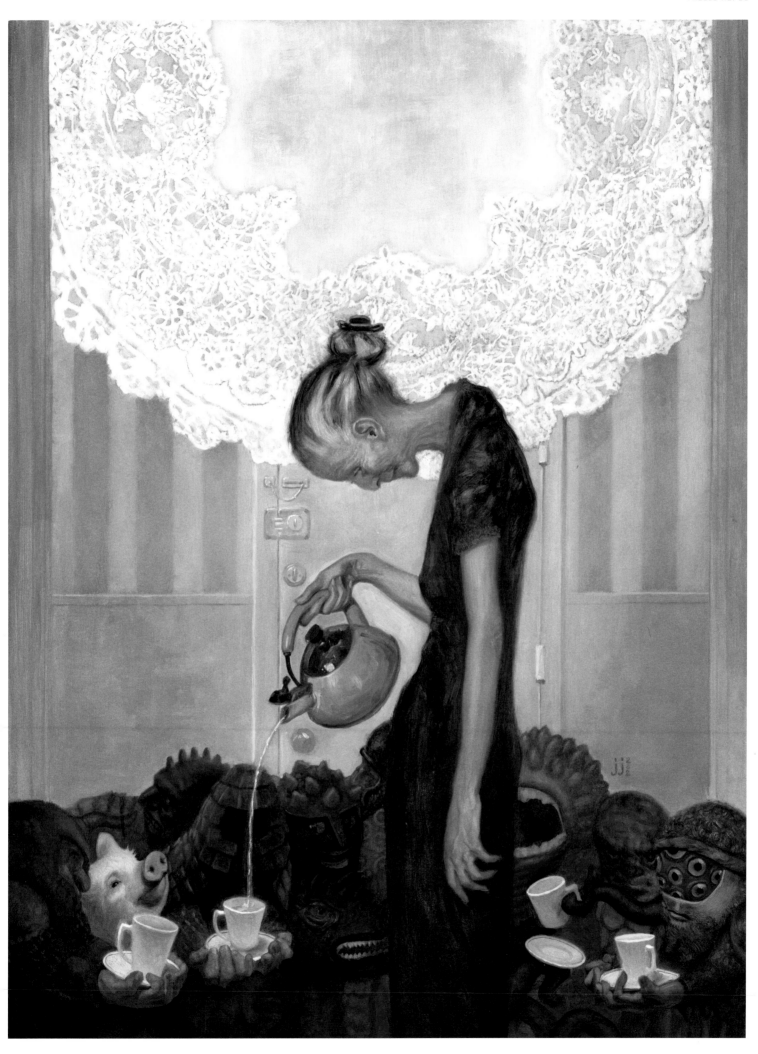

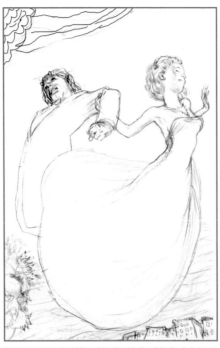

PRELIMINARY SKETCH, GRAPHITE ON BOND, 8.5 X 11"

No. 04	LEGENDS IN EXILE	4/5

"Cap: And just like that, the big day arrived. Fabletown's grandest event of the year, like Christmas and Fourth of July multiplied many times over.

Beast: At the front door by twilight. As promised, my love.

Trusty John: Lady Beauty, Lord Beast, how grand you both look tonight. And I'll be a rogue if you don't look completely human again, Sir. Congratulations.

Beast: It's my wife's fault. She loves everything about this day — including me, it seems — enough to make me handsome again."

MEDIA: OIL ON WOOD PANEL, 18 X 24".

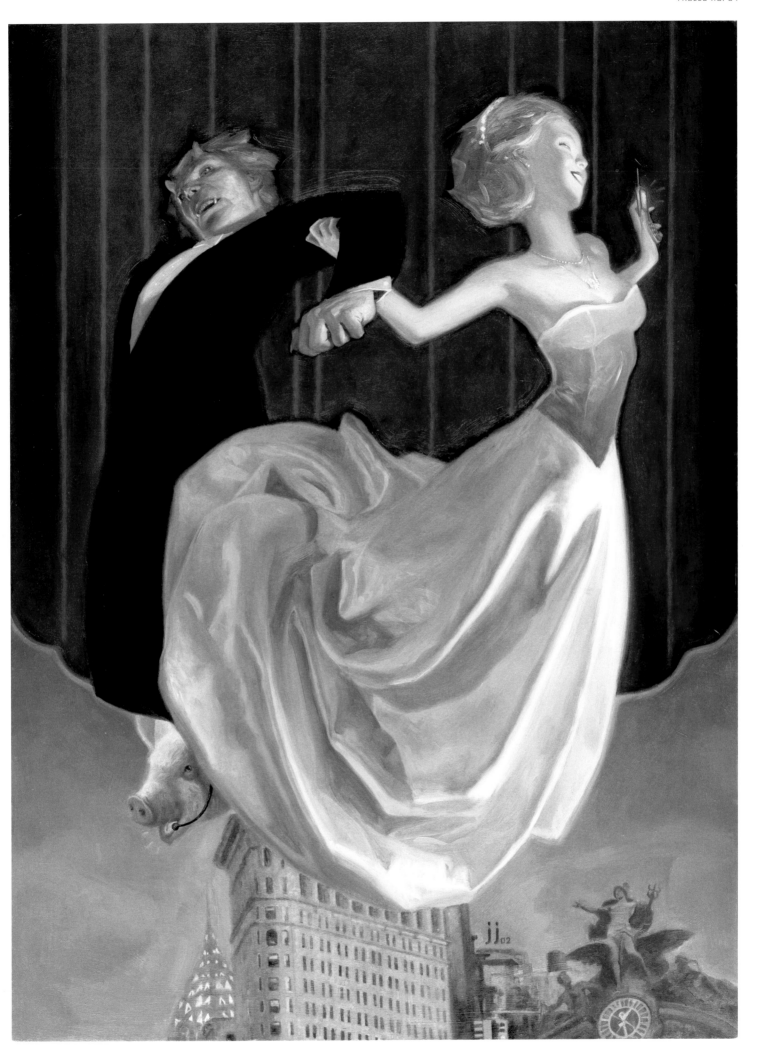

PRELIMINARY SKETCH
GRAPHITE ON BOND, 8.5 X 11"

PRELIMINARY SKETCHES, GRAPHITE ON BOND, 8.5 X 11"

No. 05	LEGENDS IN EXILE	5/5

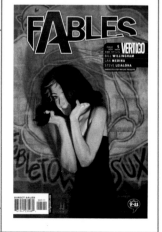

"Rose Red – is Snow White's equally lovely fraternal twin. She is the bad sister. Well, not bad *per se*, but she was always the more adventurous and free-spirited of the two, which leads her to make a number of bad life choices. For example, she became estranged from her sister when Snow caught her sleeping with Snow's ex [Prince Charming]. Rose feels guilty about the betrayal and has tried to make it up to Snow on many occasions, but her sister can hold a grudge like no one else."

Excerpted from Fables: A Proposal, 2001.

MEDIA: OIL ON LINEN, 20 X 30".

PRELIMINARY SKETCH, GRAPHITE ON BOND, 8.5 X 11"

PRELIMINARY SKETCH, GRAPHITE ON BOND, 8.5 X 11"

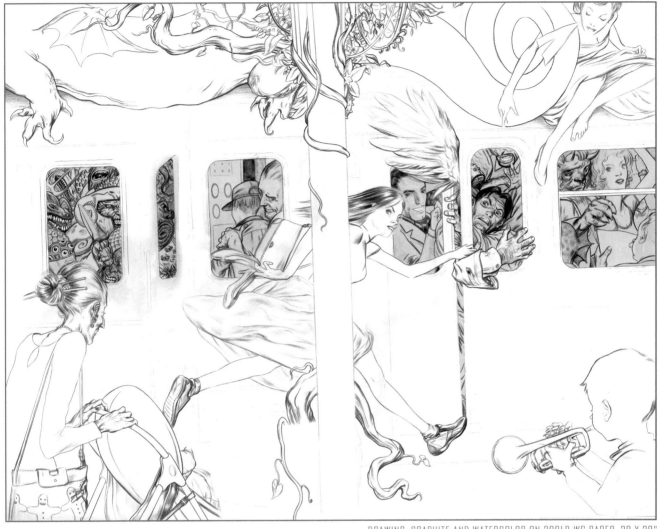

DRAWING, GRAPHITE AND WATERCOLOR ON 300LB WC PAPER, 20 X 30"

TPB 01 | LEGENDS IN EXILE

Metro

COLLECTED MATERIAL: ISSUES 1 – 5

MEDIA: GRAPHITE, WATERCOLOR, DIGITAL COLOR.

"James Jean: As a ploy to make more money, I proposed the idea of a wraparound cover, which has since become a staple of the series. Hunger made me more shrewd, I suppose, but the wraparound cover also presented a broader, more comfortable canvas with which to work."

FABLES - COVERS
BY JAMES JEAN

Metro

TPB 01 | LEGENDS IN EXILE

COLLECTED MATERIAL: ISSUES 1 - 5

MEDIA: GRAPHITE, WATERCOLOR, DIGITAL COLOR.

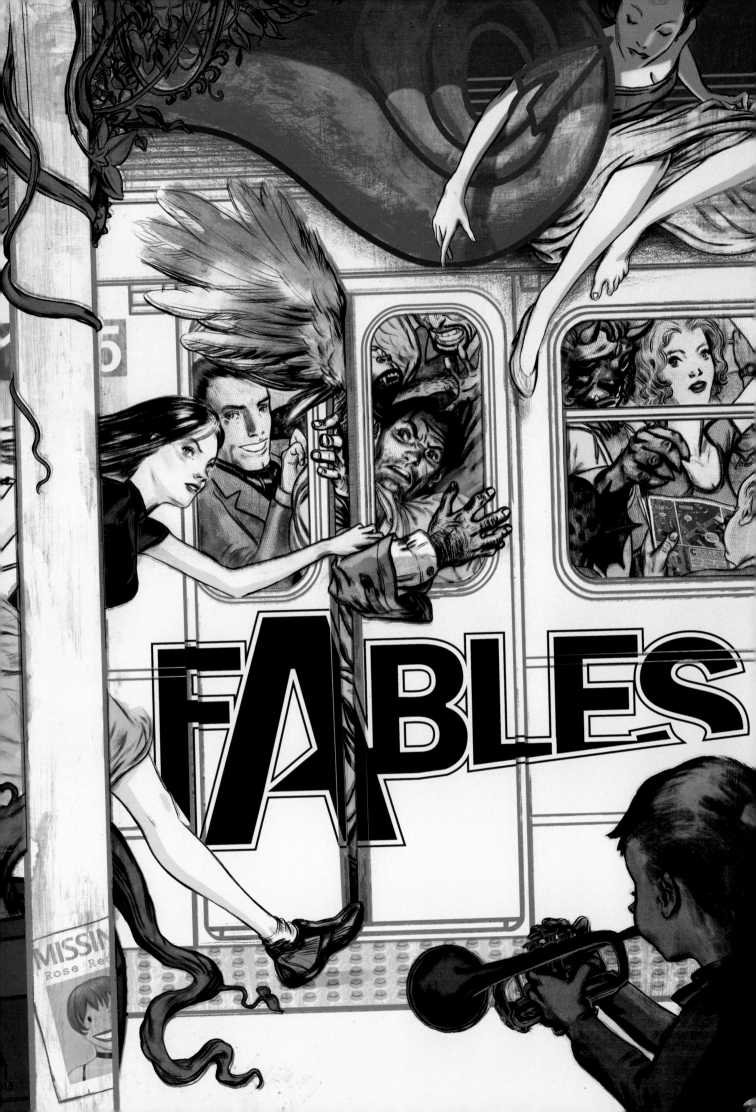

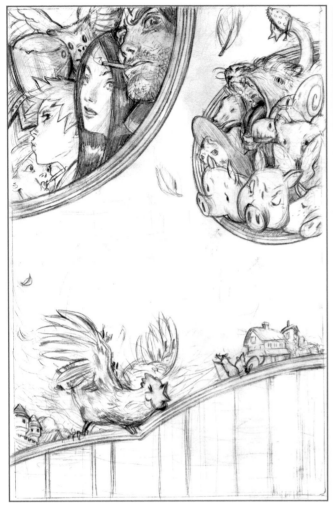

SKETCH, GRAPHITE ON BOND, 8.5 X 11"

DRAWING, COLORED PENCIL AND GOUACHE ON RIVES BFK, 20 X 30"

| No. 06 | ANIMAL FARM | 1/5 |

"**Rose:** How much longer until we reach your damned farm?

Snow: Are you kidding me? In all the years — centuries — we've lived here in New York, you've never once bothered to visit the upstate community? We've been on the farm's land for the past twenty miles.

Snow: We like to keep it remote up here, far away from prying eyes. Our strongest distraction spells are woven onto this land to prevent the Mundy's from even getting curious about this area."

MEDIA: COLORED PENCIL, GOUACHE, DIGITAL.

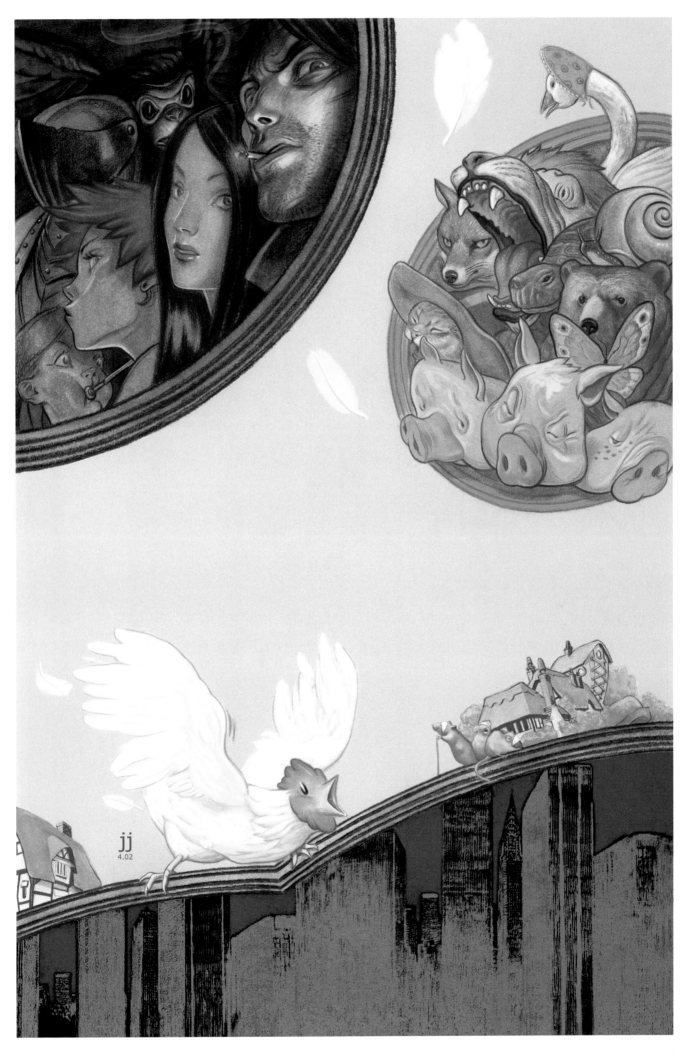

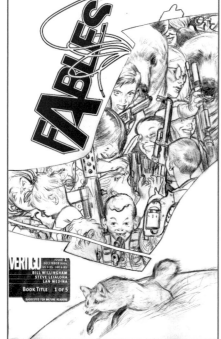

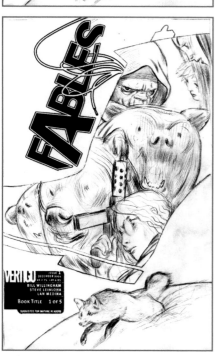

PRELIM. SKETCHES, GRAPHITE ON BOND, 5.5 X 8.5"

DRAWING, GRAPHITE & COLORED PENCIL ON 300LB WC PAPER, 14 X 21"

No. 07 | ANIMAL FARM | 2/5

"**Mama Bear:** And you're hardly stuck here like us, Goldy. You could move down to the city if you like.

Goldilocks: Don't you get it yet? After all my doctrinal lectures? When one of us is enslaved, all of us are. Yes, I could move away, but I choose to take my stand here with you. Your cause is my cause.

Goldilocks: Do you think I share your son's bed only because it happens to be 'just right'?

Papa Bear: No, it's because Papa's li'l Boo Bear is hung like a —"

MEDIA: GRAPHITE, COLORED PENCIL, DIGITAL.

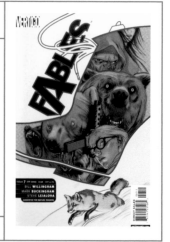

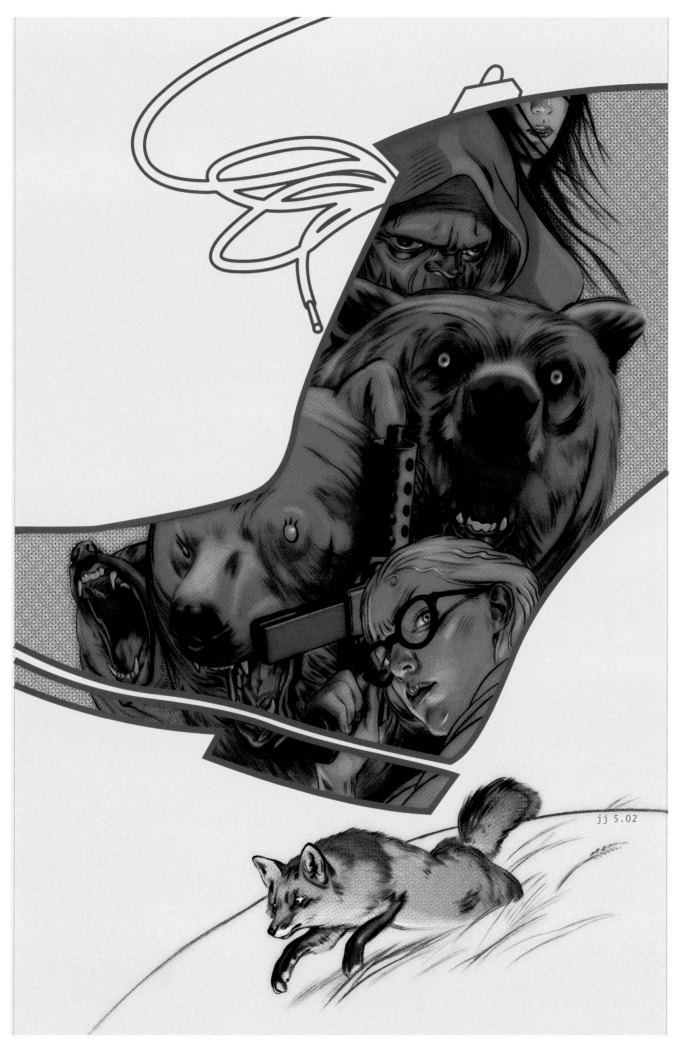

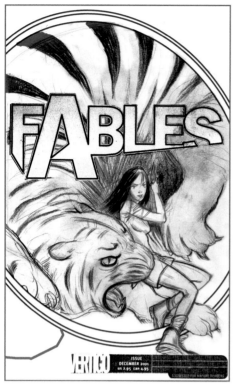

PRELIMINARY SKETCH, GRAPHITE ON BOND, 5.5 X 8.5"

PRELIMINARY SKETCH, GRAPHITE & TAPE ON BOND, 8.5 X 11"

No. 08	ANIMAL FARM	3/5

"**Snow:** Rose? What the hell — ?

Rose: You led us quite the merry chase, Sis, but all's well that ends well, as they say.

Goldy: Quit making speeches, Rose, and do what we're here to do.

Rose: Snow White, by order of the ruling council of the Fables' Revolutionary Authorities, I place you under arrest for crimes against Fablekind."

MEDIA: GRAPHITE, WATERCOLOR, DIGITAL.

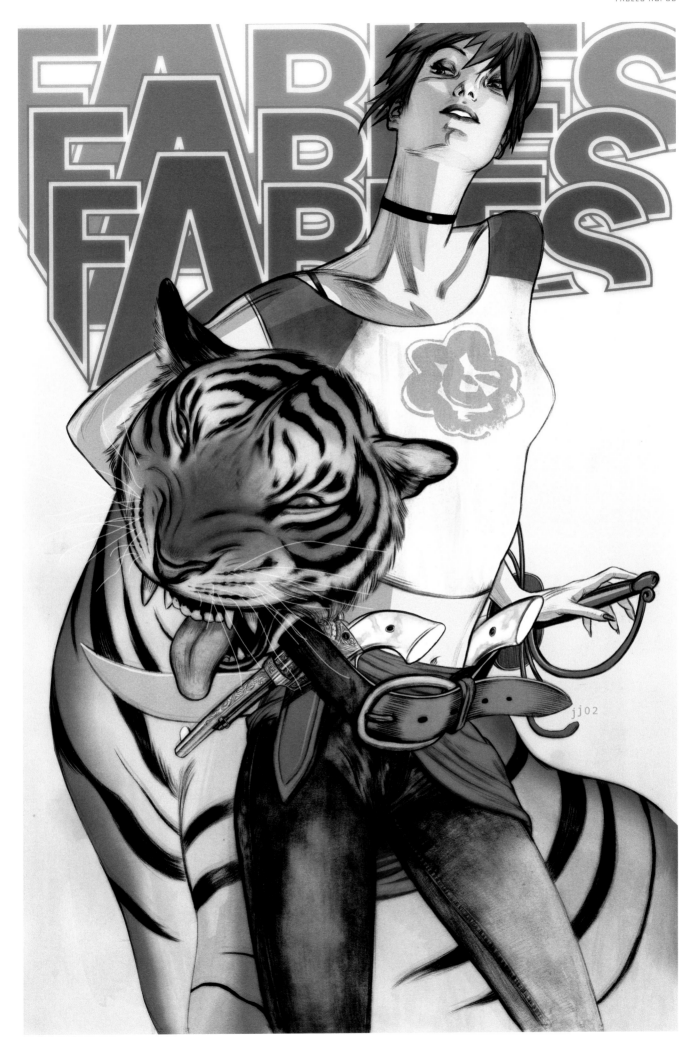

PRELIMINARY SKETCH, GRAPHITE ON BOND, 8 X 10"

DRAWING, GRAPHITE & COLORED PENCIL ON WC PAPER, 14 X 21"

No. 09	ANIMAL FARM	4/5

"Goldilocks: Who said anything about arresting her? Shoot the oppressor!

Rose: That wasn't our deal, Goldilocks. My condition for joining you was that you let Snow White live — at least long enough to stand trial.

Goldilocks: We don't have time for show trials now. And we can't leave her free to continue to sow her mischief among the loyalist scum. Put a bullet in her head so we can get on with our glorious work.

Goldilocks: Or, if you don't have the stomach for it, stand aside and I'll do it."

MEDIA: GRAPHITE, COLORED PENCIL, DIGITAL.

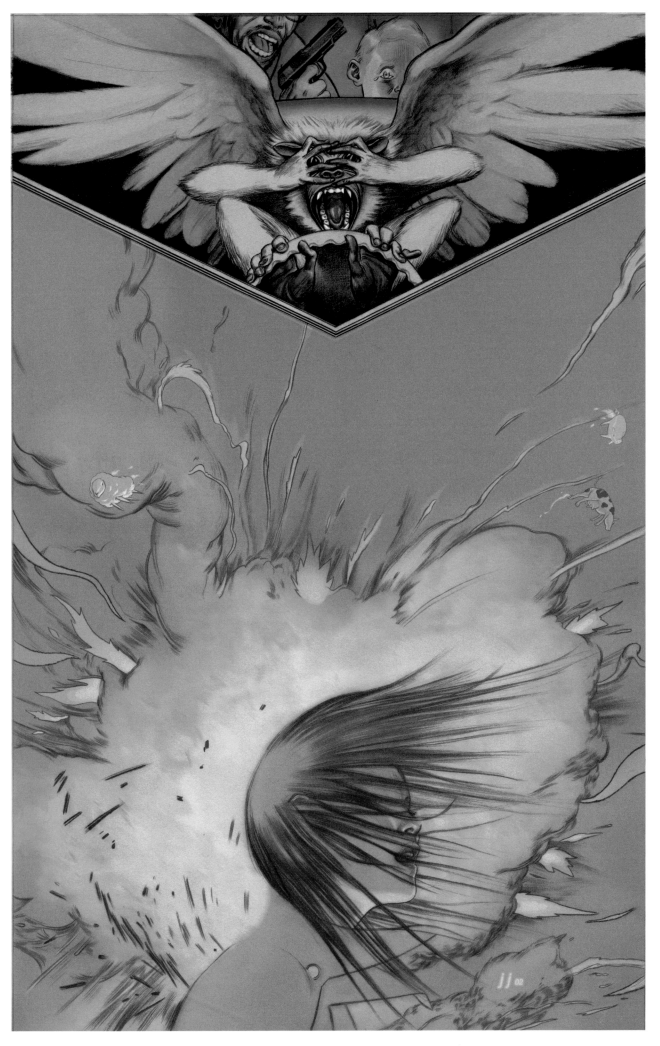

PRELIMINARY SKETCH, GRAPHITE ON BOND, 5.5 X 8.5"

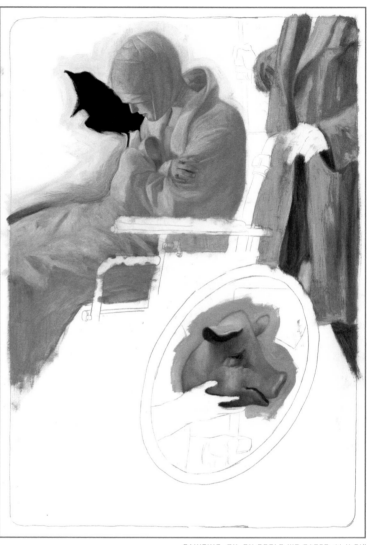

PAINTING, OIL ON 300LB WC PAPER, 14 X 21"

No. 10 | ANIMAL FARM | 5/5

"**Snow:** What happened, Colin?
Colin: The short version is: I got my head chopped off and mounted, while you got yours substantially blown off by a high-powered rifle.
Snow: Then where are we now?
Colin: You got me, Snow, my sweet darlin'. Although, judging by the lack of set decoration, I'd guess we're in limbo, or some similar waiting room to the afterlife.
Snow: So . . . uhm . . . we're dead then?
Colin: Well, considering my condition, I certainly hope so, but I'm not entirely convinced you are. You have that still-holding-on-to-her-last-shuddering-breath look about you.
Snow: Then what should I do?
Colin: I don't know. Have you tried waking up?"

MEDIA: GRAPHITE, WATERCOLOR, BLUE TRANSFER PAPER, OIL, DIGITAL.

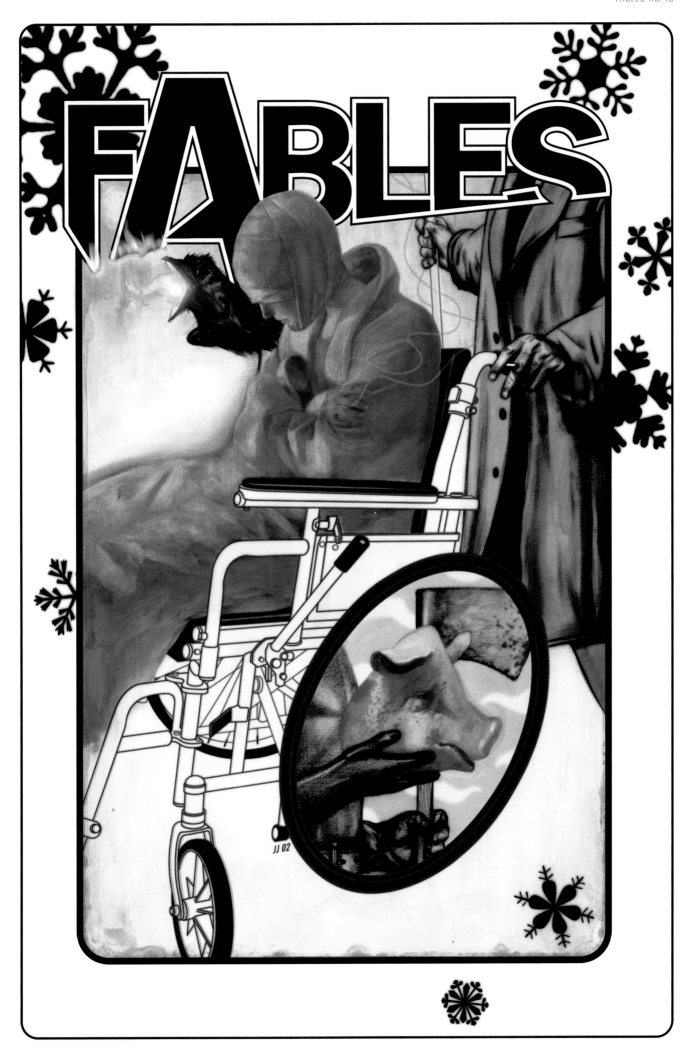

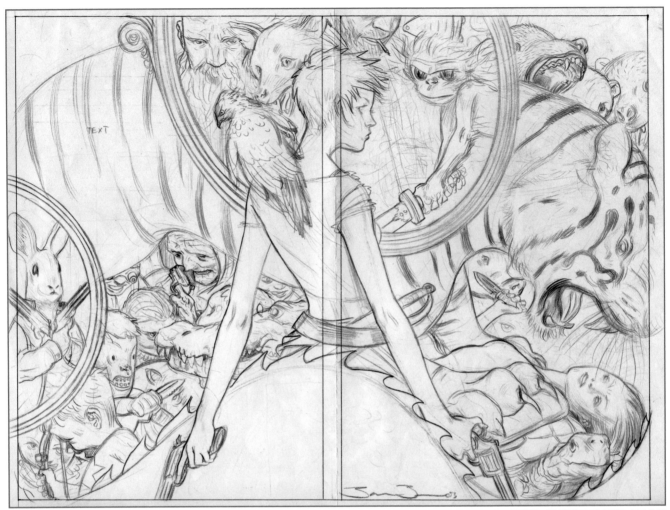

TEXT

PRELIMINARY SKETCH, GRAPHITE ON BOND, 8.5 X 11"

PRELIMINARY SKETCH, GRAPHITE ON BOND, 2 X 4"

Bigby
Snow Weyland
Red
3 Pigs
Reynard
Goldie
Shere Kahn
3 Bears
Bufkin (drunk)
Hawks
Rabbit
Frog
Goat
Crocodile
Dragon

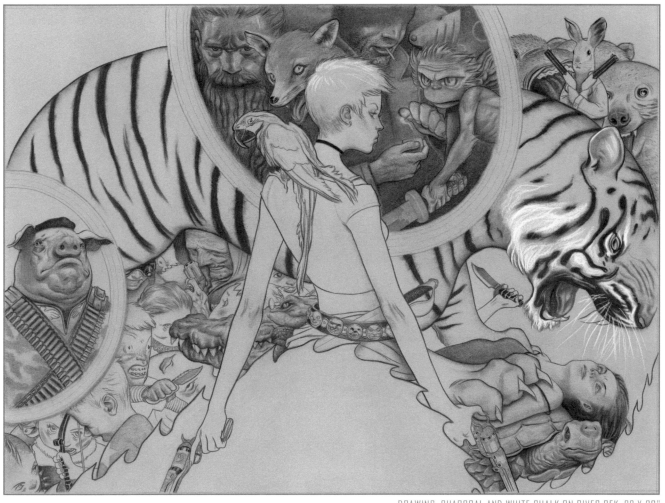

DRAWING, CHARCOAL AND WHITE CHALK ON RIVES BFK, 22 X 30"

TPB 02 | ANIMAL FARM

COLLECTED MATERIAL: ISSUES 6 - 10

MEDIA: CHARCOAL, WHITE CHALK, WATERCOLOR, DIGITAL COLOR.

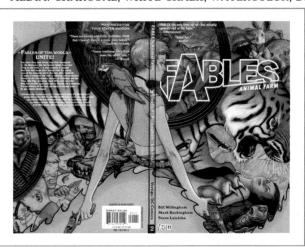

"JJ: Having drawn Shere Kahn on the cover to no. 8, the trade paperback was another opportunity to explore the beautiful graphic gifts of the tiger. The oval framing elements used in the covers to no. 6 and no. 10 are repeated here, and I was able to fit in the mosaic of children that was originally rejected on the cover to no. 7."

33

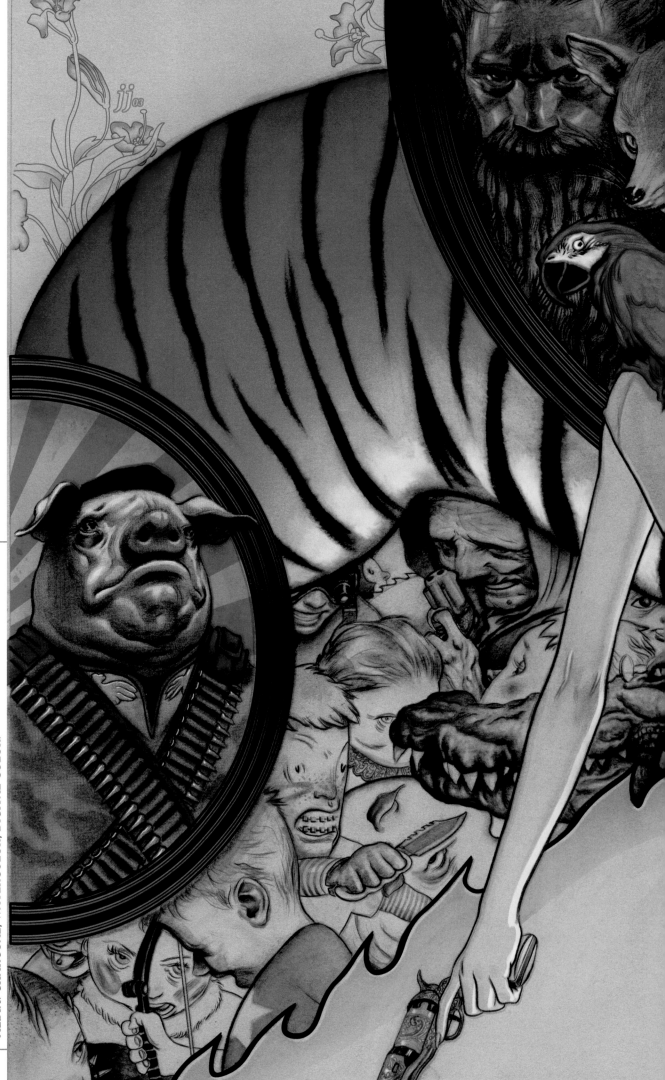

TPB 02 | ANIMAL FARM

COLLECTED MATERIAL: ISSUES 6 - 10

MEDIA: CHARCOAL, WATERCOLOR, DIGITAL COLOR.

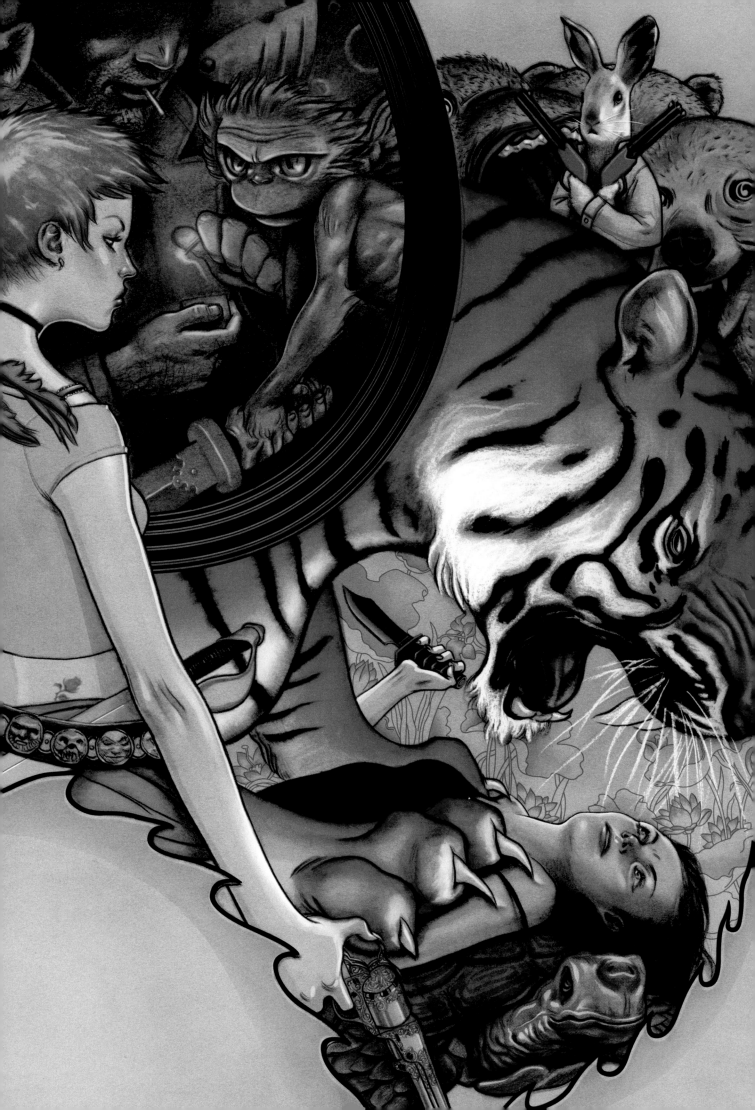

PRELIMINARY SKETCH, GRAPHITE ON BOND, 8.5 X 11"

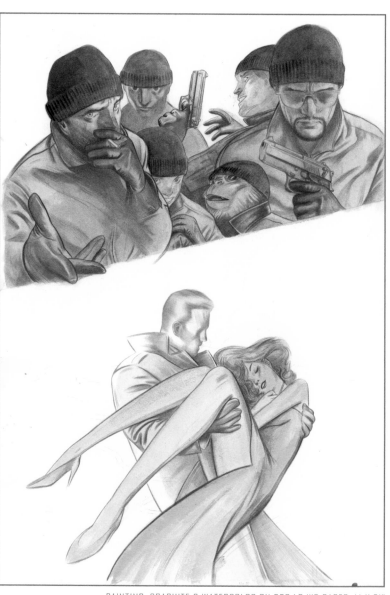

PAINTING, GRAPHITE & WATERCOLOR ON 300 LB WC PAPER, 14 X 21"

No. 12	A TWO-PART CAPER	1/2

"**Sharp:** I'm Tommy Sharp. I write the Sharp Comments column for the Daily News. Perhaps you've read it.
Bigby: Nope. I read The Post. And you're already beginning to bore me. Why don't you say what you want to say and move along?
Sharp: Fine. Then here's my business in a nutshell. For the past few years I've been working on a story about your underground community.
Sharp: I've put in the hours, checked and double-checked the research and done the legwork.
Bigby: How lovely for you.

Sharp: I know all your secrets."

MEDIA: GRAPHITE, WATERCOLOR, PIGMENT INK, DIGITAL.

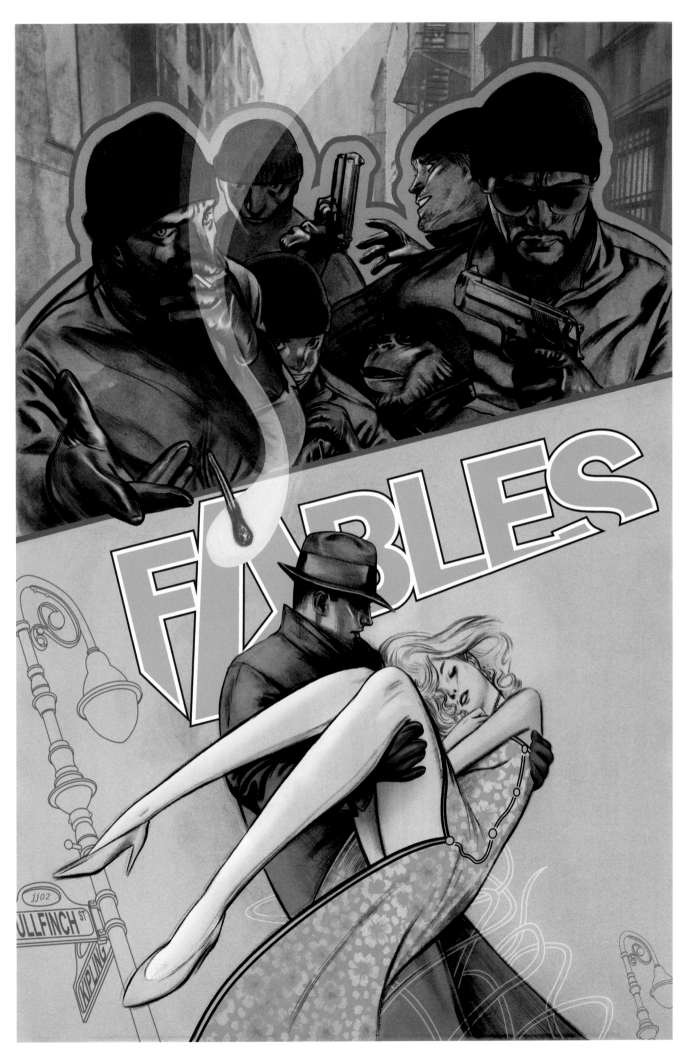

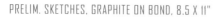

PRELIM. SKETCHES, GRAPHITE ON BOND, 8.5 X 11"

PAINTING, GRAPHITE & OIL ON 300LB WC PAPER, 14 X 21"

No. 13 | A TWO-PART CAPER | 2/2

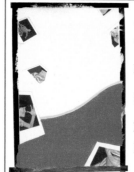

"**Sharp:** Oh my God! It's you! How did you get me? What did you do?

Bigby: Here. Look at yourself in this. Look at your neck.

Snow: What did you sick creatures do to me?

Bigby: You figured out we're vampires, Tommy. You know what we did. We drank your blood."

MEDIA: GRAPHITE, OIL, ACRYLIC, POLAROID FILM, METAL TAPE, DIGITAL.

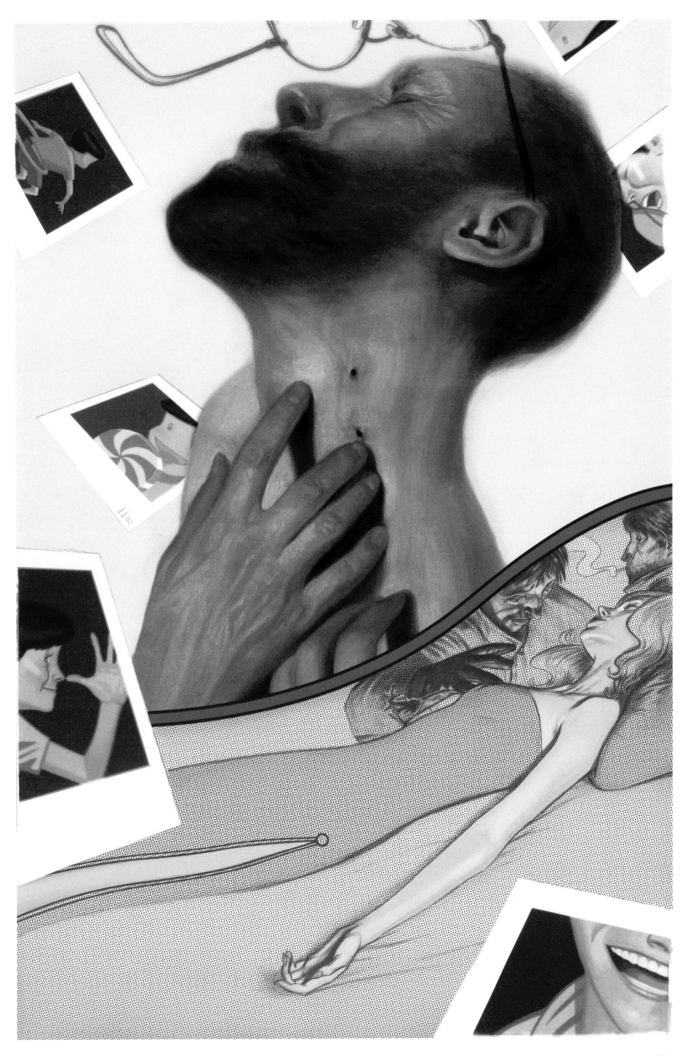

DRAWING, COLORED PENCIL ON 300LB WC PAPER, 14 X 21"

| No. 14 | STORYBOOK LOVE | 1/4 |

"**Goldilocks:** You should tell your manservant Hobbes that he doesn't need to put his glamour up every time I see him.

Goldilocks: I'm no homocentric species bigot. And I'm hardly a shrinking violet, to wilt at the sight of a goblin male in his natural state.

Bluebeard: Hobbes' natural state was sacked by the Adversary, just as yours and mine were, Goldilocks.

Goldilocks: You know what I meant.

Bluebeard: Yes, and I know the increasingly overt suggestions you've been making to Hobbes every time he's had to visit your rooms."

MEDIA: COLORED PENCIL, DIGITAL.

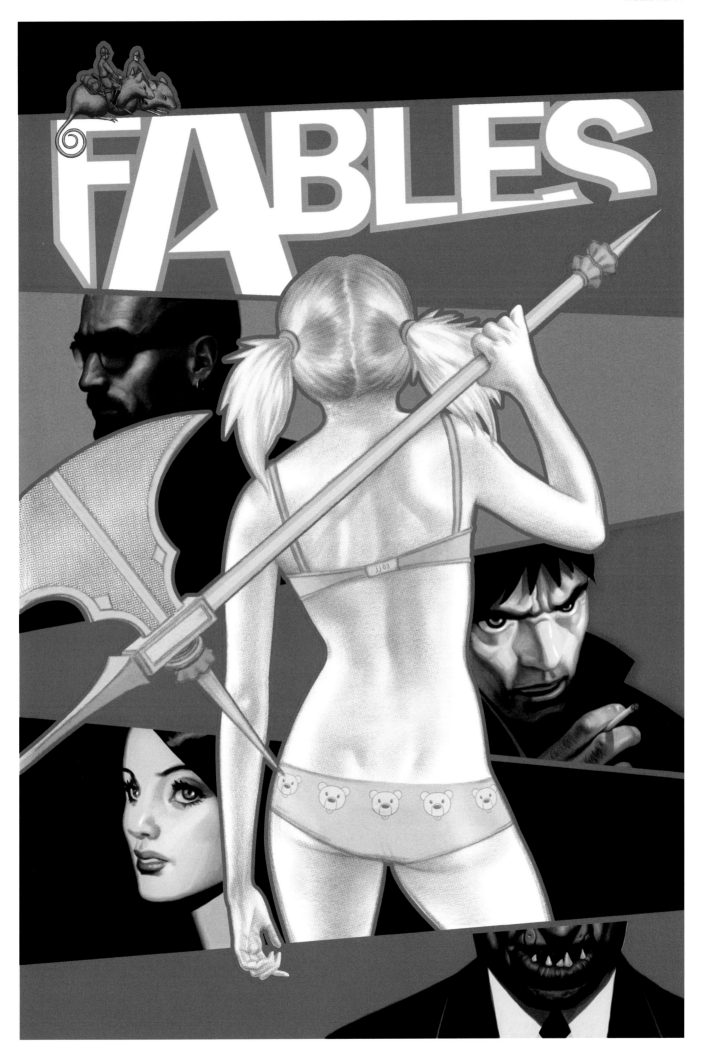

PRELIM. SKETCH, GRAPHITE ON BOND/DIGITAL, 8.5 X 11"

DRAWING, MIXED MEDIA ON PAPER, 14 X 21"

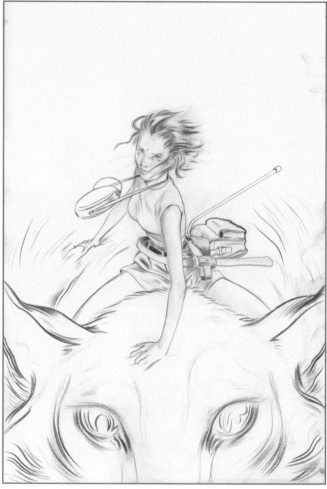

DRAWING, GRAPHITE ON PAPER, 14 X 21"

No. 15 | STORYBOOK LOVE | 2/4

"**Bigby:** It wasn't just a flat tire that sent us over the cliff. There was a gunshot, but its sound came after the blowout. You no doubt couldn't hear it over your own screaming at the time. My ears are more sensitive, though.

Bigby: The trip down the cliff actually helped us some. It abruptly removed us from his killing zone — saved us from a second shot. But that was some time ago, and he — whoever the hunter is — will have been moving back in on us for all that time.

Bigby: So we'll need to move out fast, as soon as I change to wolf form. Night or day, I can cover a lot of miles quickly, even with a passenger.

Bigby: Now help me get undressed. You'll have to carry what's left of my clothes, as well as your stuff, if you want me to have something to wear once I change back."

MEDIA: GRAPHITE, COLORED PENCIL ACRYLIC, DIGITAL.

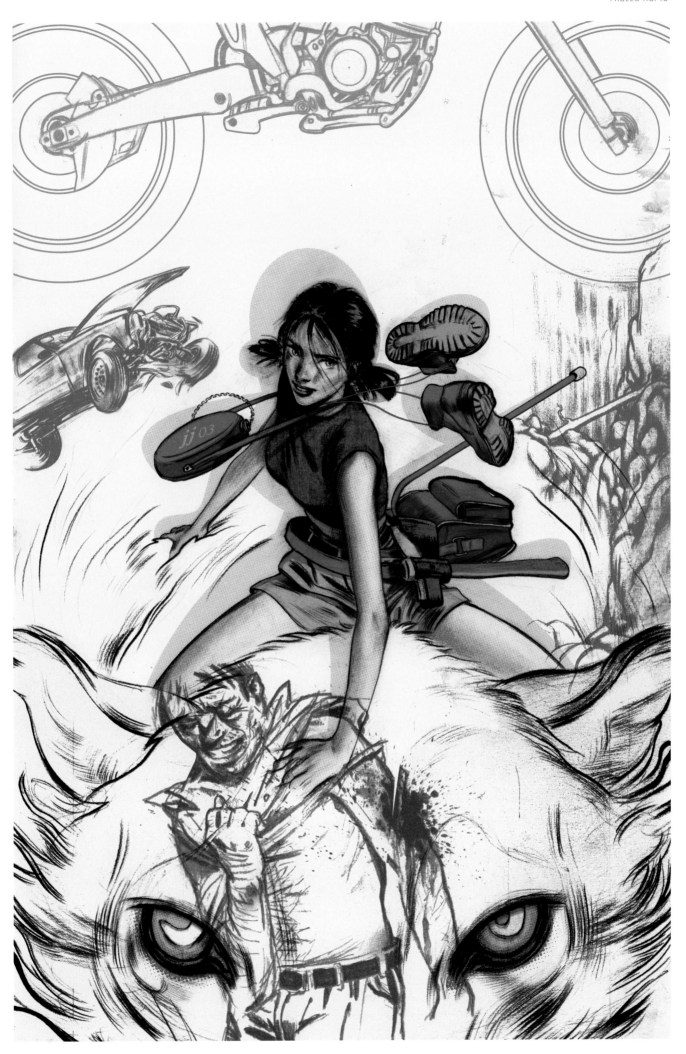

DRAWING, GRAPHITE & WATERCOLOR ON PAPER, 7 X 14"

PRELIMINARY SKETCHES, GRAPHITE & DIGITAL, 5.5 X 8.5"

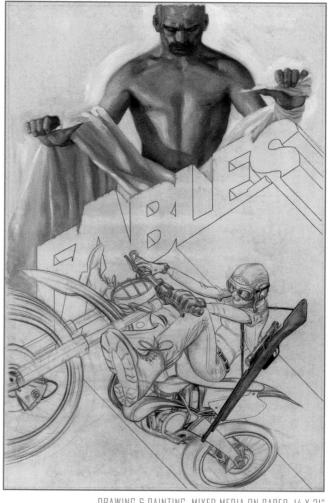

DRAWING & PAINTING, MIXED MEDIA ON PAPER, 14 X 21"

No. 16	STORYBOOK LOVE	3/4

"Bluebeard: That's it! I surrender! You win!

Charming: You haven't been listening. Surrender isn't an option!

Bluebeard: But I'm begging you! AAAHH!

Bluebeard: You prick! You've killed me!

Bluebeard: But I win too, though — in a way. I was trying to tell you — but you wouldn't listen. You see — I already killed the wolf, and your princess, too. Already done."

MEDIA: GRAPHITE, WATERCOLOR, PIGMENT INK, OIL PAINT, DIGITAL.

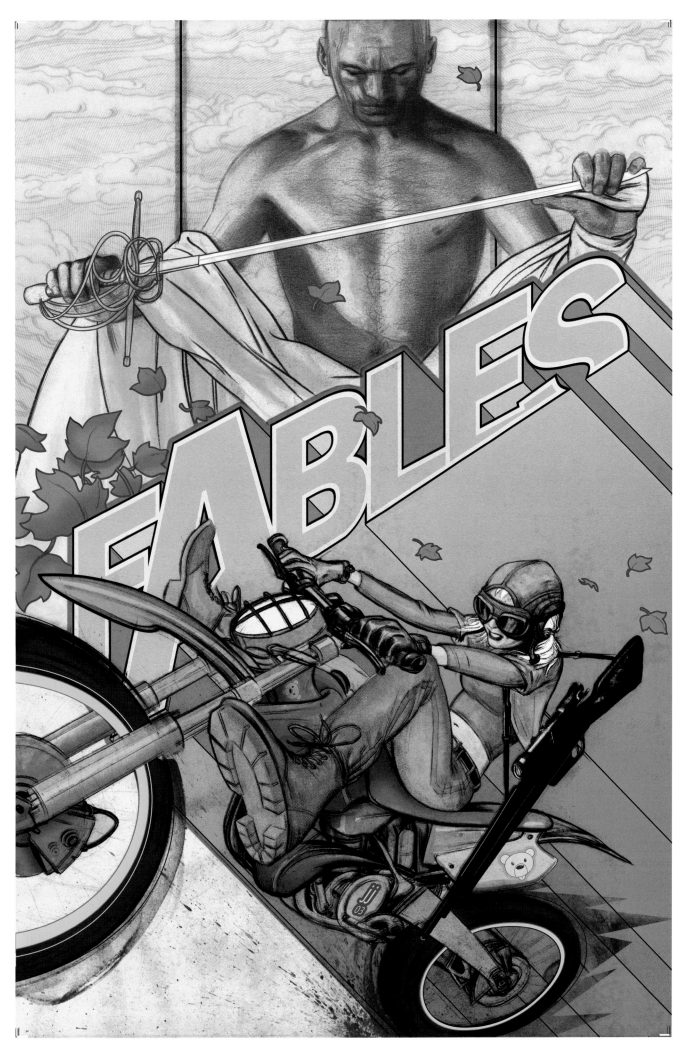

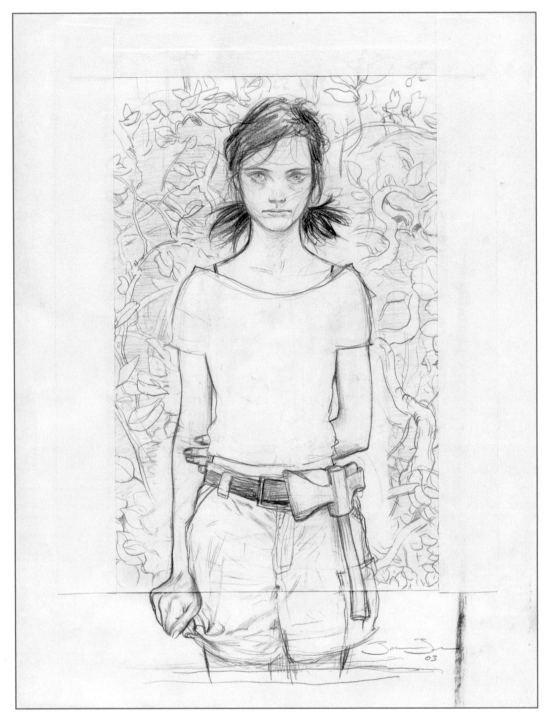

PRELIMINARY SKETCH, GRAPHITE AND TAPE ON BOND, 8.5 X 11"

No. 17 | STORYBOOK LOVE | 4/4

"**Wolf:** You . . . should . . . have . . . used . . . silver.

Goldilocks: What's that? Excuse me?

Wolf: Silver bullets. These steel and lead things hurt like the dickens, but they can't kill me or do anything permanent.

Goldilocks: Well, that's no fair. I'm using top of the line 30-378 Weatherby hunting rounds. They can kill a charging elephant with one shot and they should have made a right royal pudding of your innards.

Wolf: My bones and vessels and guts are already knitting back together. I'll have you between my jaws soon enough.

Goldilocks: Do tell? Then here's an appetizer.

sfx: **BLAM!**"

MEDIA: GRAPHITE, WATERCOLOR, OIL, DIGITAL.

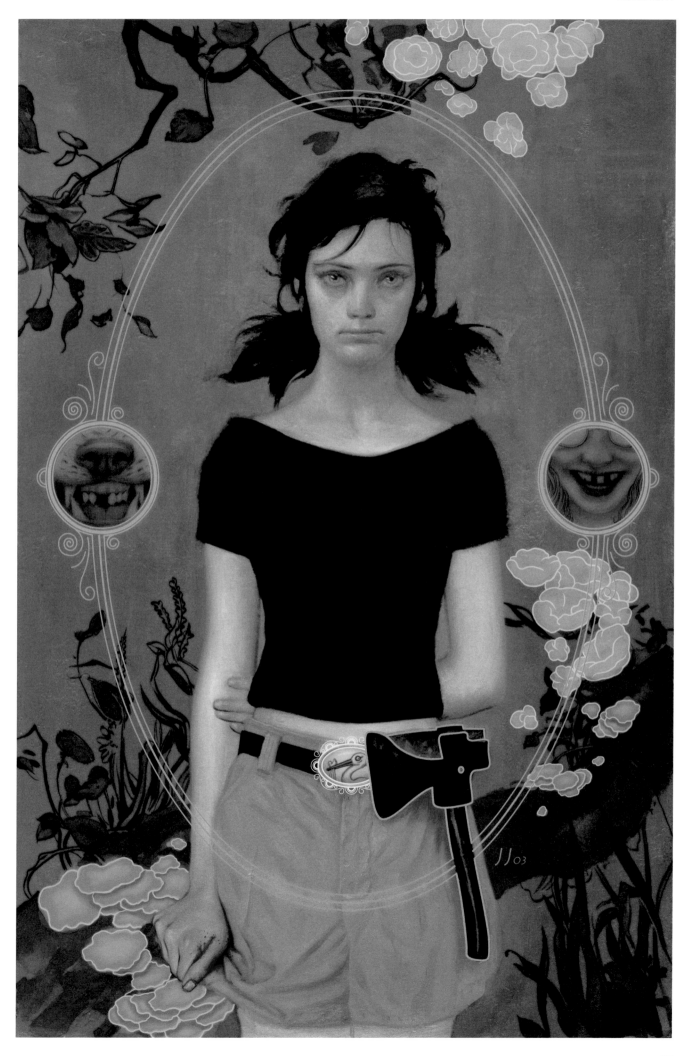

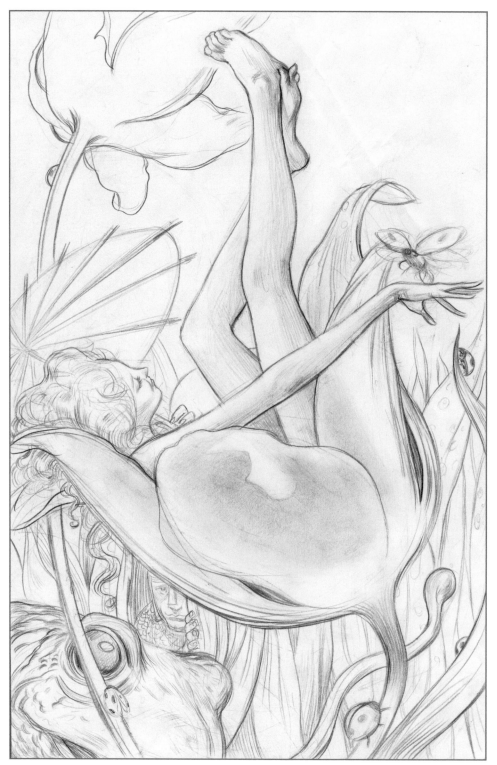

PRELIMINARY SKETCH, GRAPHITE ON BOND, 7 X 10.5"

No. 18 | BARLEYCORN BRIDES

"**Cap (Bigby):** Years passed with nary a woman in the unhappy village of Smalltown — until Thumbelina showed up, after escaping from her own distant homeland.

Thumbelina: Hi. The Fabletown authorities said I would be staying here, since we're — uhm — the same size.

Horndog No. 1: A girl? A real girl?

Horndog No. 2: That ain't no girl, boy. That thar's all woman.

Horndog No. 3: And a gorgeous one at that!"

MEDIA: GRAPHITE, WATERCOLOR, DIGITAL.

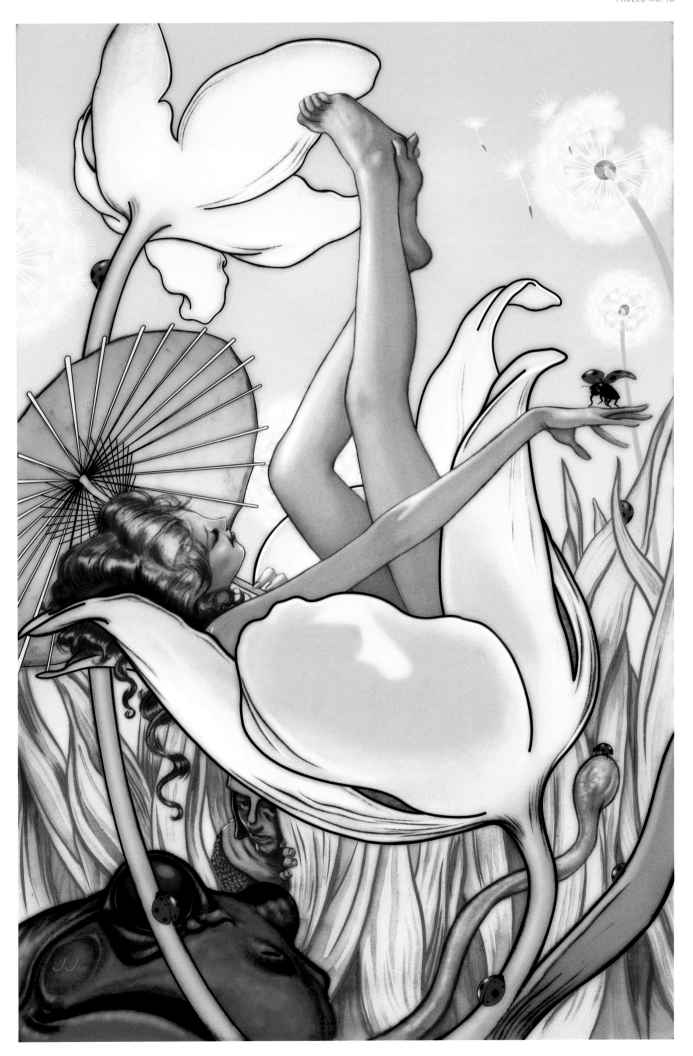

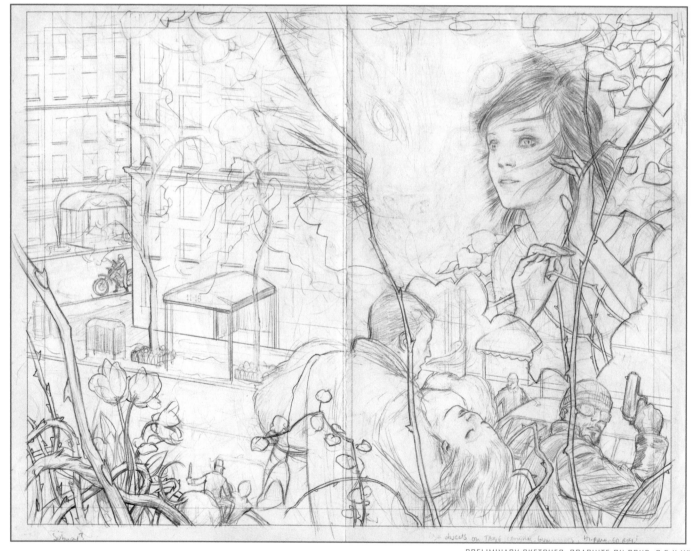

PRELIMINARY SKETCHES, GRAPHITE ON BOND, 8.5 X 11"

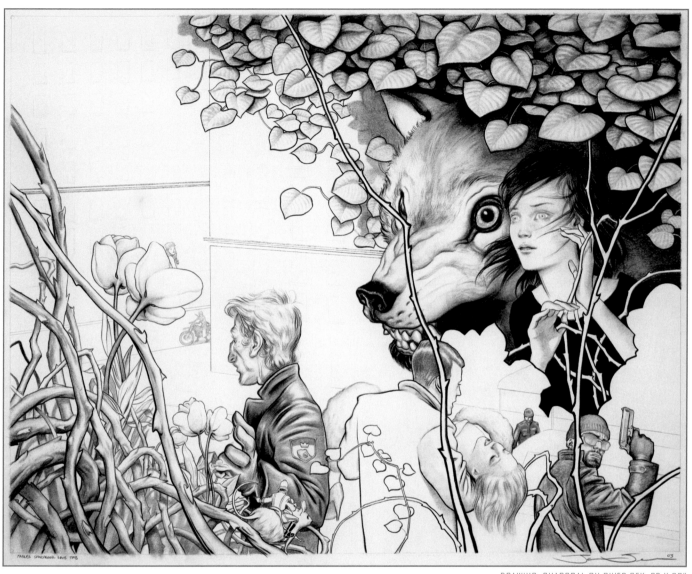

DRAWING, CHARCOAL ON RIVES BFK, 22 X 30"

TPB 03 | STORYBOOK LOVE

COLLECTED MATERIAL: ISSUES 11 - 18

MEDIA: CHARCOAL, WATERCOLOR, PIGMENT INK, DIGITAL COLOR.

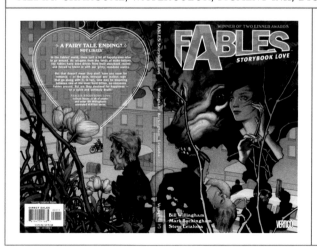

"JJ: The foliage in the charcoal drawing took a particularly long time to render, but they ended up dark and obscured in the final. There is always a heavy investment in the infrastructure behind each Fables cover; some of it is squandered, but it's always better to have more material to work with while I'm editing and paring down the cover to its essence."

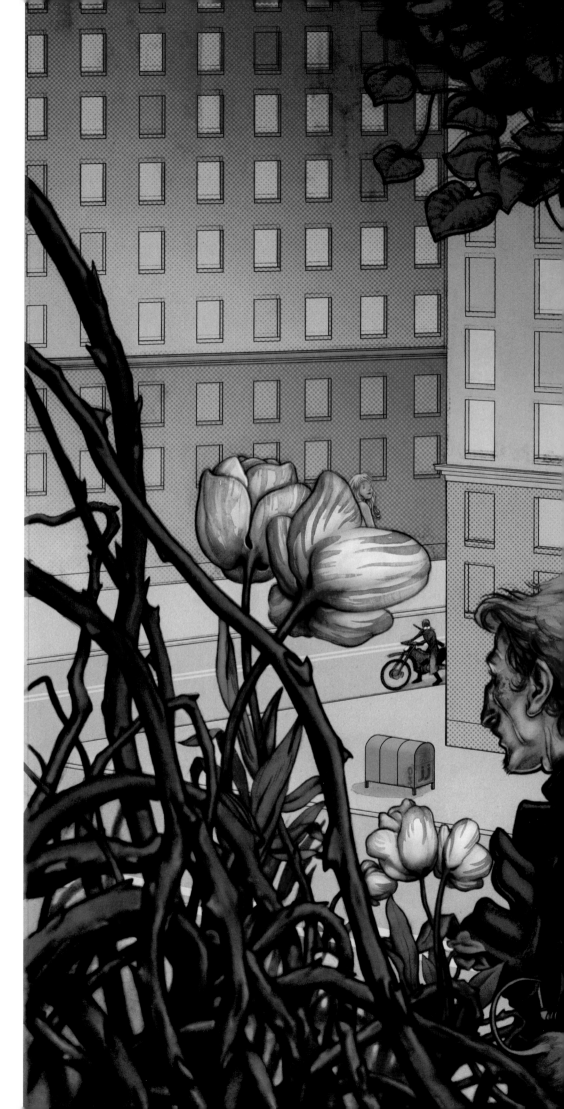

TPB 03 | STORYBOOK LOVE

COLLECTED MATERIAL: ISSUES 11 - 18

MEDIA: CHARCOAL, WATERCOLOR, PIGMENT INK, DIGITAL COLOR.

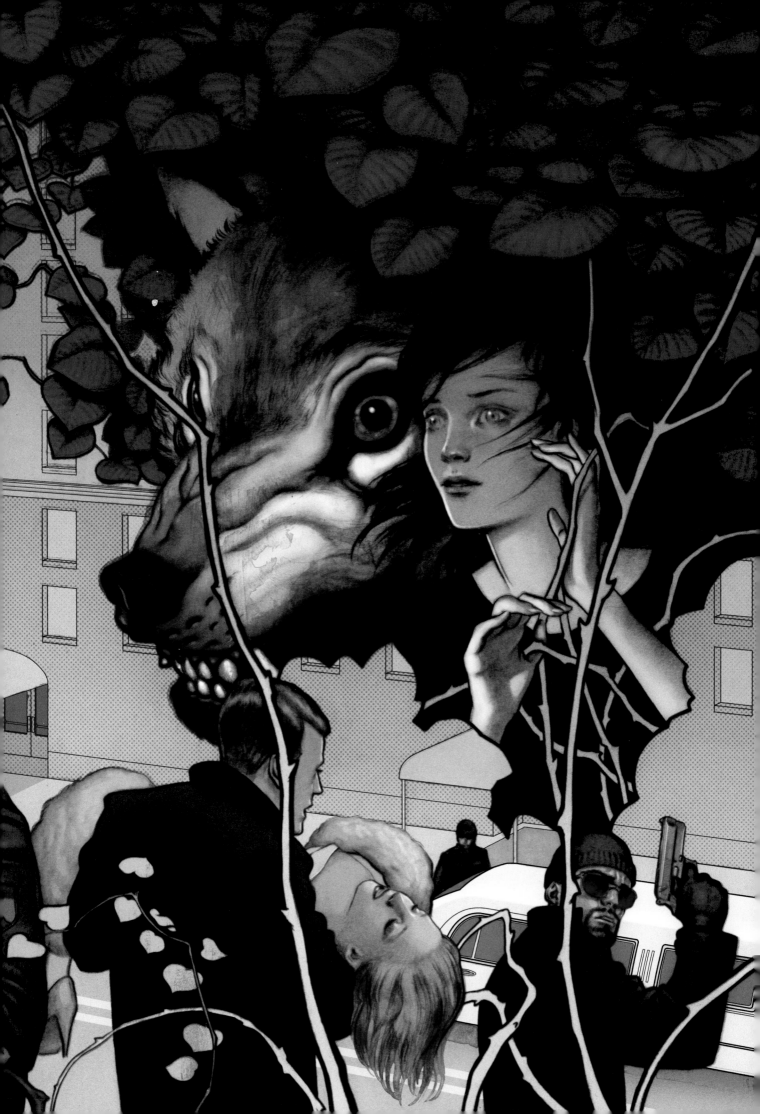

PRELIMINARY SKETCH
GRAPHITE ON BOND/DIGITAL, 6.5 X 10.25"

RED RIDING HOOD DRAWING
GRAPHITE ON RIVES BFK, 5 X 5"

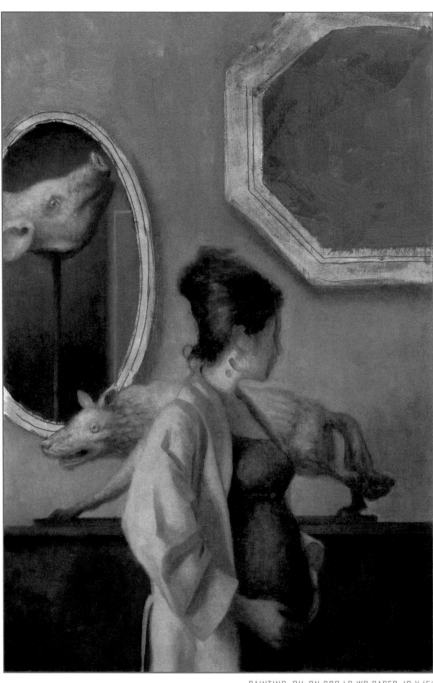

PAINTING, OIL ON 300 LB WC PAPER, 10 X 15"

No. 19 | MARCH OF THE WOODEN SOLDIERS | 1/8

"**Colin:** How're things here and upstate? How're the new little pigs doing?
Snow: Okay, I guess. Rose is running the farm now, so I don't get up there much.
Colin: Well, you will. You'll have to once your babies are born.
Snow: Babies? Plural?
Colin: You know — since they won't be allowed to stay down here.
Snow: What do you mean? Why wouldn't they — ?
Colin: We can't talk about that now, Snow. I don't know how long I'll be able to stay, and I need to warn you.
Snow: About what?
Colin: Things are going to get bad soon. Real bad. Not just for you, but for all of Fabletown.
...

Cap (Colin): Terrible things are on the way."

MEDIA: GRAPHITE, OIL, WATERCOLOR, DIGITAL.

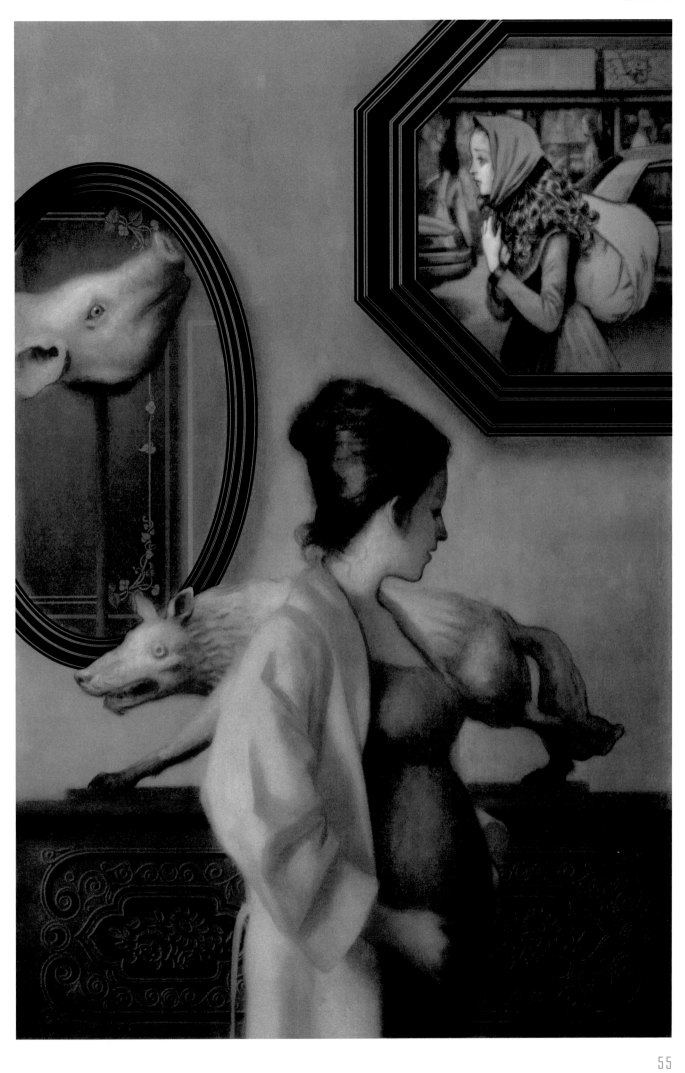

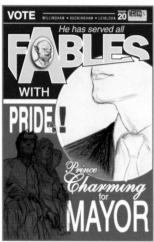

PRELIMINARY SKETCHES,
GRAPHITE ON BOND/DIGITAL, 6.5 X 10.25"

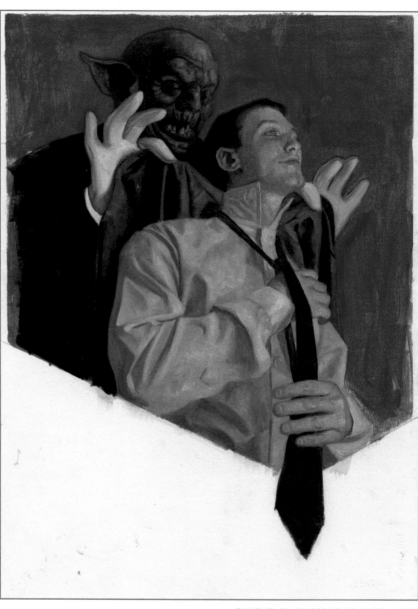

PAINTING, OIL ON 300 LB WC PAPER, 11 X 15"

| No. 20 | MARCH OF THE WOODEN SOLDIERS | 2/8 |

"**Charming:** The first thing the **new** administration will do is fund **free glamours** for anyone who needs them. No more will Fables be shipped off to the Farm just for looking a **touch** inhuman.

...

Charming: And how about government-sponsored **transformations** for any Farm Fable who might want to end centuries of unfair confinement up there?

...

Charming: My fellow citizens, it's time to make a **proactive** decision for the **future** of Fabletown. If you want to help usher in a new golden age, simply **sign** the petition."

MEDIA: OIL, DIGITAL.

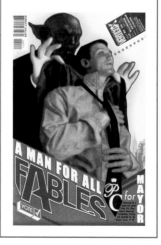

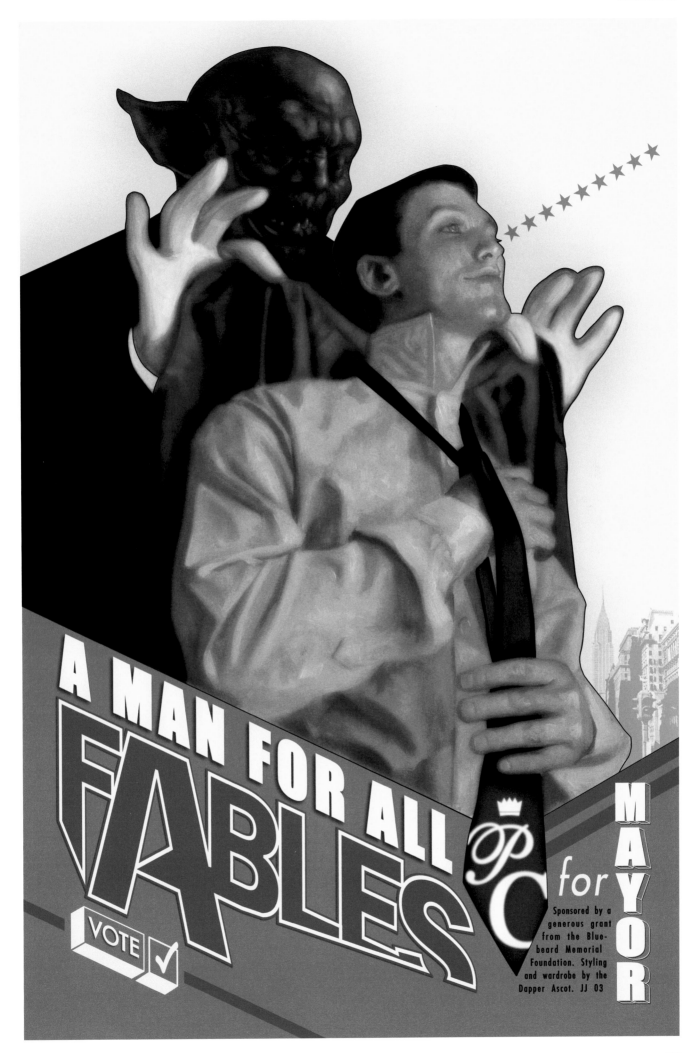

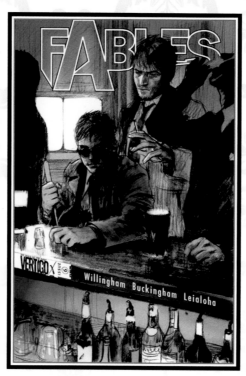

PRELIMINARY SKETCH
GRAPHITE ON BOND/DIGITAL, 6.5 X 10.25"

| No. 21 | MARCH OF THE WOODEN SOLDIERS | 3/8 |

"**Bigby:** How've you been, Kay?

Kay: I've been better and I've been worse.

Bigby: Christ's Holy Pecker. You've gouged your eyes out again. Why do you do it?

Kay: You know why. When I can see, I can't help but see every evil deed that each person has committed in his life. No visions of the good — only the evil — in minute detail. Can you imagine what it's like to know such things?

Kay: Better not to see at all."

MEDIA: OIL ON 300LB WC PAPER, 15 X 22", DIGITAL.

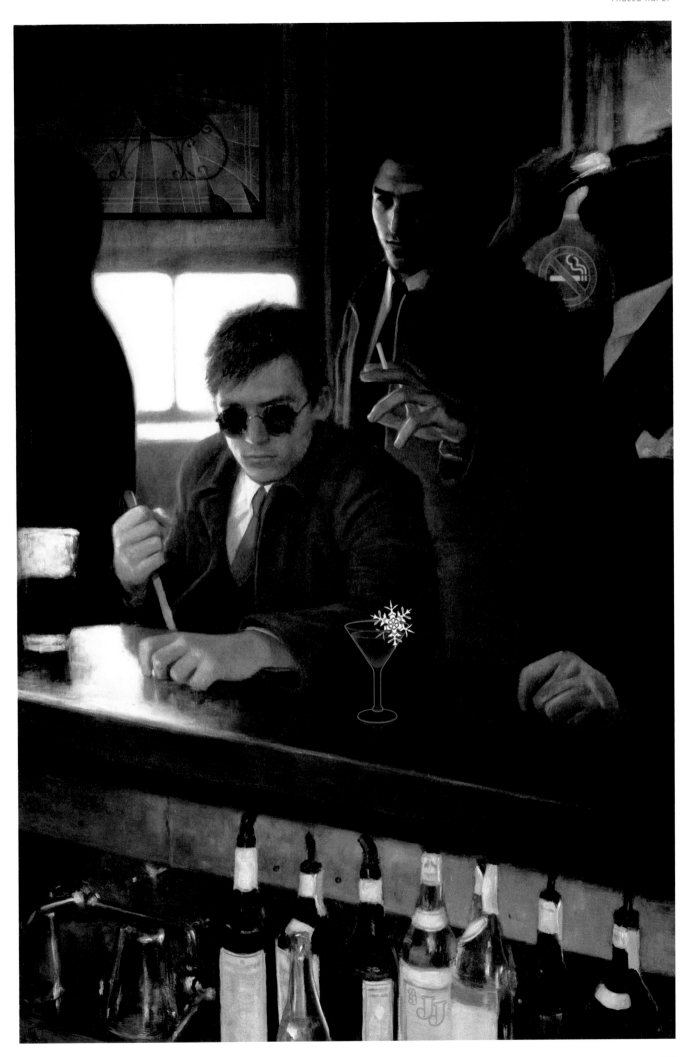

PRELIMINARY SKETCH
GRAPHITE ON BOND, 5.5 X 8.5"

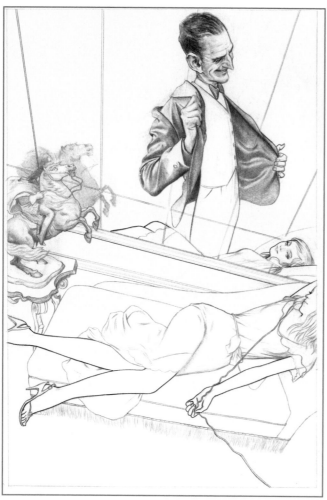

DRAWING, GRAPHITE & SUMI INK ON 300LB WC PAPER, 11 X 15"

ALTERNATIVE FINAL

| No. 22 | CINDERELLA LIBERTINE | 1/1 |

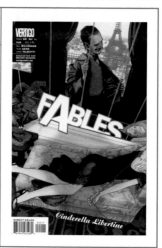

"Panel One

Now we finally pull back to see this room in full. It's a luxurious Paris bedroom suite. The statue we just saw in detail is visible in the background, on its table near one of the many windows in this room, overlooking a breathtaking view. There are other busts and statues and vases in the room, as well as real paintings on the walls. Cinderella is even more breathtaking than the room or the scenery. She's talking on the room phone, pacing as she talks, twirling the long phone cord around her fingers as she does so. She is dressed in a long and lacy teddy, over a set of naughty lingerie - not whorish Frederick's of Hollywood type stuff, but something stylish and just a bit risqué. Something a bride might save for her wedding night."

MEDIA: GRAPHITE, SUMI INK, WATERCOLOR, DIGITAL.

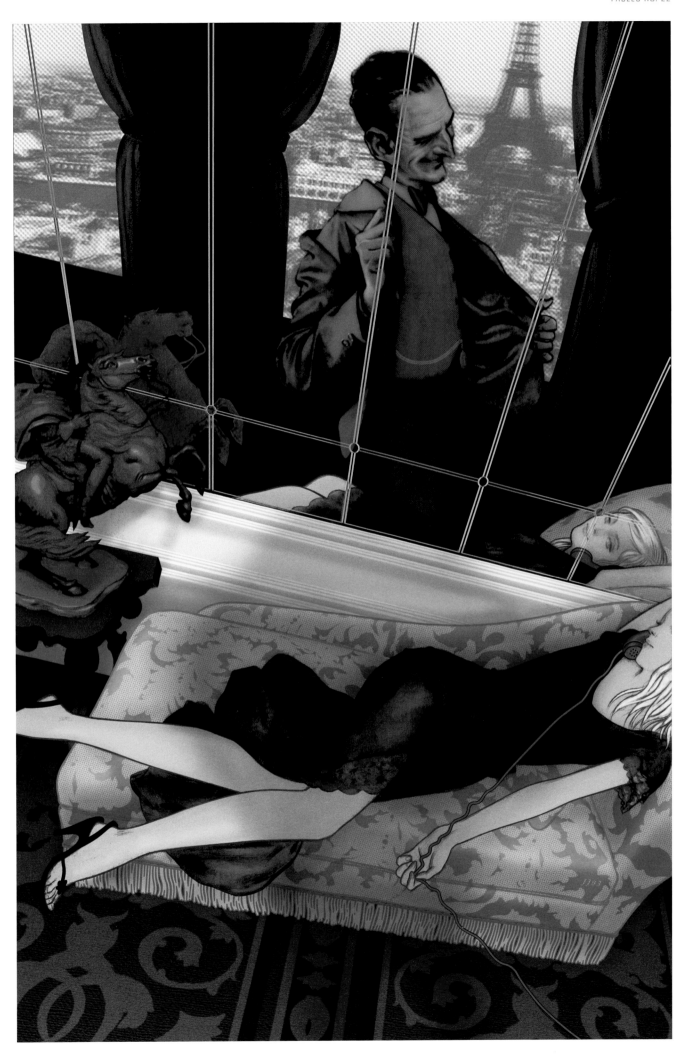

PRELIMINARY SKETCHES
GRAPHITE ON BOND, 7 X 10.5"

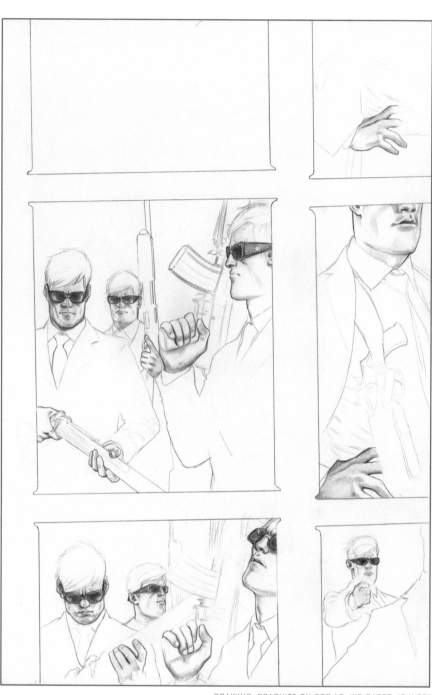

DRAWING, GRAPHITE ON 300 LB. WC PAPER, 15 X 22"

No. 23 | MARCH OF THE WOODEN SOLDIERS | 4/8

"**Big Ned:** Good morning, Gentlemen. You're certainly here early.

Drew: As they say, the early bird catches the worm.
Hugh: Though I caution you not to conclude by the aphorism that we wish you to offer us food.
Lou: True. Kindly interpret the saying strictly in a metaphorical sense.

Big Ned: Uhm . . . sure. Ah . . . what can I do for you?

Lou: We're eager to buy guns.
Hugh: Agreed. Our enthusiasm overflows.

Big Ned: Okay. You're in the right place. What sorts of guns did you have in mind?

Drew: One of each kind."

MEDIA: GRAPHITE, WATERCOLOR, PIGMENT INK, DIGITAL.

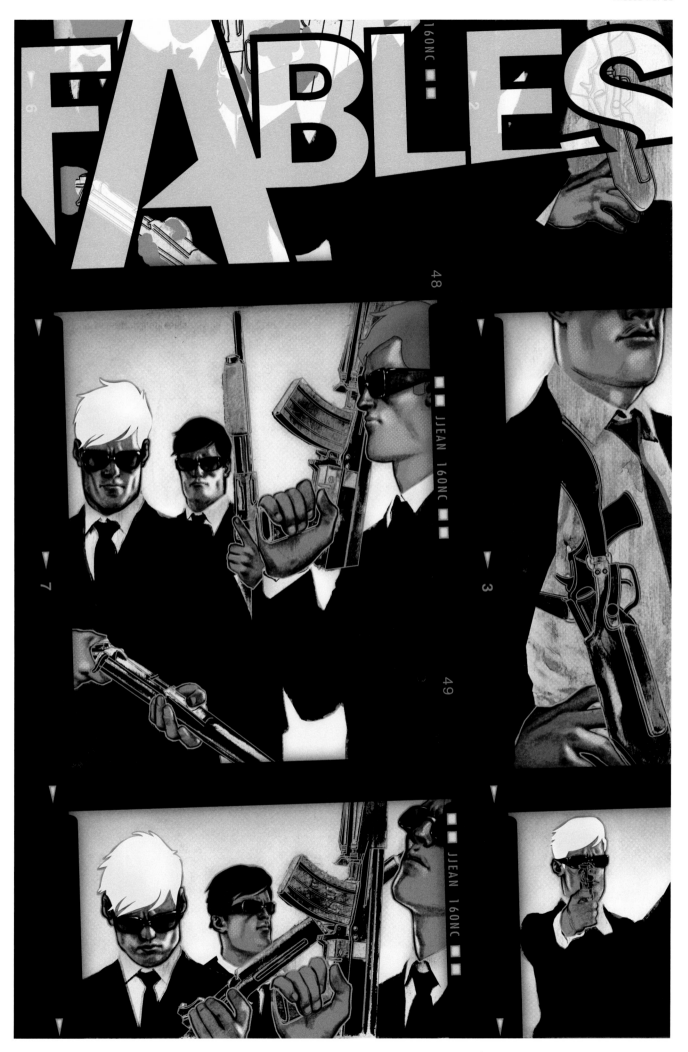

 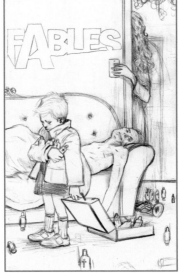 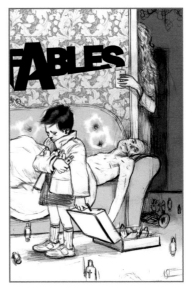

PRELIMINARY SKETCHES, GRAPHITE ON BOND/DIGITAL, 5.5 X 8.5"

DRAWING (PARTIAL SCAN), GRAPHITE ON 300 LB. WC PAPER, 11 X 15"

| No. 24 | MARCH OF THE WOODEN SOLDIERS | 5/8 |

"**Hugh:** Tomorrow, when we return to collect our Emperor's property, we will also be taking the noble Pinocchio with us.
Fly: What?
Pinocchio: Why me?

Panel Four

As Hugh and Drew answer Pinocchio's question, Lou, now free of both Boy Blue's body and the Emperor's letter, now carefully draws his two pistols from his twin underarm holsters.

Drew: Because you're the First Carved. Our eldest brother.
Hugh: Beloved to us – even though horribly tainted by your unfortunate transformation to meat."

MEDIA: GRAPHITE, WATERCOLOR, DIGITAL.

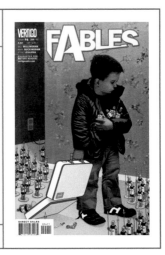

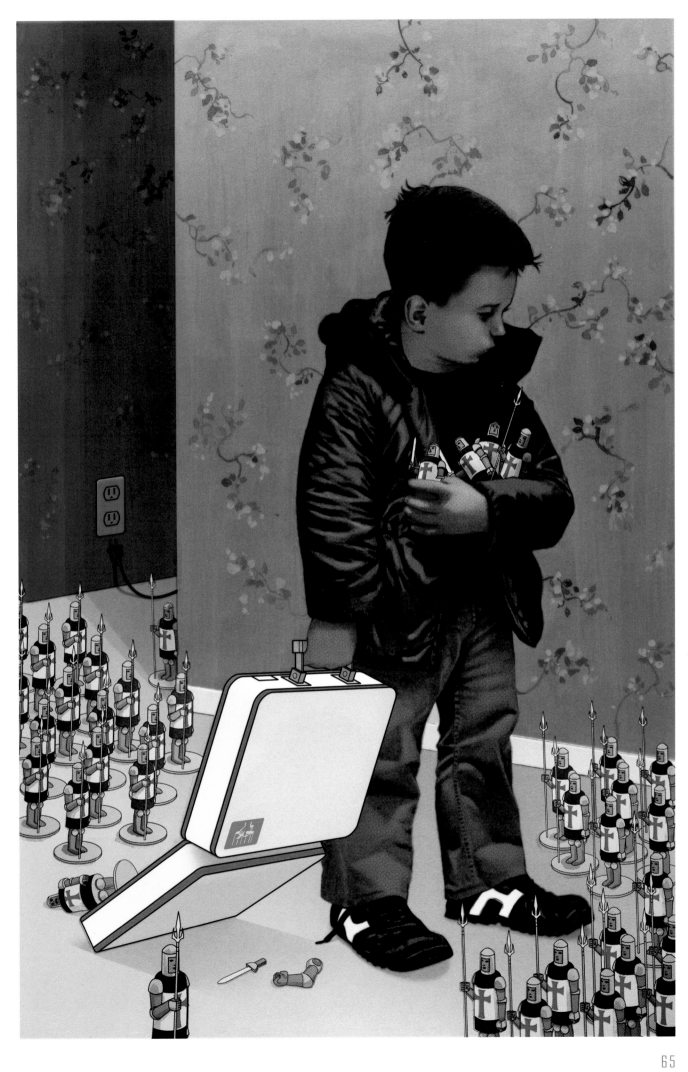

PRELIMINARY SKETCH 1
GRAPHITE ON BOND, 5.5 X 8.5"

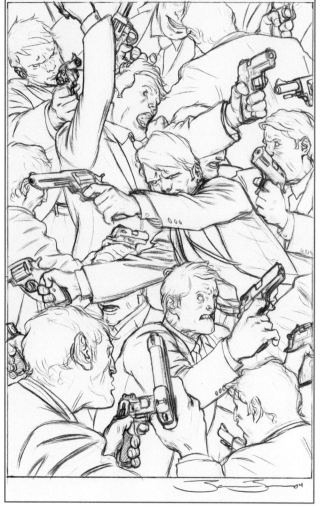

PRELIMINARY SKETCH 2, GRAPHITE ON BOND, 5.5 X 8.5"

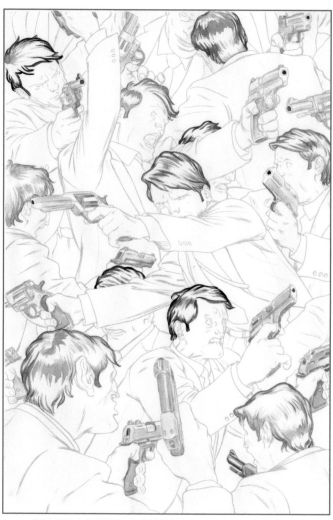

COLLATERAL PAINTING, WATERCOLOR & PIGMENT INK ON BOND, 7 X 10.5"

| No. 25 | MARCH OF THE WOODEN SOLDIERS | 6/8 |

"Hugh: Ready, brothers?

Drew: I'm positively aquiver with anticipation, brother.

Lou: It is my fondest desire to bust a host of caps into multitudes of fleshy personages."

MEDIA: GRAPHITE, WATERCOLOR, PIGMENT INK, DIGITAL.

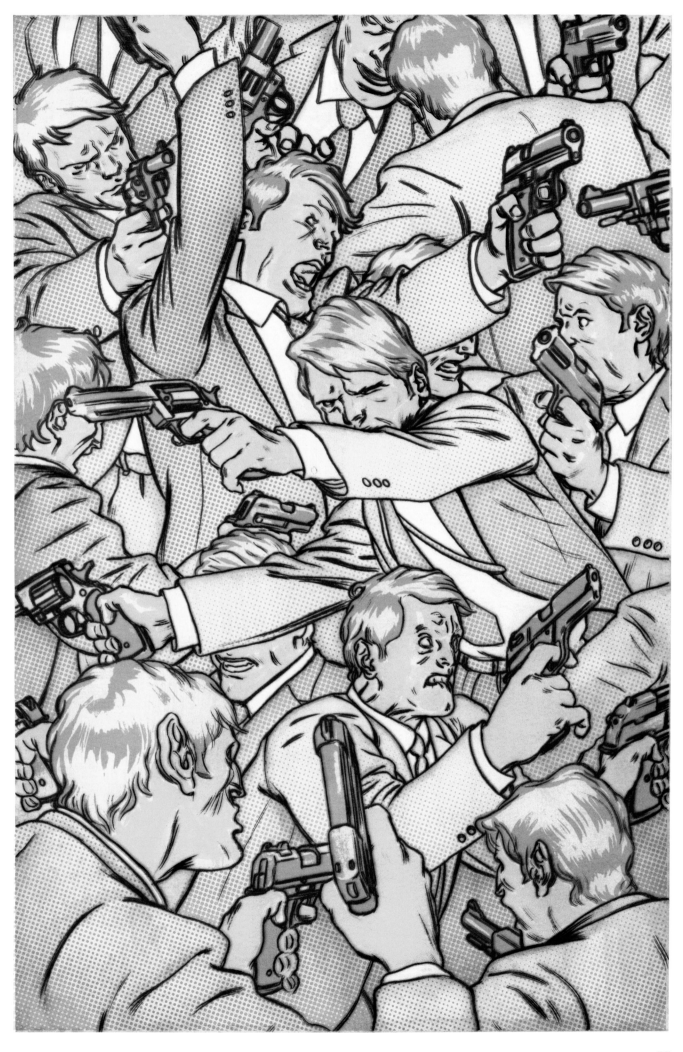

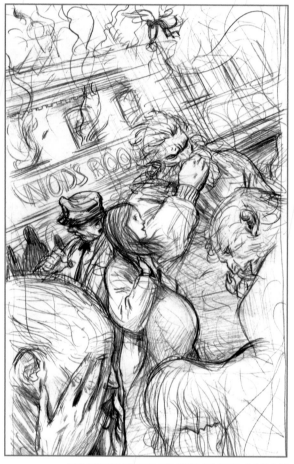

PRELIMINARY SKETCH, GRAPHITE ON BOND, 5.5 X 8.5"

No. 26	MARCH OF THE WOODEN SOLDIERS	7/8

"**Pinocchio:** No! No! What's she doing?

Jack: Get back in here, you little twerp!

Pinocchio: Snow doesn't understand! Those creatures are like me! Made like me, out of hardwood!

Pinocchio: Yes, they'll burn eventually, but not quickly! And until then they'll still walk and kill and set fire to whatever they touch!

Pinocchio: Snow's just created two hundred mobile human torches!"

MEDIA: GRAPHITE, DIGITAL.

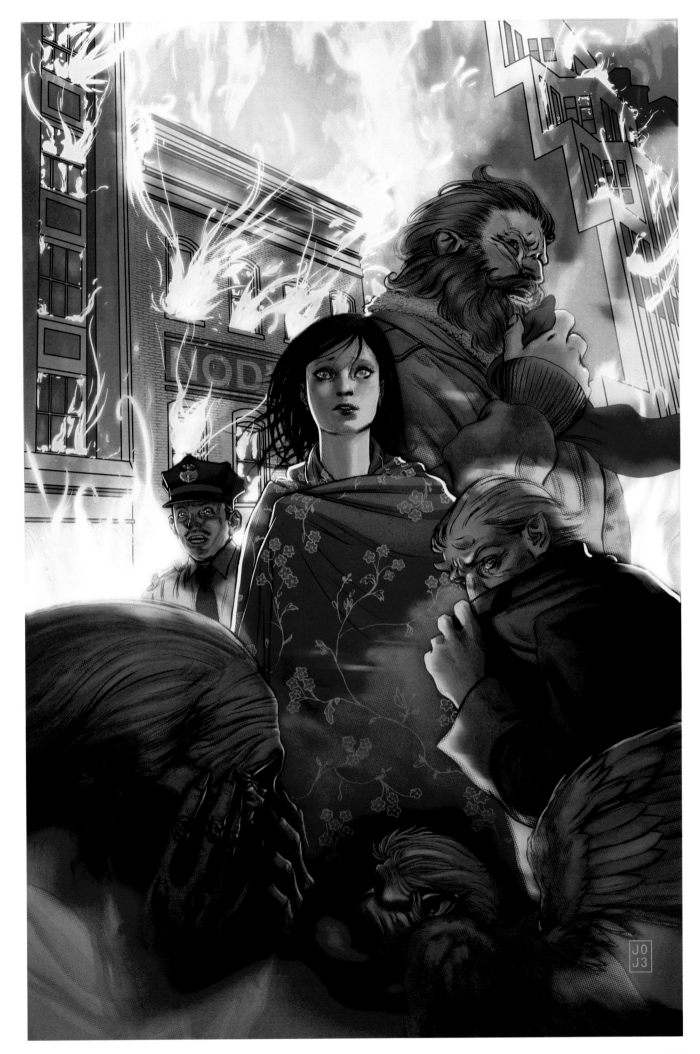

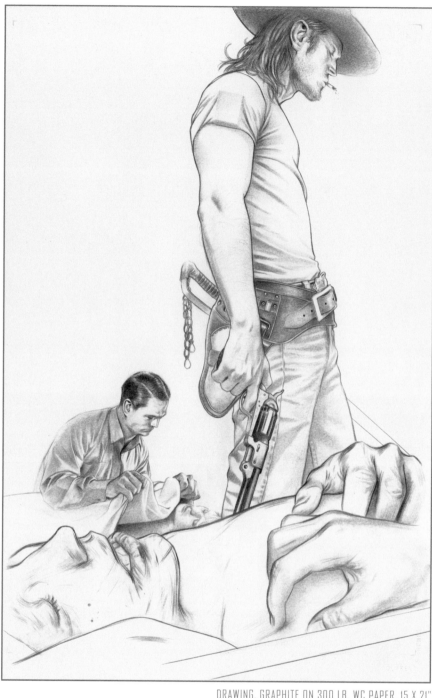

PRELIMINARY SKETCHES
GRAPHITE ON BOND/DIGITAL. 5.5 X 8.5"

DRAWING, GRAPHITE ON 300 LB. WC PAPER, 15 X 21"

| No. 27 | MARCH OF THE WOODEN SOLDIERS | 8 / 8 |

"Cap: Friday, March 29th.

Voice (from city): Turning back to local news, a block party in the Upper West Side got out of hand yesterday, resulting in a minor building fire, which was quickly extinguished, with no injuries reported."

MEDIA: GRAPHITE, WATERCOLOR, DIGITAL.

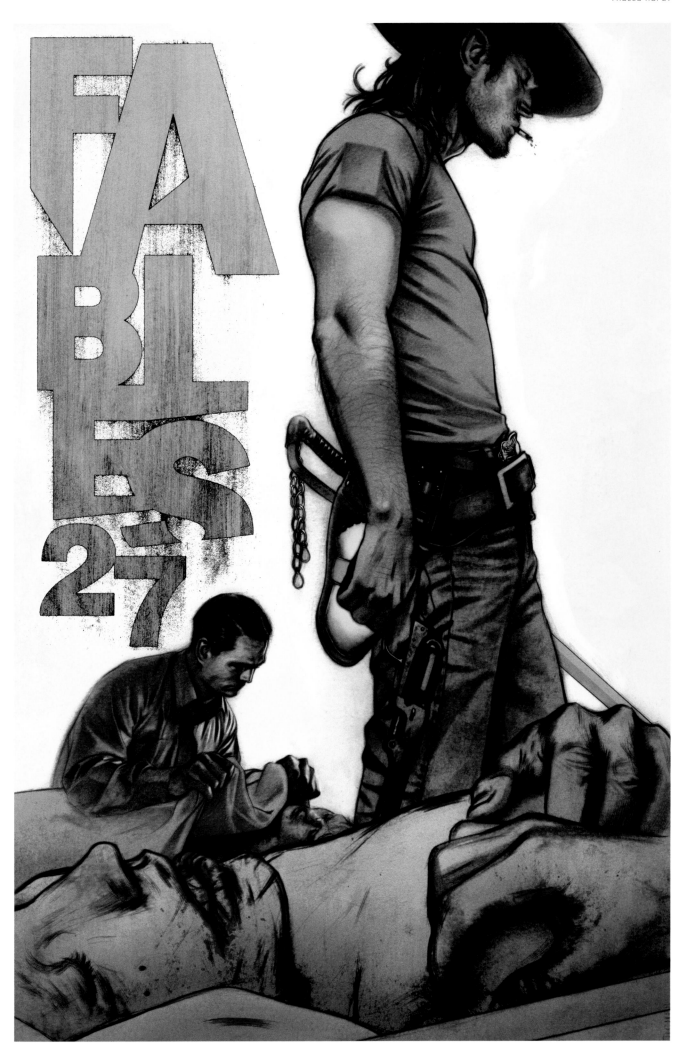

PRELIMINARY SKETCH, GRAPHITE ON BOND, 5.5 X 8.5"

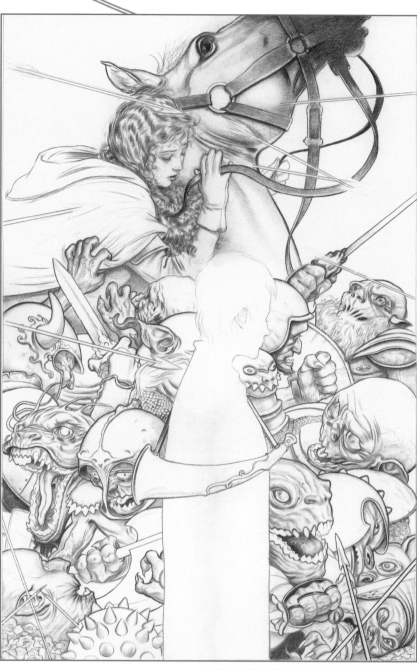

DRAWING, GRAPHITE ON 300LB. WC PAPER, 15 X 22"

PRESTIGE ONE-SHOT	THE LAST CASTLE	1/1

"**Red Riding Hood:** I don't want to go without you. Damn your colonel and damn your stubborn military honor! Some things have to be more important than duty!

Red Riding Hood: Come with me, Blue.

Red Riding Hood: Or let me stay here with you.

Little Boy Blue: No, I have to stay and you have to go, because I need you to live — to survive this for both of us. What little courage I can summon up to stay depends on the sure knowledge that I've bought your life by doing so."

MEDIA: GRAPHITE, WATERCOLOR, PIGMENT INK, DIGITAL.

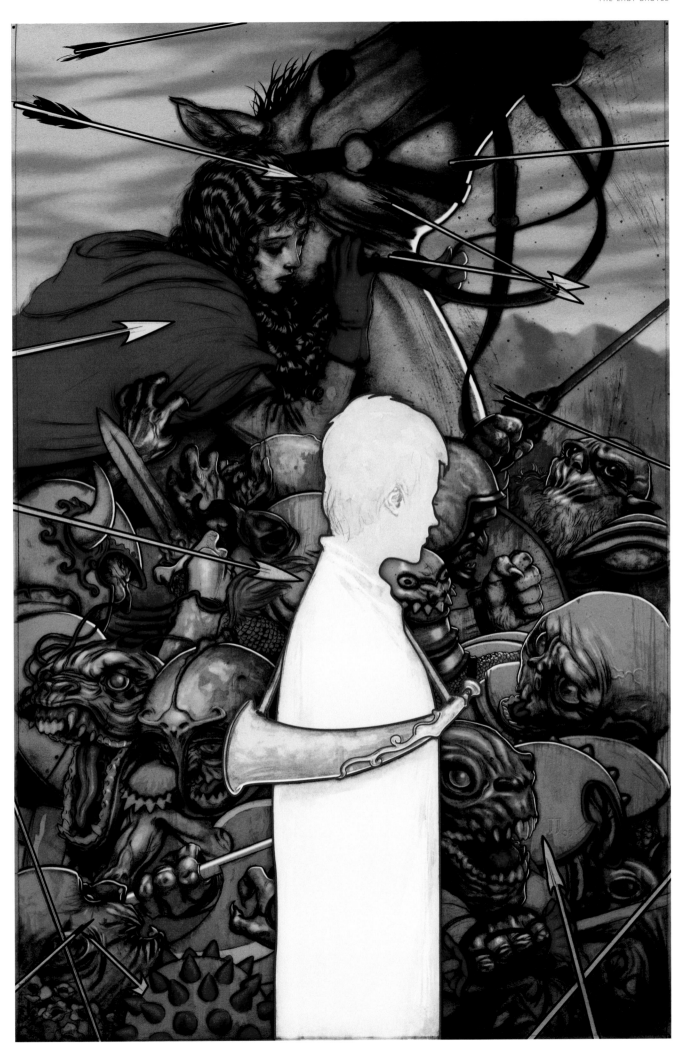

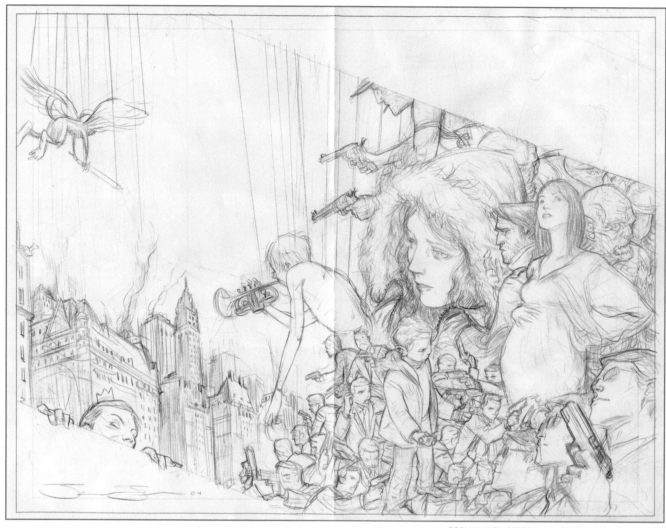

PRELIMINARY SKETCH, GRAPHITE ON BOND, 7.5 X 10"

PRELIMINARY SKETCH, GRAPHITE ON BOND, 7.5 X 10"

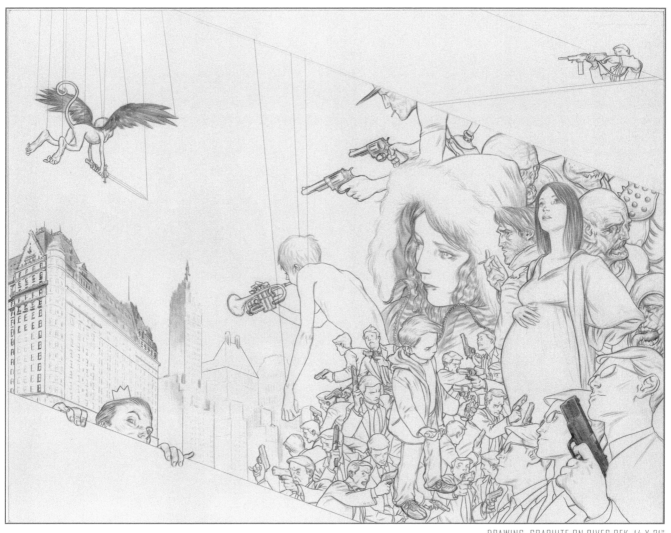

DRAWING, GRAPHITE ON RIVES BFK. 14 X 21"

TPB 04	MARCH OF THE WOODEN SOLDIERS	
COLLECTED MATERIAL: ISSUES 19 – 21, 23 – 27, THE LAST CASTLE		
MEDIA: GRAPHITE, WATERCOLOR, DIGITAL COLOR.		

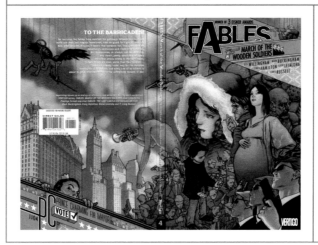

"JJ: This cover is a conflation of visual ideas, from the puppet strings, to the various depictions of the wooden soldiers, to the typography mimicking a ballot box. In creating a montage, I'm thinking about the hierarchy of plot elements, flatness vs. depth, and how to create an image that's interesting and balanced from front to back. The lighting and color help create a sense of coherence throughout the image — for example, the orange in the cityscape on the back cover is reflected in the soldiers' faces."

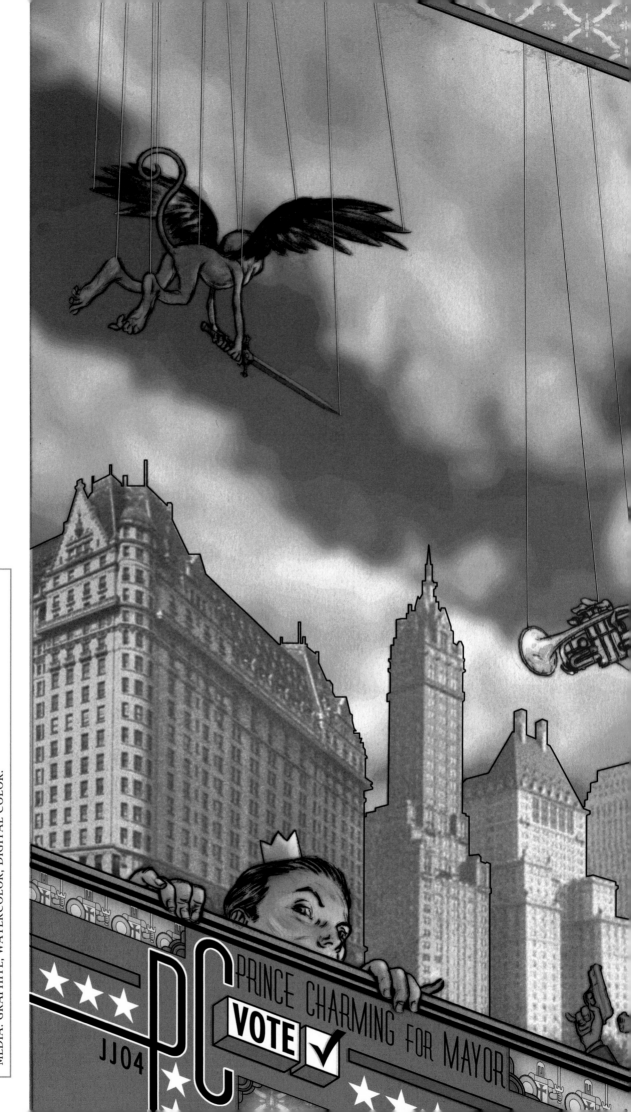

TPB 04 | MARCH OF THE WOODEN SOLDIERS

COLLECTED MATERIAL: ISSUES 19 - 21, 23 - 27, THE LAST CASTLE

MEDIA: GRAPHITE, WATERCOLOR, DIGITAL COLOR.

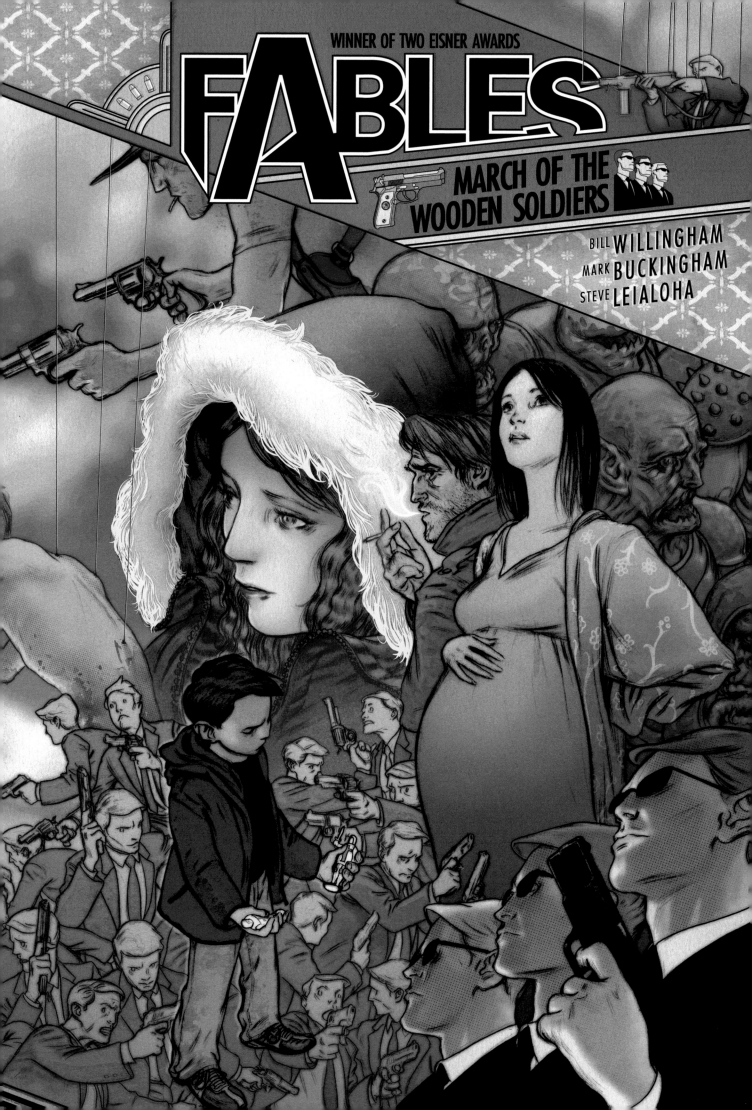

PRELIMINARY SKETCH
GRAPHITE ON BOND/DIGITAL, 5.5 X 8.5"

DRAWING, CHARCOAL ON RIVES BFK, 20 X 30"

No. 28 | WAR STORIES | 1/2

"Cap: July 26th, 1944.

Cap: After more than a month of getting chewed up in the hedgerows of Normandy, they promised us a full two weeks off of the front lines.

Cap: But just a few days into our R and R, they cherry-picked eight of us unlucky bastards from Dog Company — 3rd of the 605th — for a special mission.

Cap: Operation Chambermaid.

Cap: Don't bother trying to look it up. There's no surviving record. It never officially happened.

Cap: Four days later we dropped, under jet black canopies, practically in der Führer's backyard."

MEDIA: CHARCOAL, WATERCOLOR, DIGITAL.

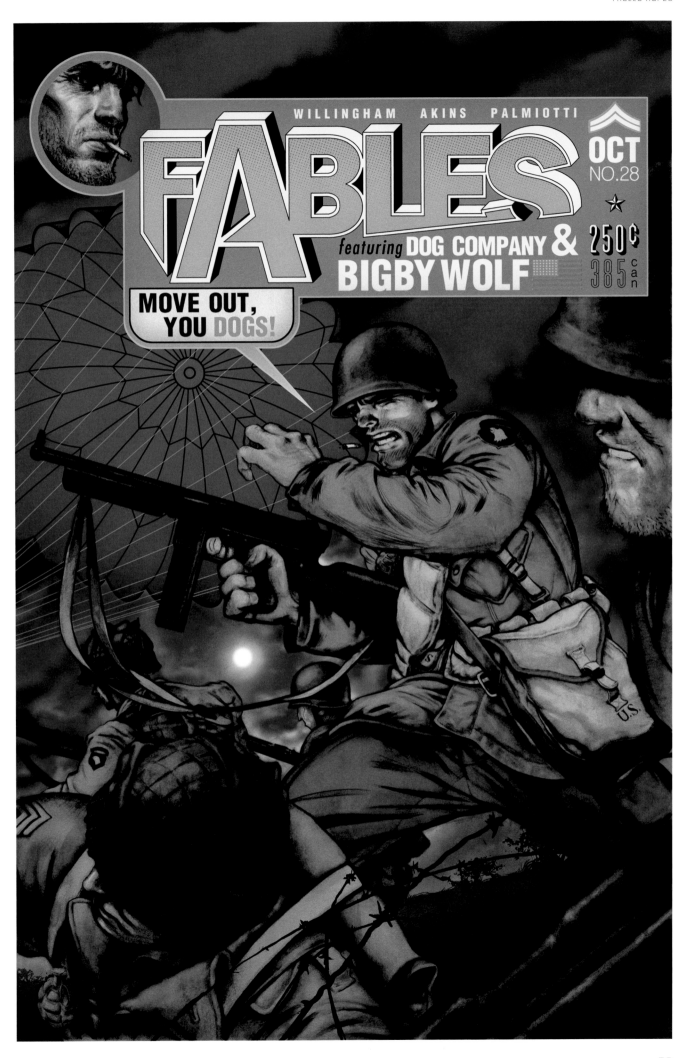

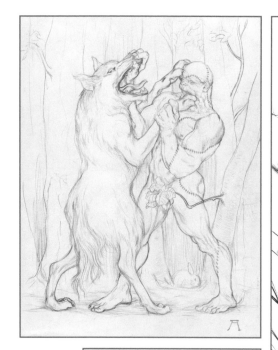

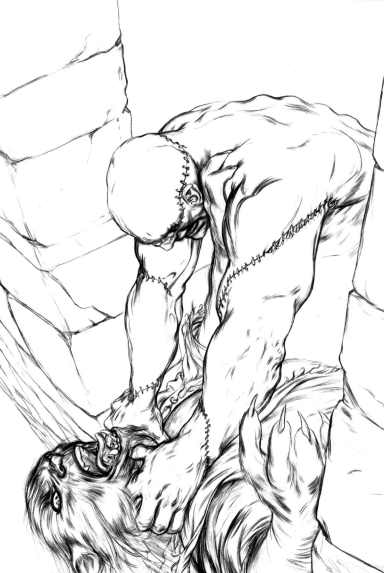

PRELIMINARY SKETCHES, GRAPHITE ON BOND, 7.5 X 10"

DRAWING, GRAPHITE ON BRISTOL, 11 X 17"

No. 29	WAR STORIES	2/2

"General: <Worry about your own part of the project, Doctor. My men have done everything that is required.>
General: <The evidence has been planted where the enemy couldn't help but find it.>
General: <Transmissions were made in codes that we know they've broken.>
General: <The bait is out there, and soon enough our foes must act upon it.>
General: <It remains only for us to be patient.>
General: <And ready.>

Doctor Wechsler: <In the meantime then, we'll finish the reassembly of the monster.>
Doctor Wechsler: <Perhaps the original can still be of use to the fatherland.>"

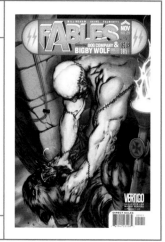

MEDIA: GRAPHITE, WATERCOLOR, PIGMENT INK, DIGITAL.

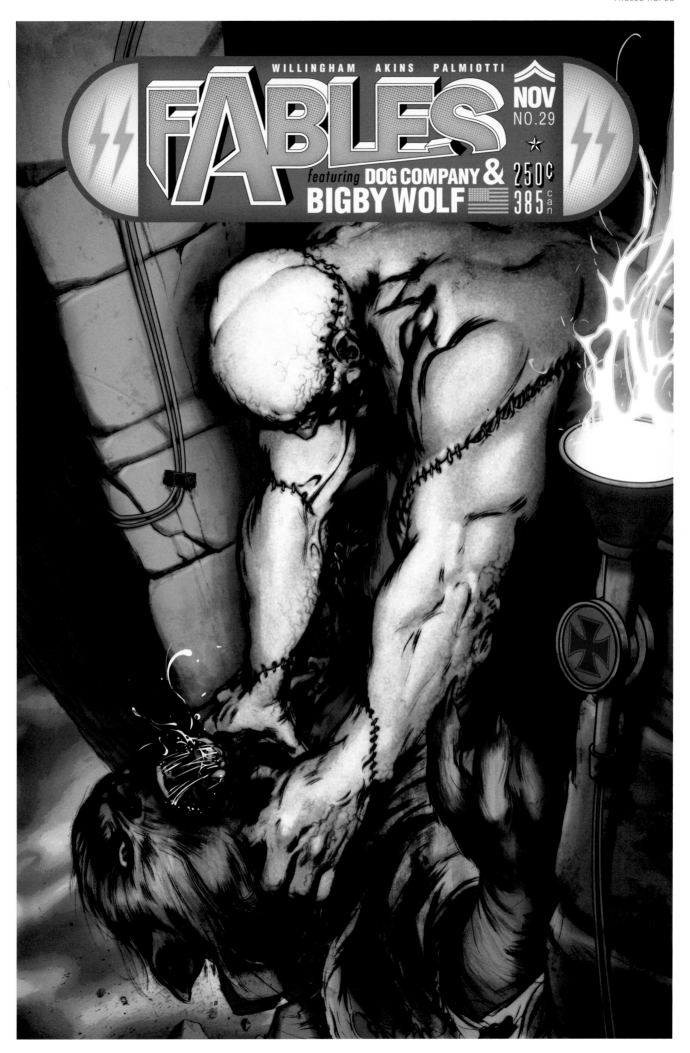

PRELIM. SKETCH 1
GRAPHITE ON BOND, 5.5 X 8.5"

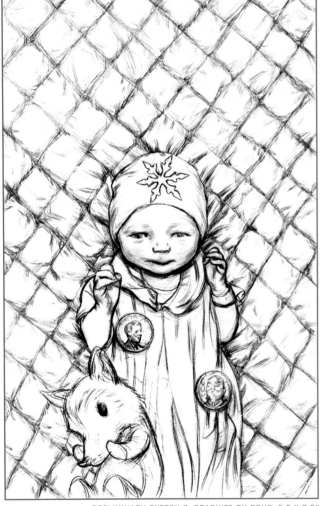

PRELIMINARY SKETCH 2, GRAPHITE ON BOND, 5.5 X 8.5"

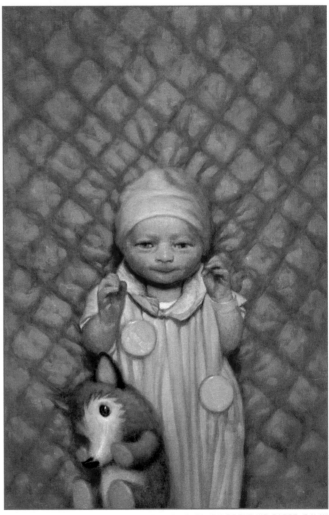

PAINTING, OIL ON 300LB WC PAPER, 7 X 11"

| No. 30 | THE MEAN SEASONS | 1/4 |

"Panel Five

We pull back for a somewhat wider shot as Swineheart proudly holds up a tiny newborn baby girl, which is all messy with blood and goo and is still trailing the twisted rope of the umbilical cord. The nurse steps up with a pair of scissors, to cut the cord. Snow looks mildly panicked at the sight of her new baby. She's a bit delirious and thinks the umbilical is a birth defect.

Swineheart: Look at that, Snow!
Swineheart: You've got a healthy baby girl! Entirely normal looking.

Snow: Normal? Are you blind? She's got a tail!"

MEDIA: GRAPHITE, OIL, WATERCOLOR, PIGMENT INK, DIGITAL.

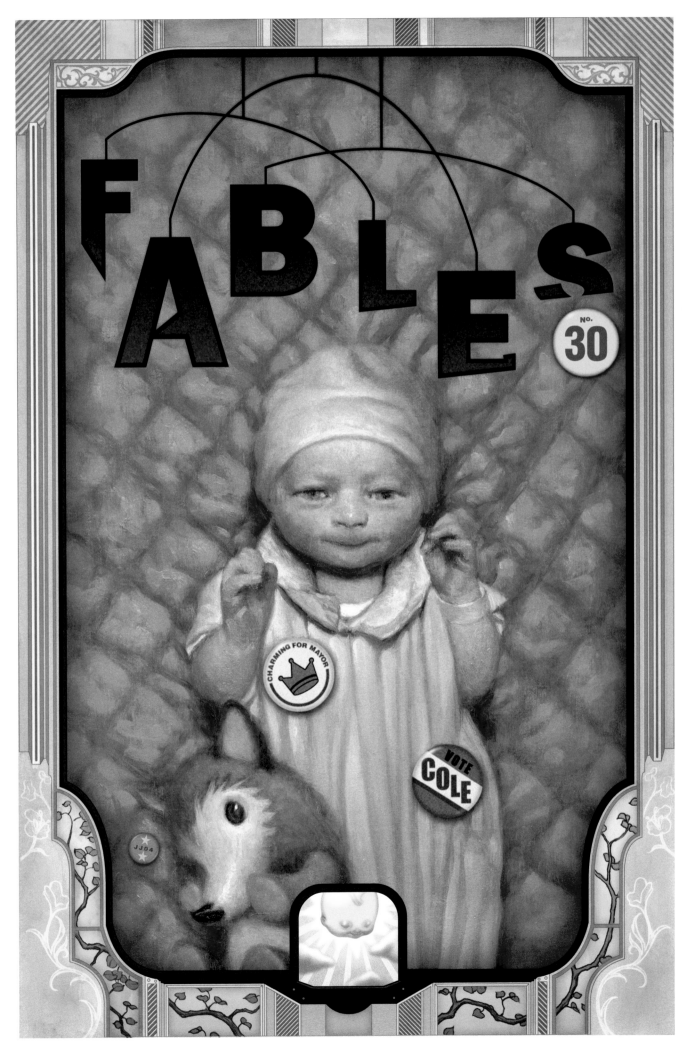

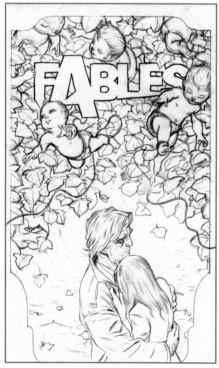

PRELIM. SKETCH, GRAPHITE ON BOND, 5.5 X 8.5"

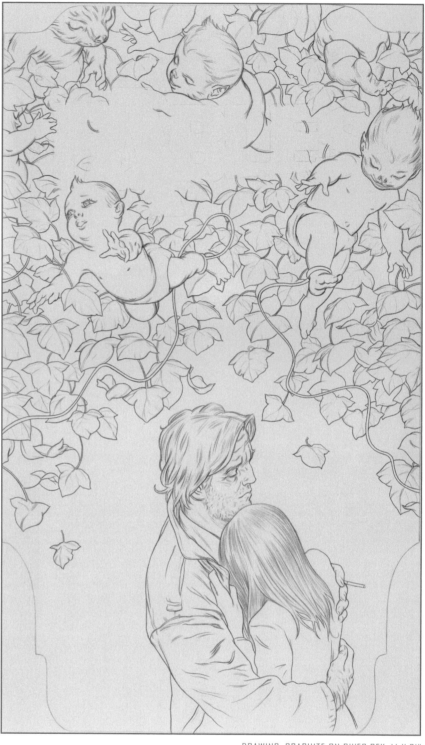

DRAWING, GRAPHITE ON RIVES BFK, 14 X 21"

No. 31 | THE MEAN SEASONS | 2/4

"**Snow:** Then how do we fix this?

Wolf: Easy. Don't go to the Farm. Come away with me.

Panel Three
Bigby looks at Snow, maybe gripping her again, even more intensely. Tears fill her eyes.

Wolf: There are still forests in this world where no one will ever find us.

Wolf: We'd be free to raise our family, without interference from Fable or Mundy.

Panel Four
Snow is too overcome to talk. She buries her head in Bigby's chest, trying to hold back the tears she knows are coming. Bigby looks heartbroken. He knows what her answer will be."

MEDIA: GRAPHITE, ACRYLIC, PIGMENT INK, DIGITAL.

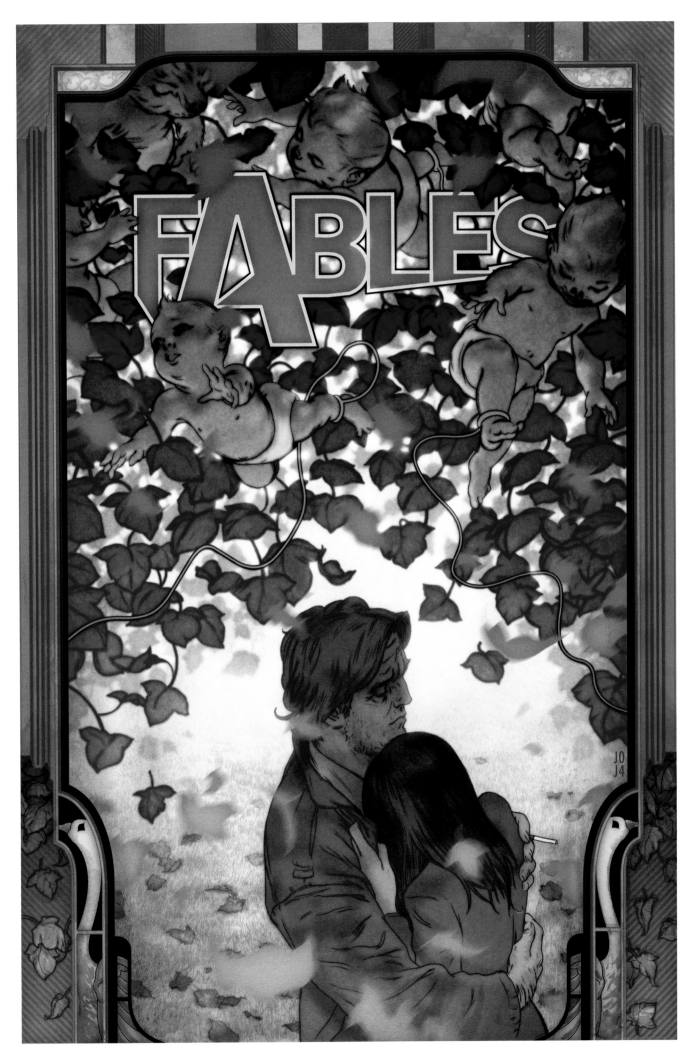

PRELIM. SKETCH. GRAPHITE ON BOND/DIGITAL. 5.5 X 8.5"

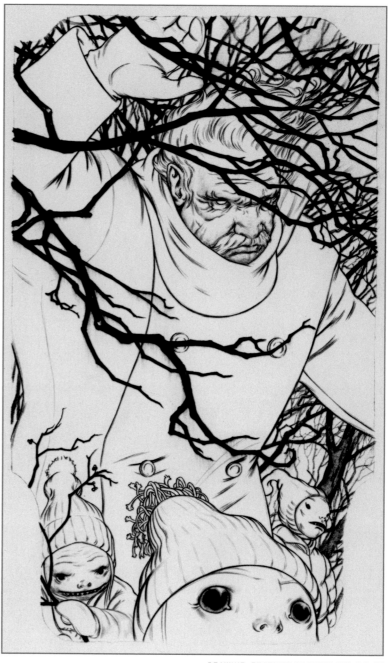

DRAWING. GRAPHITE ON RIVES BFK. 11 X 17"

| No. 32 | THE MEAN SEASONS | 3/4 |

"Panel One

This is a full-page splash. Now we turn our angle of view, so that we can see what all of the other Fables can see. Mr. North (from this issue's first page) is there, standing grim and imposing in the snow, dressed in white and gray clothes. Now his clothes are modern and Mundy in style, including a long, thick winter coat. His long scarf blows in the wind, as if to show that, even while standing still, it tends to be constantly breezy around the human embodiment of the North Wind. The three Attendant Winds, Mistral, Whiff and Squall, are also there, standing slightly behind and to one or the other side of their master. The deep snow comes up almost to their chests. They are also dressed in modern civilian dress, but in clothes from the kids' department. We can see some of the crowd of surprised and wary Fables, including Rose and Snow, surrounding the new arrivals in a half-circle, but none of them willing to approach too close to these strange and forbidding newcomers."

MEDIA: GRAPHITE, WATERCOLOR, DIGITAL.

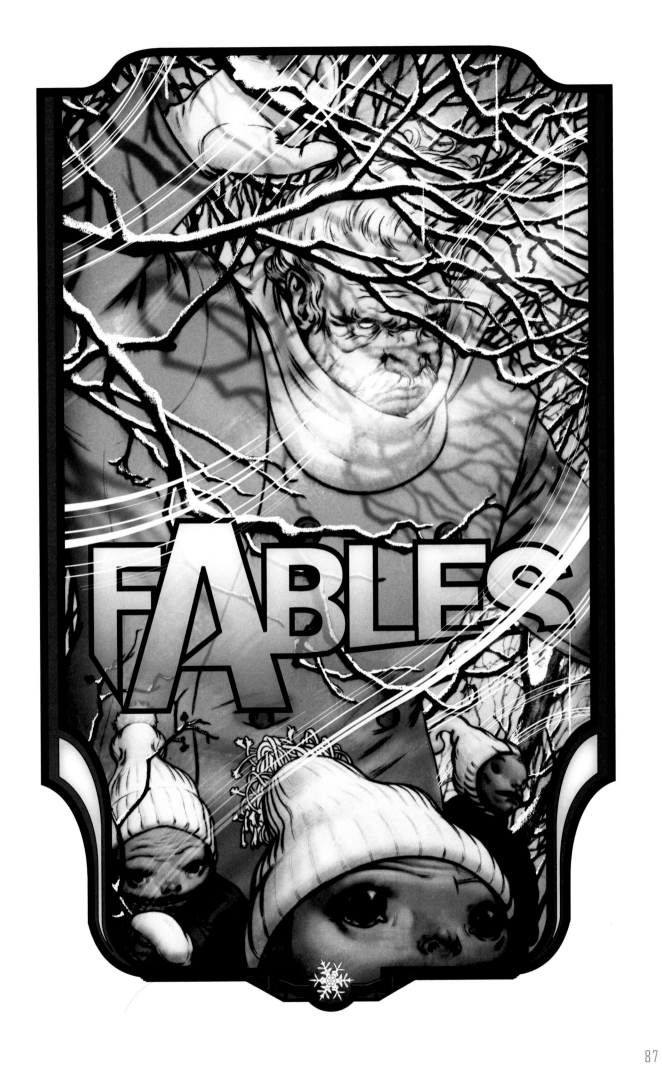

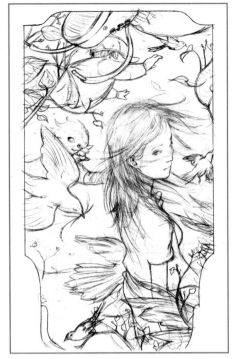

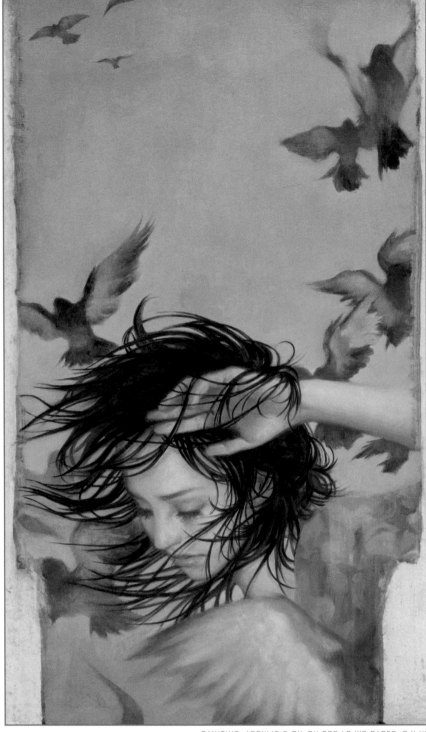

PRELIMINARY SKETCH, GRAPHITE ON BOND, 5.5 X 8.5"

PAINTING, ACRYLIC & OIL ON 300 LB WC PAPER, 8 X 11"

No. 33 | THE MEAN SEASONS | 4/4

"Panel Four
Now every head turns (except Mary's) to look at North, who speaks up from back in the crowd, where he and Snow are standing. Mary has left the group, sadly carrying her dead lamb away home.

North: It's a wild zephyr.

Beast: Excuse me?

Panel Five
Close on North. Those nearest him look at him with some surprise.

North: The killer is a zephyr – a living gust of wind, much like my Attendant Winds, except this thing can't take solid form."

MEDIA: GRAPHITE, ACRYLIC, OIL, DIGITAL.

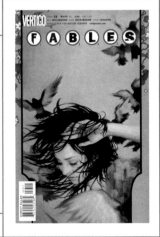

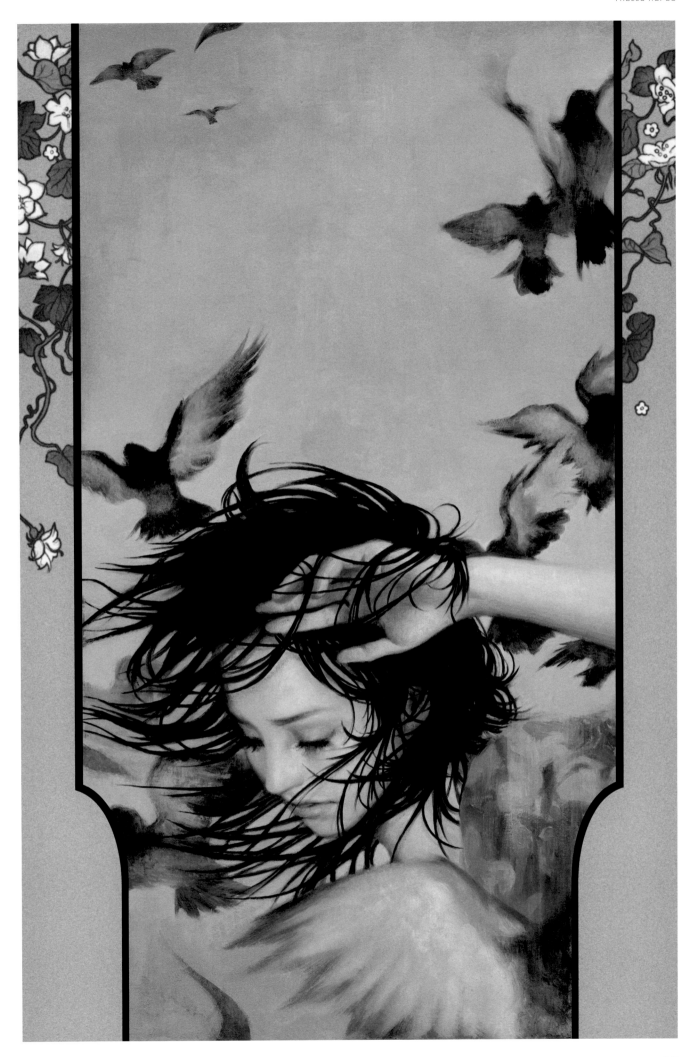

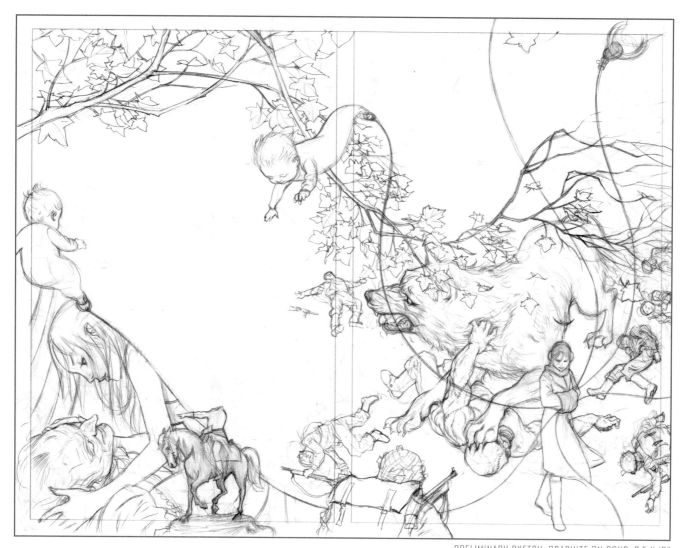

PRELIMINARY SKETCH, GRAPHITE ON BOND, 7.5 X 10"

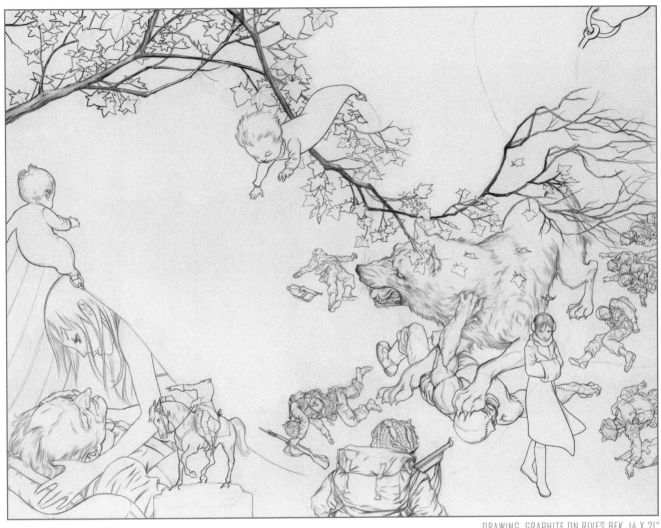

DRAWING, GRAPHITE ON RIVES BFK, 14 X 21"

TPB 05 | THE MEAN SEASONS

COLLECTED MATERIAL: ISSUES 22, 28 – 33

MEDIA: GRAPHITE, WATERCOLOR, DIGITAL COLOR.

"JJ: I wanted to express a feeling of isolation in this cover. While Snow takes a walk with her babies, lost in her thoughts, Bigby and Frankenstein fight in the background, a moment from a faded, dubious history. The composition is relatively uncluttered compared to the previous covers. Sometimes I have to remind myself that space can speak volumes."

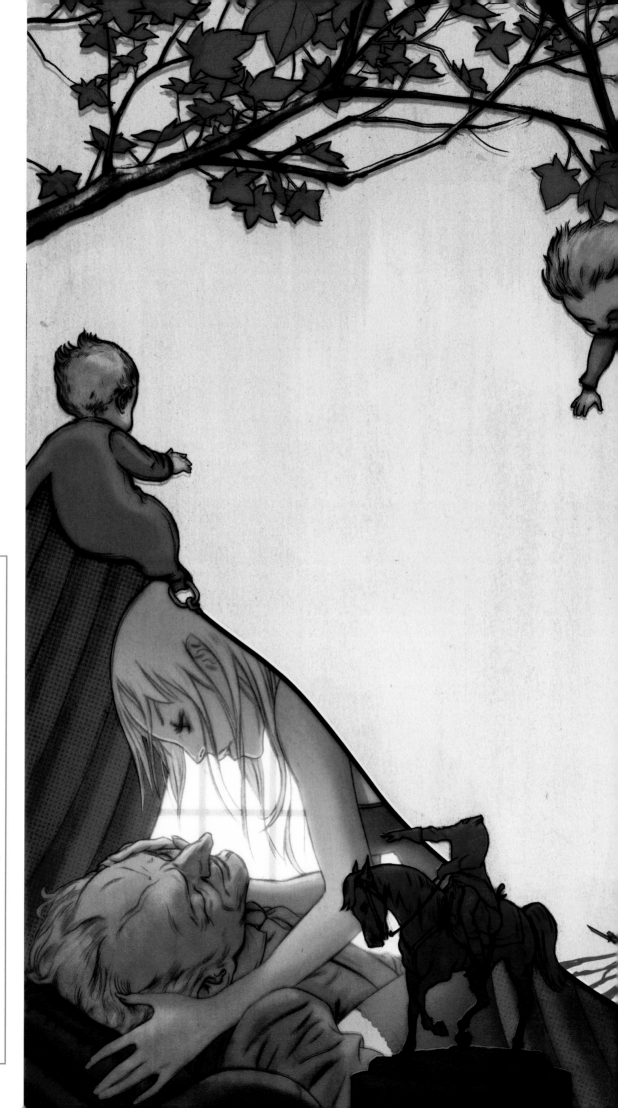

TPB 05 | THE MEAN SEASONS

COLLECTED MATERIAL: ISSUES 22, 28 - 33

MEDIA: GRAPHITE, WATERCOLOR, DIGITAL COLOR.

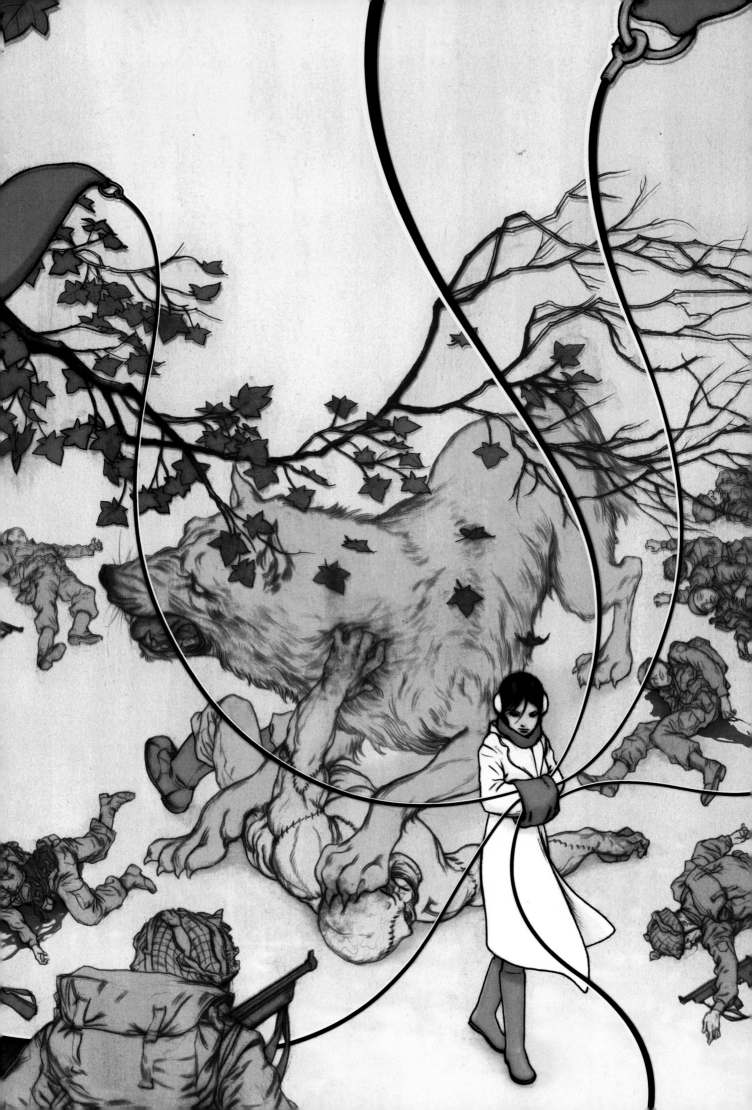

PRELIMINARY SKETCH, GRAPHITE ON BOND/DIGITAL, 5.5 X 8.5"

PAINTING, ACRYLIC & OIL ON PAPER, 20 X 30"

No. 34 JACK BE NIMBLE 1/2

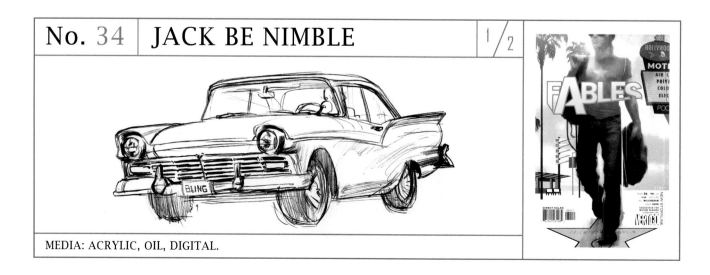

MEDIA: ACRYLIC, OIL, DIGITAL.

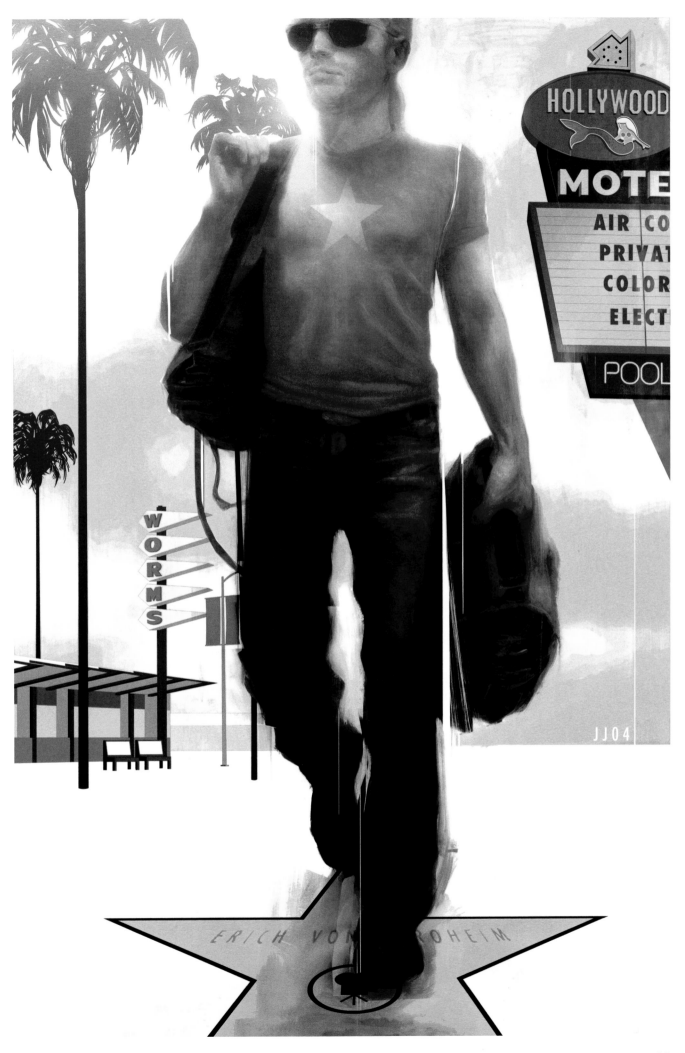

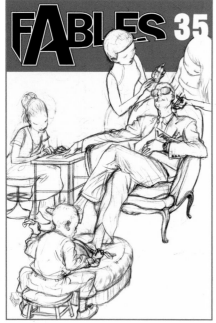

PRELIM. SKETCHES, GRAPHITE ON BOND, 5.5 X 8.5"

DRAWING, GRAPHITE ON RIVES BFK, 12 X 17"

| No. 35 | JACK BE NIMBLE | 2/2 |

"Jack: Mona, darling, I know you're miffed, but I have a very good excuse for not showing up last night.

Jack: No, not twins again.

Jack: Triplets.

Jack: Trying out for parts in Jack Three. I didn't have the heart to tell them we'd already completed principal shooting on it.

Jack: You say that now, but if you saw them, you'd forgive me instantly."

MEDIA: GRAPHITE, DIGITAL.

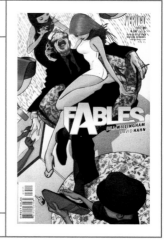

FAB!
NO. 35

PRELIMINARY SKETCH, GRAPHITE ON BOND, 5.5 X 6"

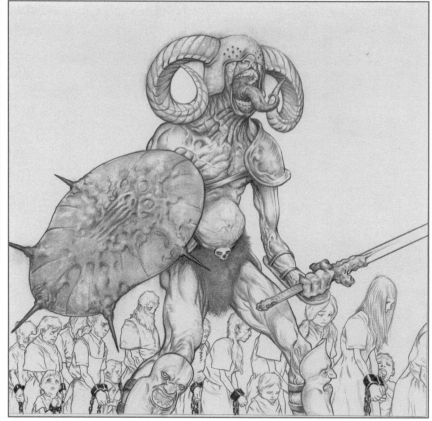

DRAWING, GRAPHITE ON RIVES BFK, 13 X 15.5"

No. 36 | HOMELANDS | 1/5

"Ogren: My plan is simple. Keep my head down, my nose clean, and visit my human mistress when I need to do what a grown goblin male, in the prime of his vigor, needs to do from time to time.

Throk: So how's she working out?

Ogren: Not too bad, except for her cooking.

Throk: Has to be better than what we get in the mess hall.

Ogren: You'd think that, but you'd be wrong. Like last night — she serves me up one of those bizarre creatures humans in this world like to keep in their yards. She kills it, guts it, cooks it up and places it in front of me, as if it's a grand thing.
Ogren: 'What's this?' I say, and she proudly announces, 'It's chicken.'
Ogren: 'Chicken?' says I, dubiously, and she says, 'Don't be a baby. Eat it. You'll like it. Trust me. It tastes just like snake.' So I tried a bite.

Ogren: I thought I was gonna die."

MEDIA: GRAPHITE, DIGITAL.

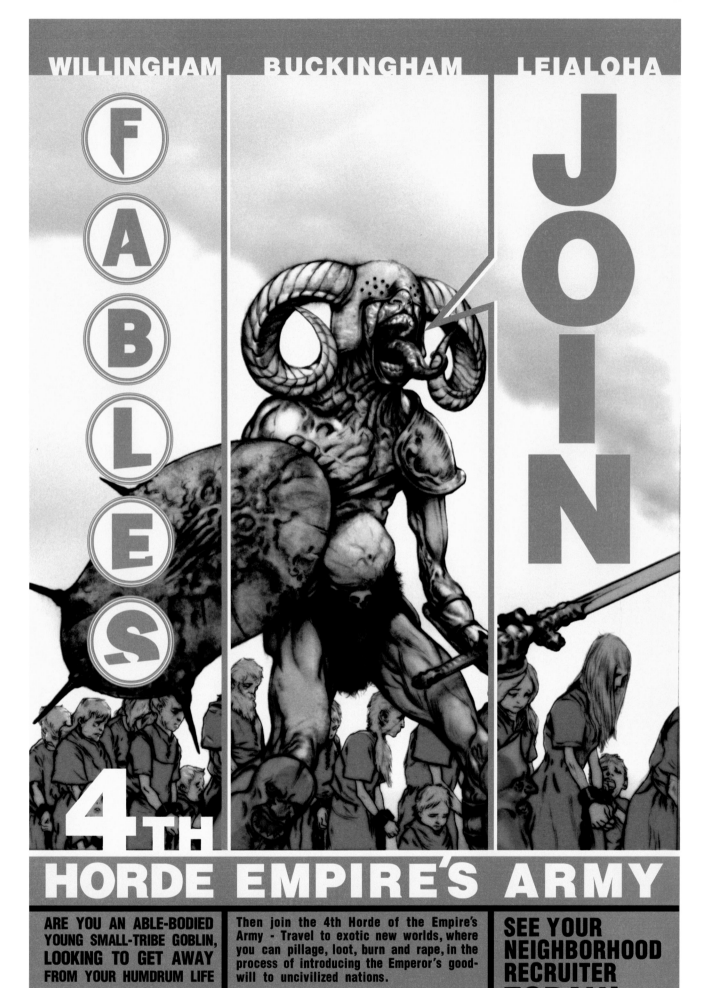

PRELIMINARY SKETCH, GRAPHITE ON BOND, 5.5 X 8.5"

DRAWING, GRAPHITE ON RIVES BFK, 14 X 21"

No. 37 | HOMELANDS | 2/5

"**Blue:** I'm on a quest to restore true love and reap a healthy measure of vengeance."

MEDIA: GRAPHITE, WATERCOLOR, DIGITAL.

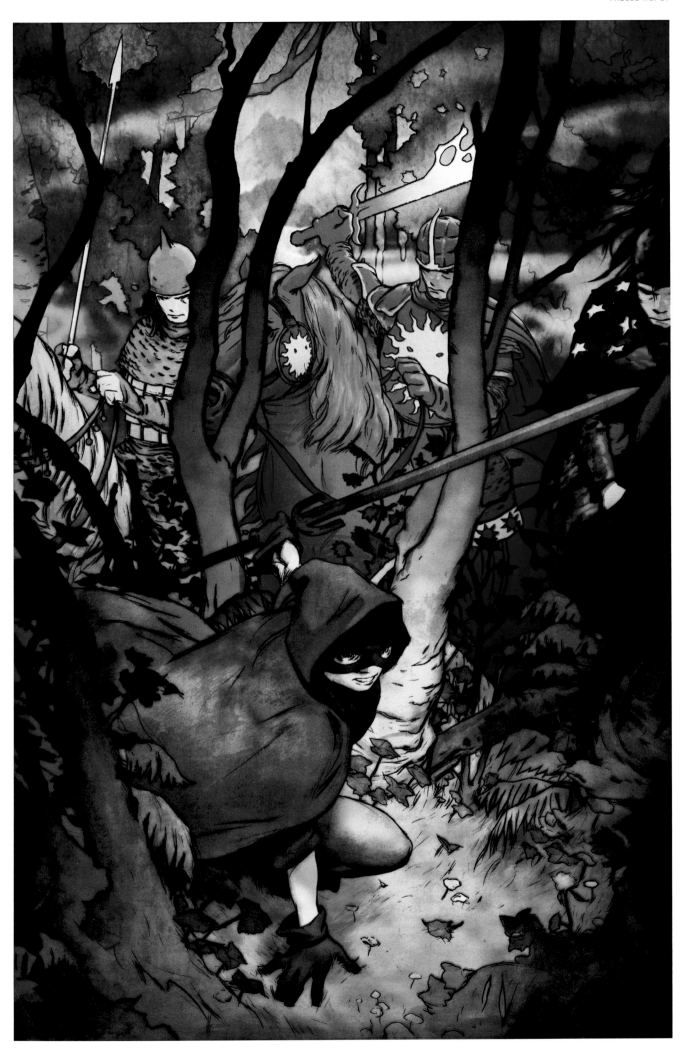

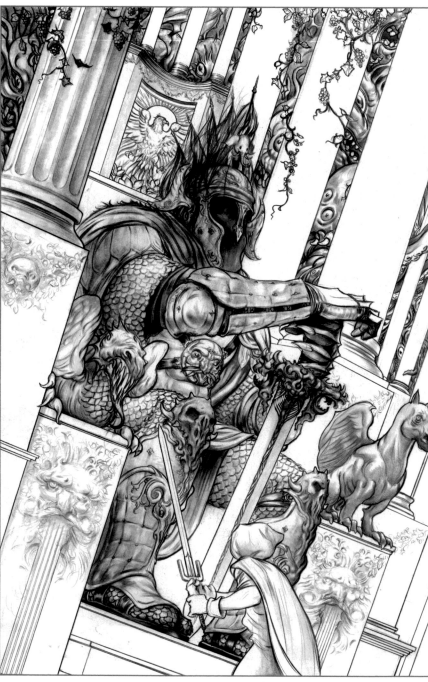

PRELIM. SKETCHES, GRAPHITE ON BOND, 5.5 X 8.5"

DRAWING, GRAPHITE ON BRISTOL, 11 X 17"

No. 38 | HOMELANDS | 3/5

"Cap: The Hall of Justice.

Minion 1: Come forward and all will be heard!
...
Minion 2: Lay your troubles at the feet of our glorious Emperor to be judged by his perfect wisdom and understanding!
...
Minion 3: Follow your guard escort into the hall, stop when he stops, and immediately hit your knees.

Minion 4: Don't speak until spoken to and make your answers short and to the point. And keep your head bowed. Never look directly at him.

Minion 2: Let the next petitioner approach and be heard!"

MEDIA: GRAPHITE, WATERCOLOR, DIGITAL.

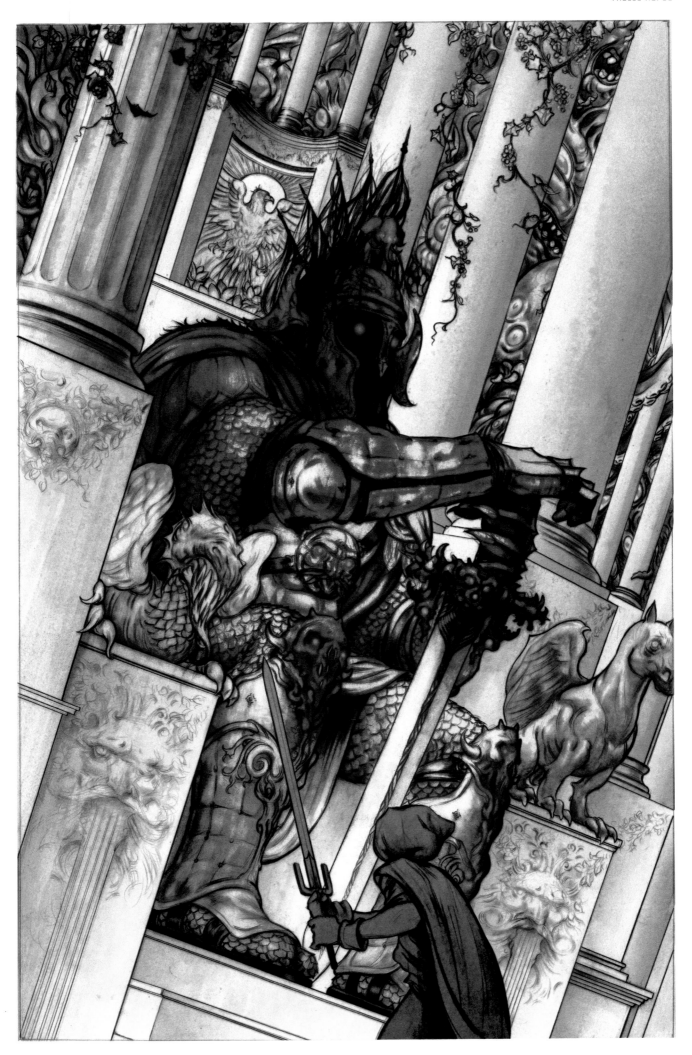

PRELIMINARY SKETCH, GRAPHITE ON BOND, 5.5 X 8.5"

DRAWING, CHARCOAL & ACRYLIC ON RIVES BFK, 15 X 22"

No. 39	MEANWHILE	1/1

"**Charming:** As a gesture of mercy you don't deserve, I'm willing to let you jump down the witching well alive, and under your own power.

Charming: The alternative is Grimble puts a bullet through your head right now, and we dump your corpse down there."

MEDIA: CHARCOAL, ACRYLIC, DIGITAL.

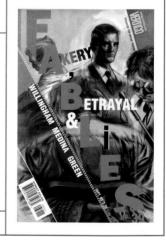

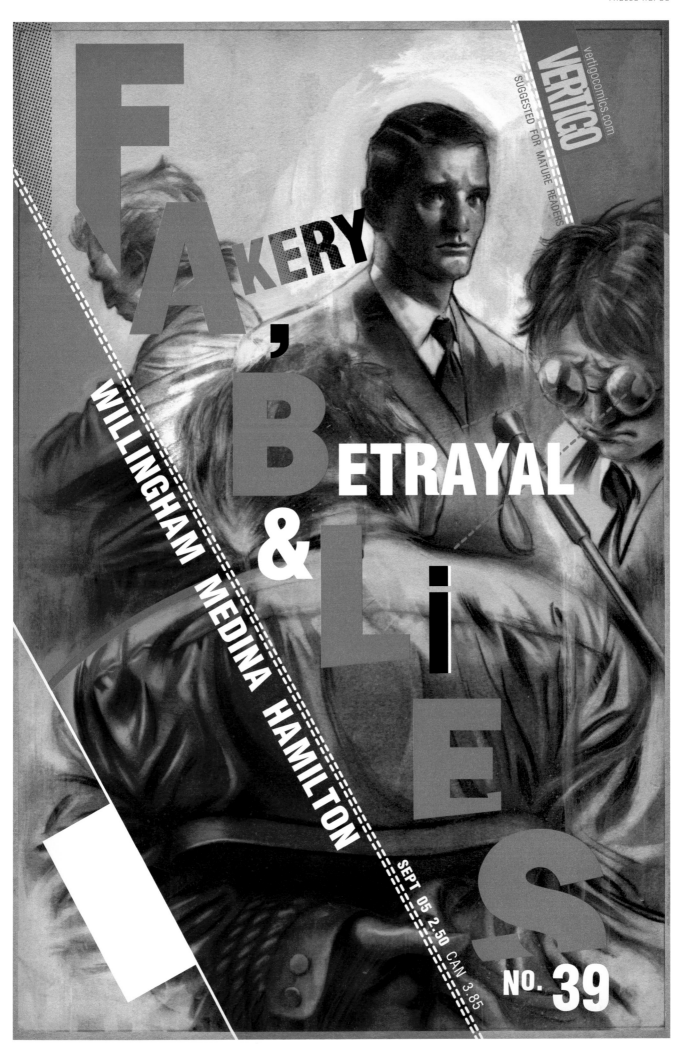

FAKERY, BETRAYAL & LIES

FABLES

WILLINGHAM MEDINA HAMILTON

SEPT 05 2.50 CAN 3.85

NO. 39

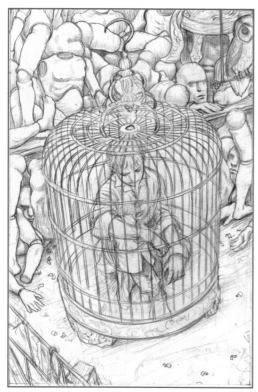

PRELIMINARY SKETCH, GRAPHITE ON BOND, 5.5 X 8.5"

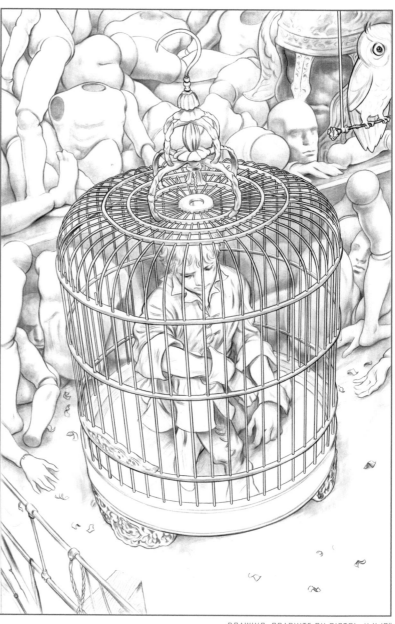

DRAWING, GRAPHITE ON BISTOL, 11 X 17"

No. 40 | HOMELANDS | 4/5

"Panel One

This is a two-page spread, with room left somewhere on this spread for this issue's titles and credits. We pull back to see the entirety of Geppetto's workshop now, and see for the first time that Blue is in the oversized birdcage in the center of the shop floor. Blue is very cramped inside the cage, which would be big enough for a palace for the average bird, but isn't nearly so roomy for a grown human. Next to the cage, in the center of the workroom floor, is the giant head of The Adversary that Blue just chopped off last issue. It's lying on one side of its face, facing in towards the birdcage, with the chopped part of its neck facing away from us, so that we still can't see that the head was made of wood. However we do see Geppetto stand up from behind the severed Adversary head and look towards Boy Blue in his birdcage. Geppetto has a slightly innocent, slightly befuddled expression on his face in this scene, as he realizes for the first time that Boy Blue is awake."

MEDIA: GRAPHITE, WATERCOLOR, PIGMENT INK, DIGITAL.

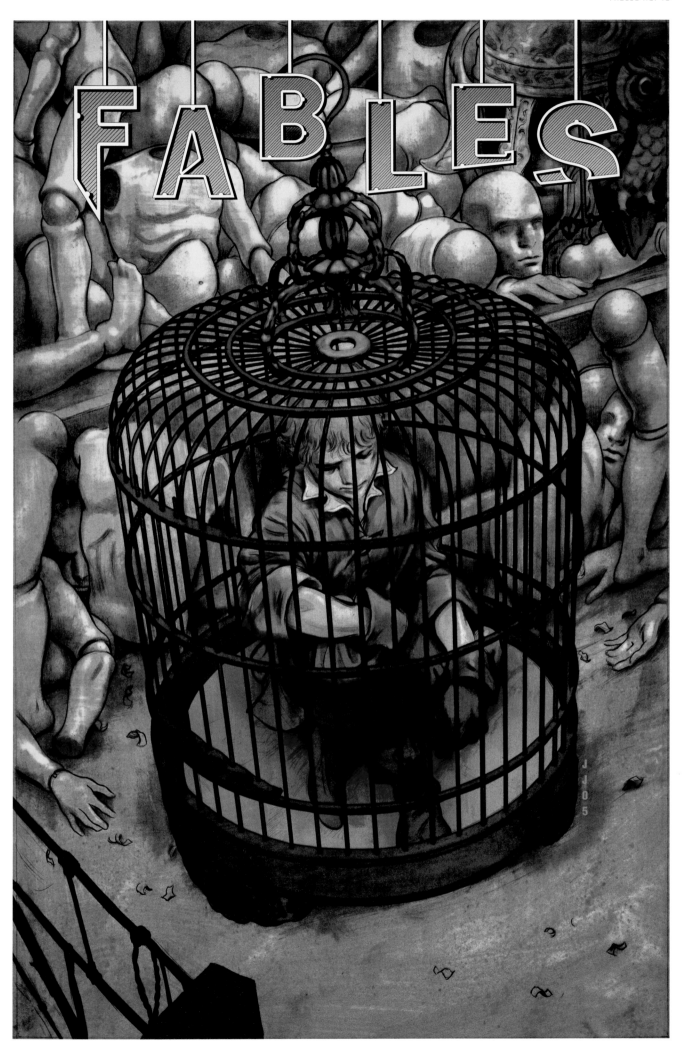

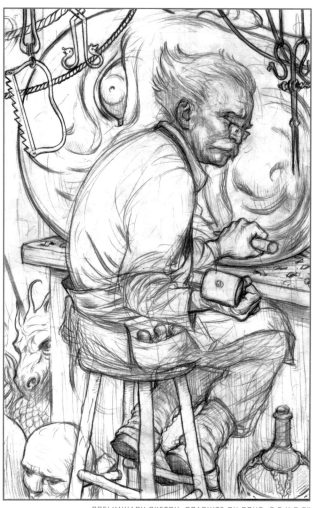

PRELIMINARY SKETCH, GRAPHITE ON BOND, 5.5 X 8.5"

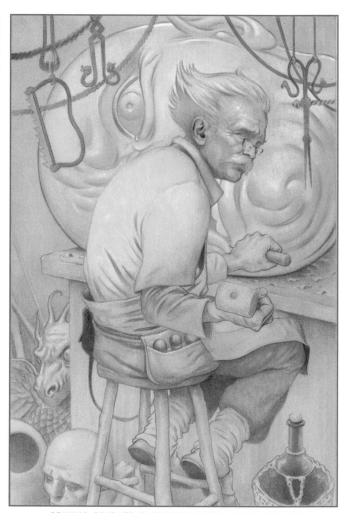

DRAWING, GRAPHITE, BLUE PENCIL & GOUACHE ON RIVES BFK, 10 X 14"

| No. 41 | HOMELANDS | 5/5 |

"Geppetto was working on the head, sanding here and there on the severed part, getting it ready for repair, when Blue's cry interrupted him. Geppetto is holding one of those old-fashioned type sanding blocks, where a piece of sandpaper is clamped around a wooden block, that has a handle on the top side, so that someone can hand-sand an area of wood. Geppetto may be holding some sort of wood-file or wood-rasp in his other hand – just so it's clear he was working on the big head, before Blue startled him. This is the master establishing shot of the interior of Geppetto's workshop – and this will set the stage for all the times you will have to be drawing it for this and the following issue. The shop in many ways is a typical medieval era woodcarver's shop. The wooden floor is covered with curled wood shavings. Each workbench and table top is covered with many projects, in various stages of completion. Lots of medieval technology woodworking tools are hung up on pegs all over the walls, or lying wherever they were set down when that particular bit of work was last done."

MEDIA: GRAPHITE, BLUE PENCIL, GOUACHE, DIGITAL.

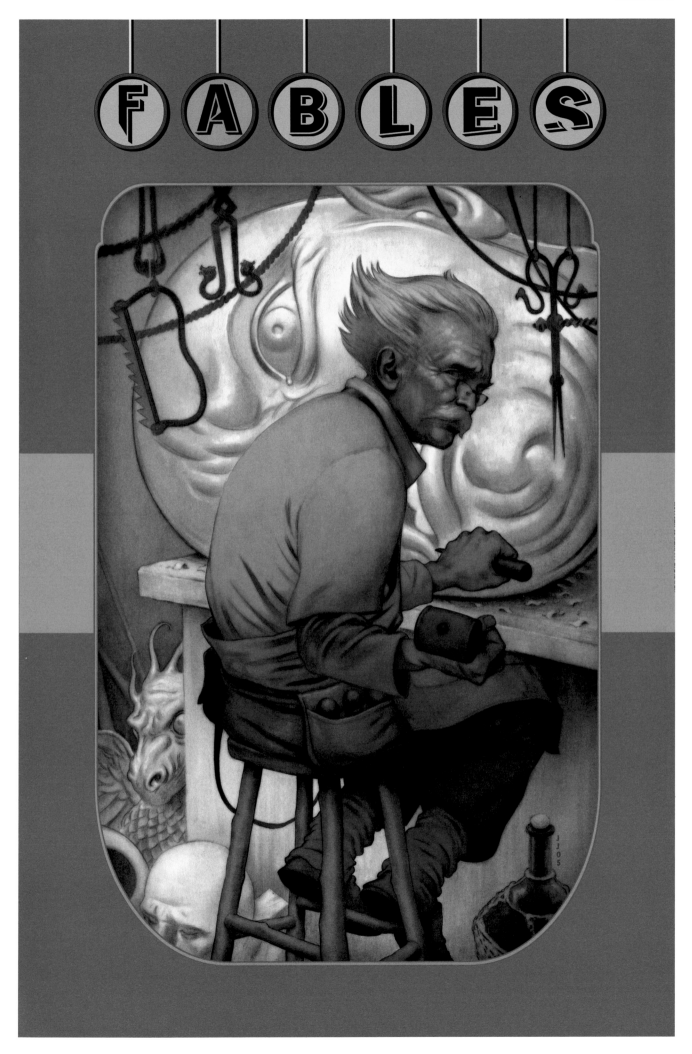

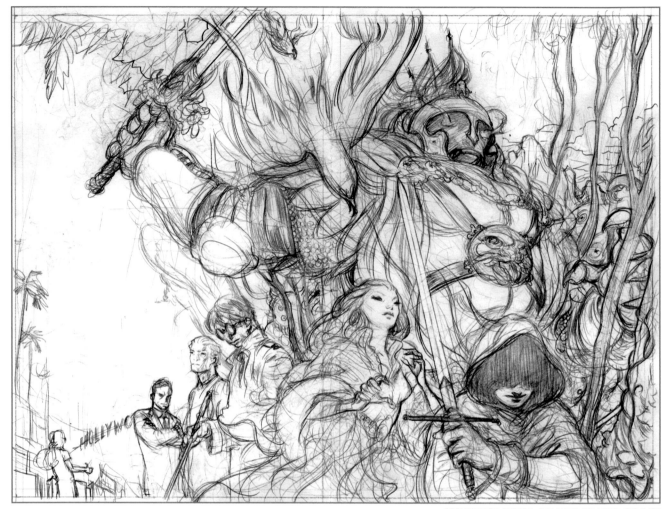

PRELIMINARY SKETCH, GRAPHITE ON BOND, 7.5 X 10"

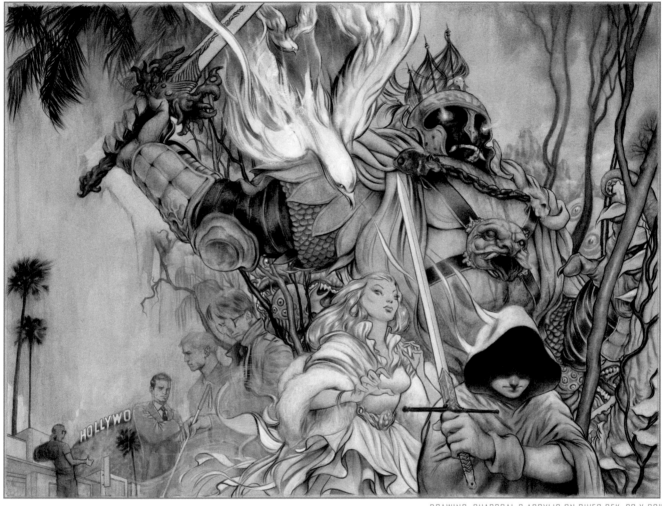

DRAWING, CHARCOAL & ACRYLIC ON RIVES BFK, 20 X 30"

TPB 06 | HOMELANDS

COLLECTED MATERIAL: ISSUES 34 – 41

MEDIA: CHARCOAL, ACRYLIC, DIGITAL COLOR.

"JJ: I designed the Emperor on the cover to no. 38, and it was great to revisit him on the trade paperback in all his massive glory. A bird from the sky descends and transforms into Boy Blue. In the back, there's a nod to Jack's adventure in Hollywood. The drawing was rendered in charcoal, sprayed with fixative, and coated with acrylic medium. Color and highlights were then added with acrylic paint."

TPB 06 | HOMELANDS

COLLECTED MATERIAL: ISSUES 34 - 41

MEDIA: CHARCOAL, ACRYLIC, DIGITAL COLOR.

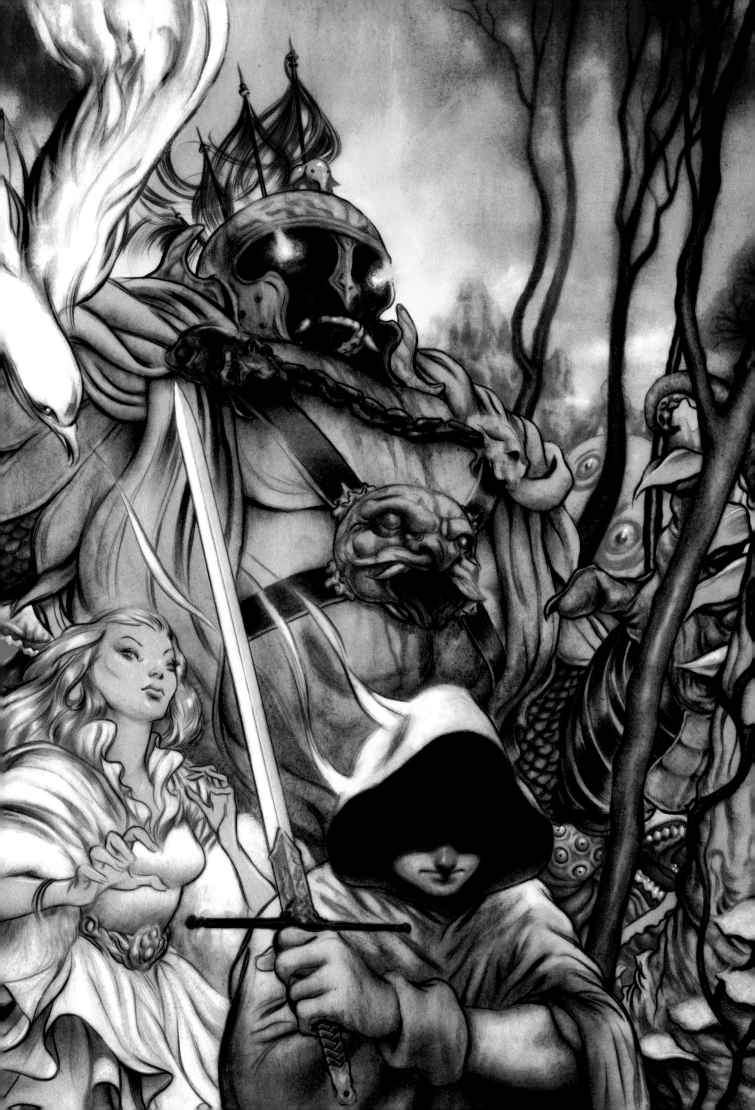

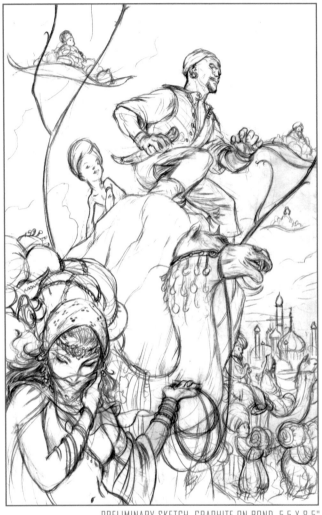

PRELIMINARY SKETCH, GRAPHITE ON BOND, 5.5 X 8.5"

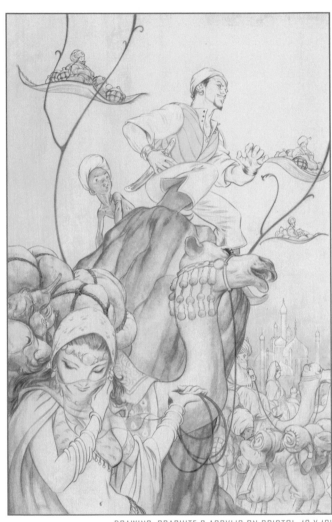

DRAWING, GRAPHITE & ACRYLIC ON BRISTOL, 13 X 19"

| No. 42 | ARABIAN NIGHTS (AND DAYS) | 1/4 |

"**Yusuf (in English):** Understand – loudly – radio – cupcake – persons!

Yusuf (in English): Jungle – girl – Sinbad – meet – lavender – rake – Fabletown – NOW!"

MEDIA: GRAPHITE, ACRYLIC, WATERCOLOR, PIGMENT INK, DIGITAL.

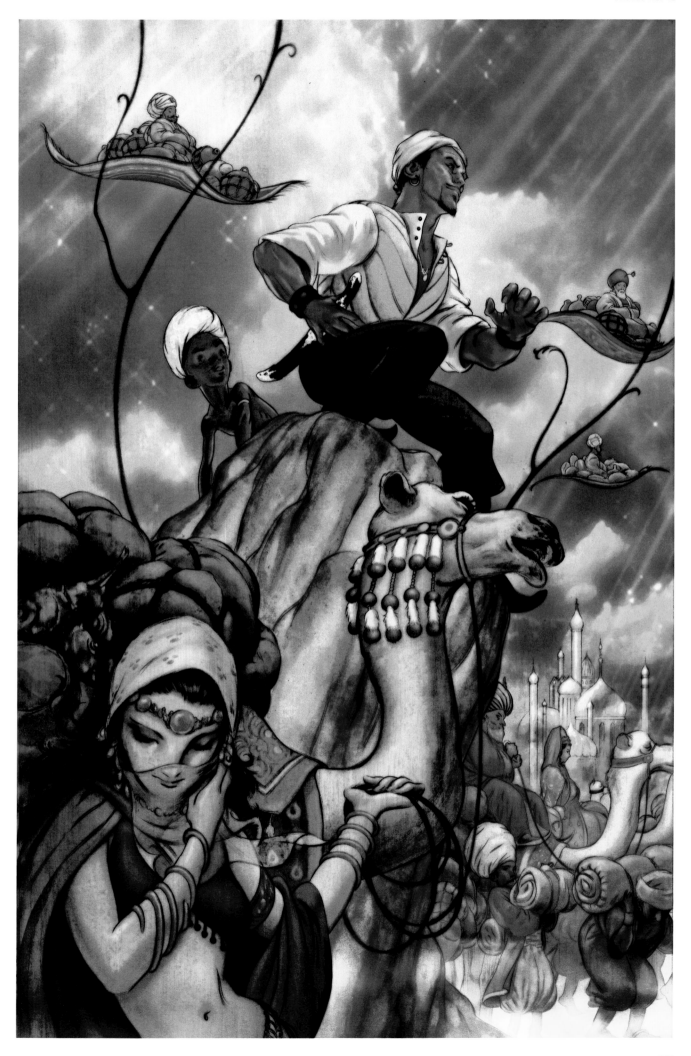

PRELIMINARY SKETCH, GRAPHITE ON BOND, 5.5 X 8.5"

DRAWING, BLUE PENCIL & PASTEL ON RIVES BFK, 13 X 19"

No. 43 | ARABIAN NIGHTS (AND DAYS) | 2/4

"The door is closed and Sinbad is gone. Yusuf stands alone in the room, literally shuddering with rage.

Yusuf (in Arabic): This – cannot – be – endured!

Panel Five

Still in a cold rage, Yusuf stalks over to the coffee table, with the D'Jinn bottle on it.

Yusuf (in Arabic): Sinbad is obviously transfixed by Western devils!

Panel Six

Yusuf picks up the bottle and pulls the stopper out of its cap, breaking the wax seal. Smoke comes pouring out of the bottle.

Yusuf (in Arabic): So my actions are just!"

MEDIA: BLUE PENCIL, PASTEL, WATERCOLOR, PIGMENT INK, DIGITAL.

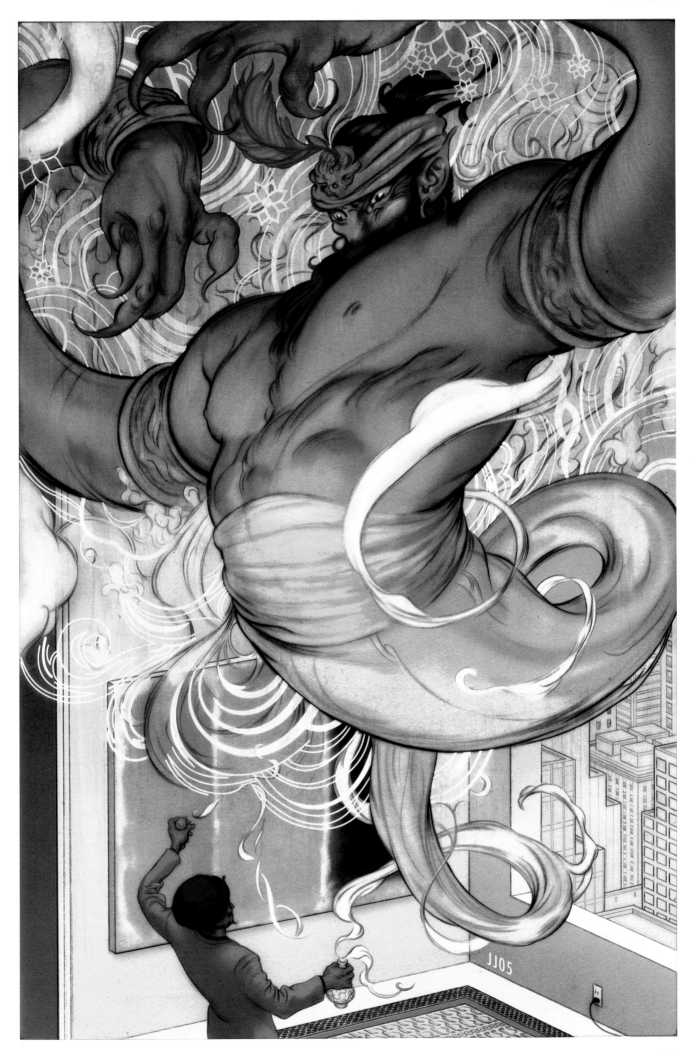

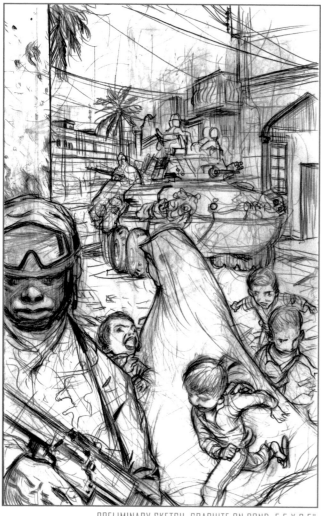

PRELIMINARY SKETCH, GRAPHITE ON BOND, 5.5 X 8.5"

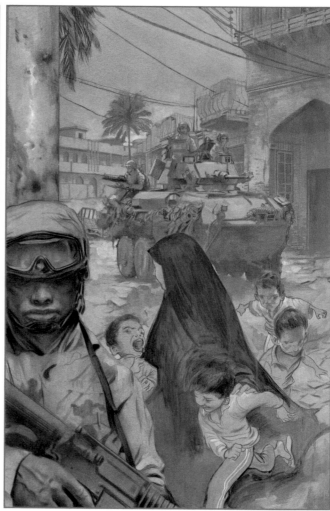

DRAWING, GRAPHITE & ACRYLIC ON RIVES BFK, 15 X 22"

| No. 44 | ARABIAN NIGHTS (AND DAYS) | 3/4 |

"This is the big panel of the page. Now we continue to follow the D'Jinn's progress as it swoops down over Baghdad. This is a bird's-eye view, looking down past the flying D'Jinn, down to the streets of Baghdad below. This is the modern Baghdad, currently under occupation by the American military.

D'Jinn (Arabic): Behold.

D'Jinn (Arabic): The Baghdad of this tawdry world's a drear and dusty thing.

Panel Three
The D'Jinn flies low along one of the city's thoroughfares, past an Army patrol, armed US troops milling around in their Humvees and Bradley armored vehicles. Iraqi civilians walk past them and generally go about their business, not paying much attention to the occupying forces – as if they're already just part of the background. No one notices the D'Jinn flying amongst them. We'll find out in a page or two that he's magically invisible to them.

D'Jinn (Arabic): Occupied by pale conqueror worms from the west."

MEDIA: GRAPHITE, ACRYLIC, DIGITAL.

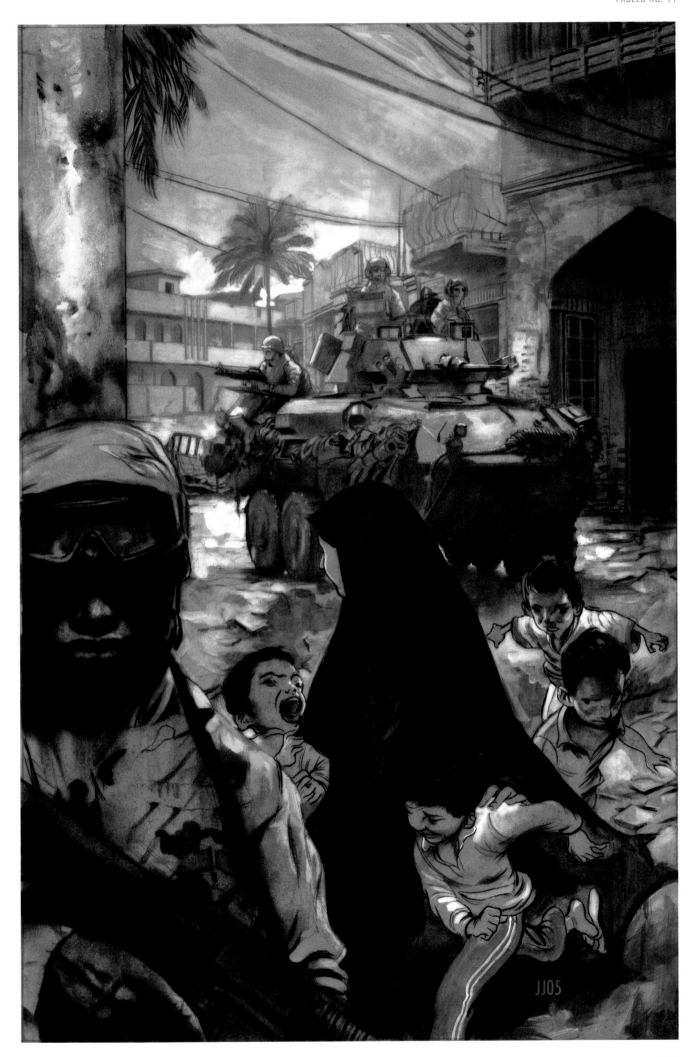

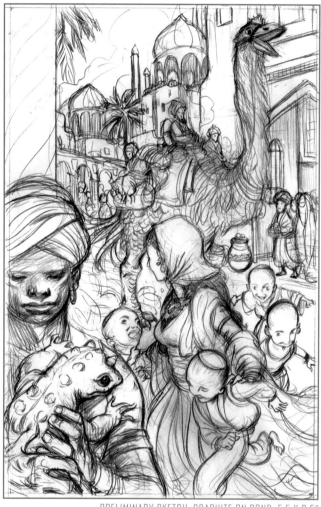

PRELIMINARY SKETCH, GRAPHITE ON BOND, 5.5 X 8.5"

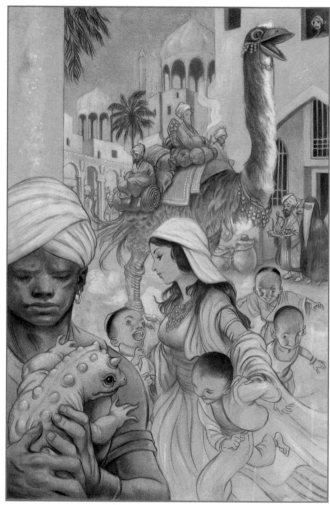

DRAWING, GRAPHITE & ACRYLIC ON RIVES BFK, 15 X 22"

No. 45 | ARABIAN NIGHTS (AND DAYS) | 4/4

"**Sinbad:** And now, great king, let me introduce you to the true Baghdad.

Cole: But –

Page Seventeen (one panel)

Panel One
This is a full-page splash. Now we finally see the other Baghdad – not the mundy (our world) version of Baghdad we saw in the previous page and last issue, but the fabled, storybook version of Baghdad, which exists in the Arabian Fable homelands. We see the glorious city in all of the panorama you can fit into this one page. It's a place of minarets and vaulting palaces and pleasure domes that would put Kublai Khan to shame. Flying carpets and exotic flying creatures dot the air. It's daytime.

Voice (from city): Oh my Lord, Sinbad, but –

Same Voice (connected balloon): But we're in the homelands!"

MEDIA: GRAPHITE, ACRYLIC, PIGMENT INK, DIGITAL.

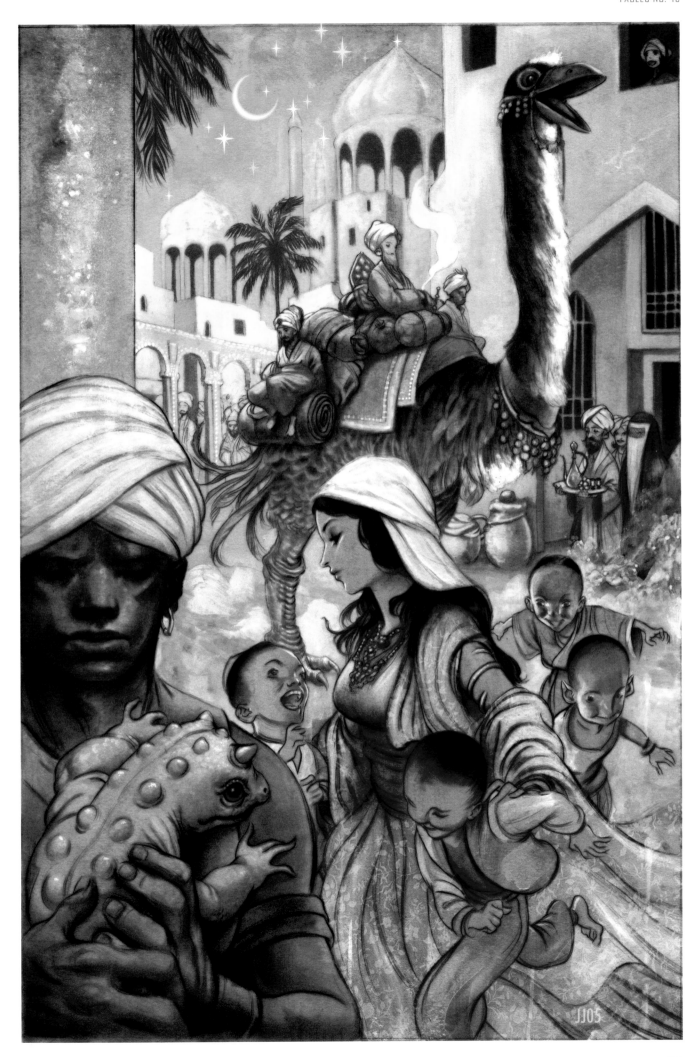

PRELIMINARY SKETCH, GRAPHITE ON BOND, 5.5 X 8.5"

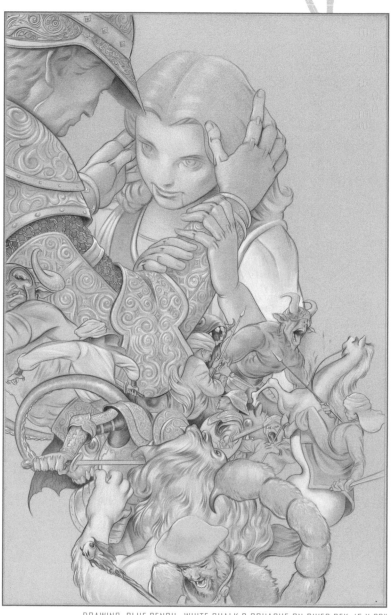

DRAWING, BLUE PENCIL, WHITE CHALK & GOUACHE ON RIVES BFK, 15 X 22"

No. 46 | THE BALLAD OF RODNEY AND JUNE | 1 / 2

"Cap (Rodney): The subtle scent of her wood oil filled my senses like a drug."

MEDIA: BLUE PENCIL, WHITE CHALK, GOUACHE, INK, DIGITAL.

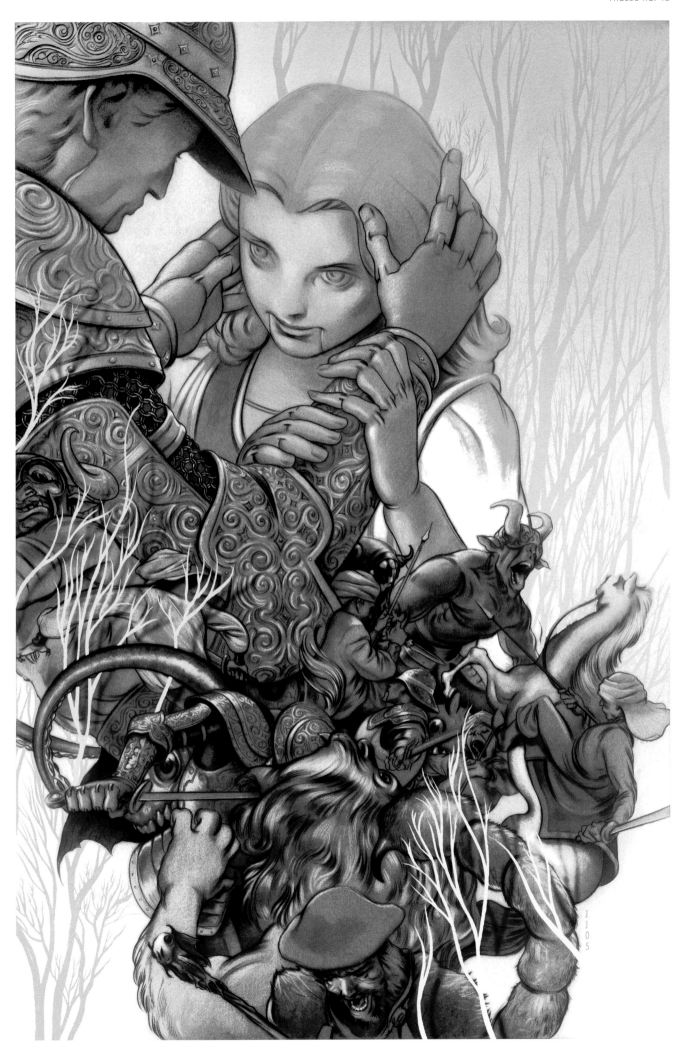

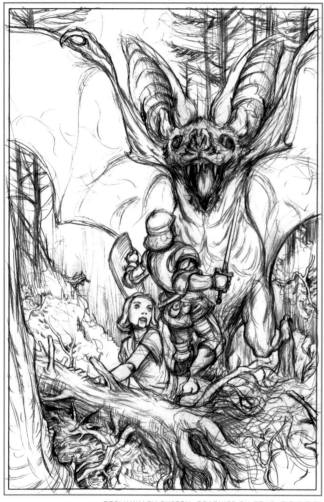

PRELIMINARY SKETCH, GRAPHITE ON BOND, 5.5 X 8.5"

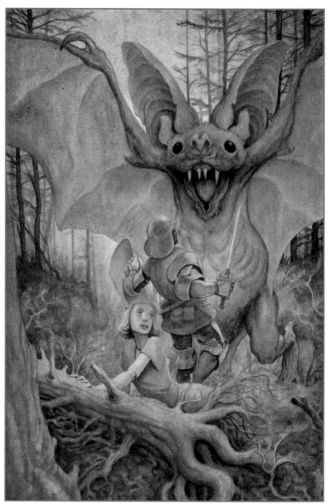

PAINTING, WATERCOLOR & ACRYLIC ON WC PAPER, 9.25 X 14"

No. 47 | THE BALLAD OF RODNEY AND JUNE | 2/2

"**Rodney:** Yes, father Geppetto. June and I are in love.

Panel Three. Same scene. Rodney and June nervously tell Gepetto why they have come there.

June: We'd like you to transform us into real flesh.
...

Geppetto: No gift of this magnitude is bestowed without a dear price.

Panel Two. Closer on Gepetto as he gives the two a very serious look.

Geppetto: Sometimes a terrible price."

MEDIA: GRAPHITE, WATERCOLOR, ACRYLIC, DIGITAL

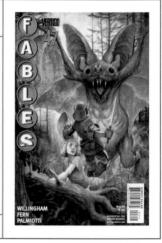

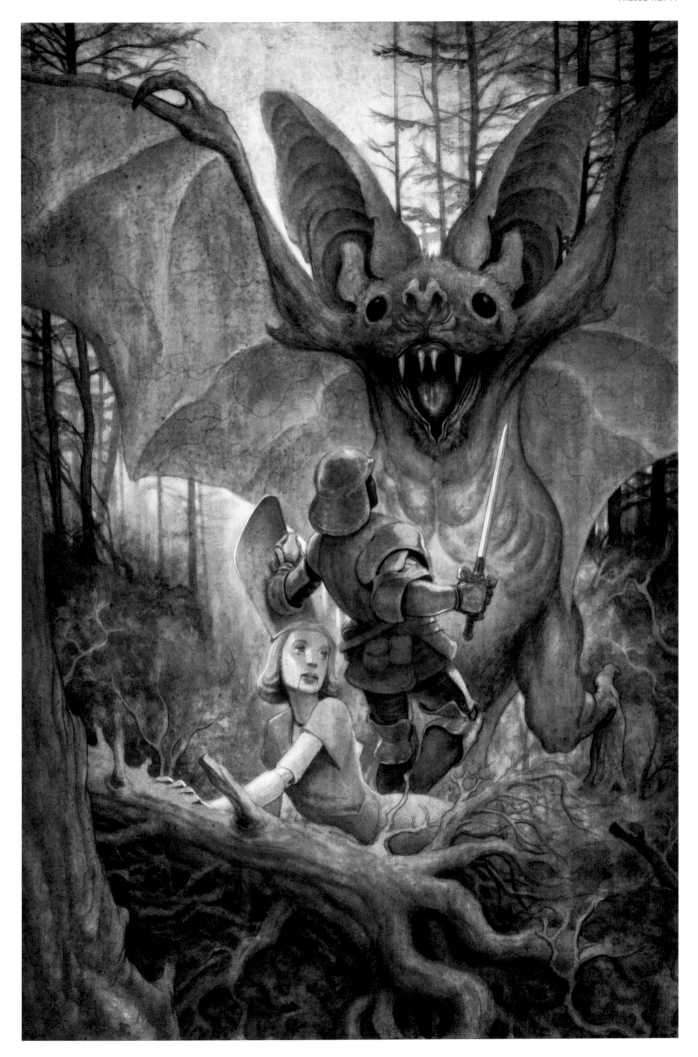

PRELIMINARY SKETCH, GRAPHITE ON BOND, 7.5 X 10"

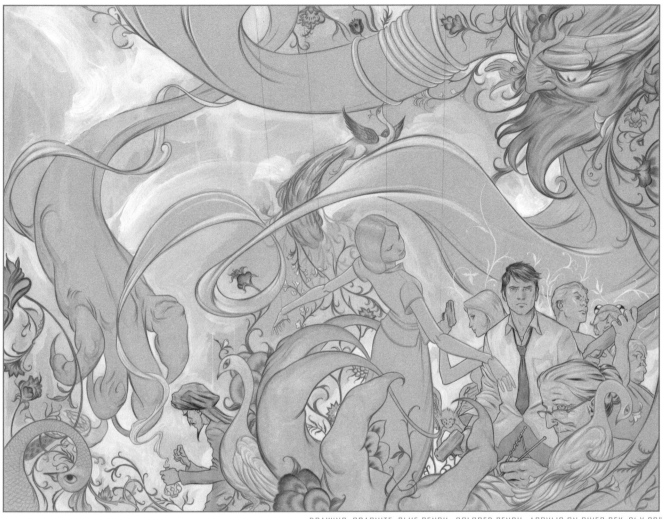

DRAWING, GRAPHITE, BLUE PENCIL, COLORED PENCIL, ACRYLIC ON RIVES BFK, 21 X 29"

TPB 07 ARABIAN NIGHTS (AND DAYS)

COLLECTED MATERIAL: ISSUES 42 - 47

MEDIA: GRAPHITE, BLUE PENCIL, COLORED PENCIL, ACRYLIC, DIGITAL COLOR.

"JJ: I researched Islamic tapestries and patterns while creating this composition. The arabesques of the decorative elements are echoed in the body of the D'Jinn. I always try to find a graphic idea to tie the entire composition together (in this case, the uncorking of the D'Jinn's vessel), to fuse the front and back covers while emphasizing the ensemble nature of the book. Each character performs a role, each gaze a different pitch in the composition."

TPB 07 | ARABIAN NIGHTS (AND DAYS)

COLLECTED MATERIAL: ISSUES 42 - 47

MEDIA: GRAPHITE, BLUE PENCIL, COLORED PENCIL, ACRYLIC, DIGITAL COLOR.

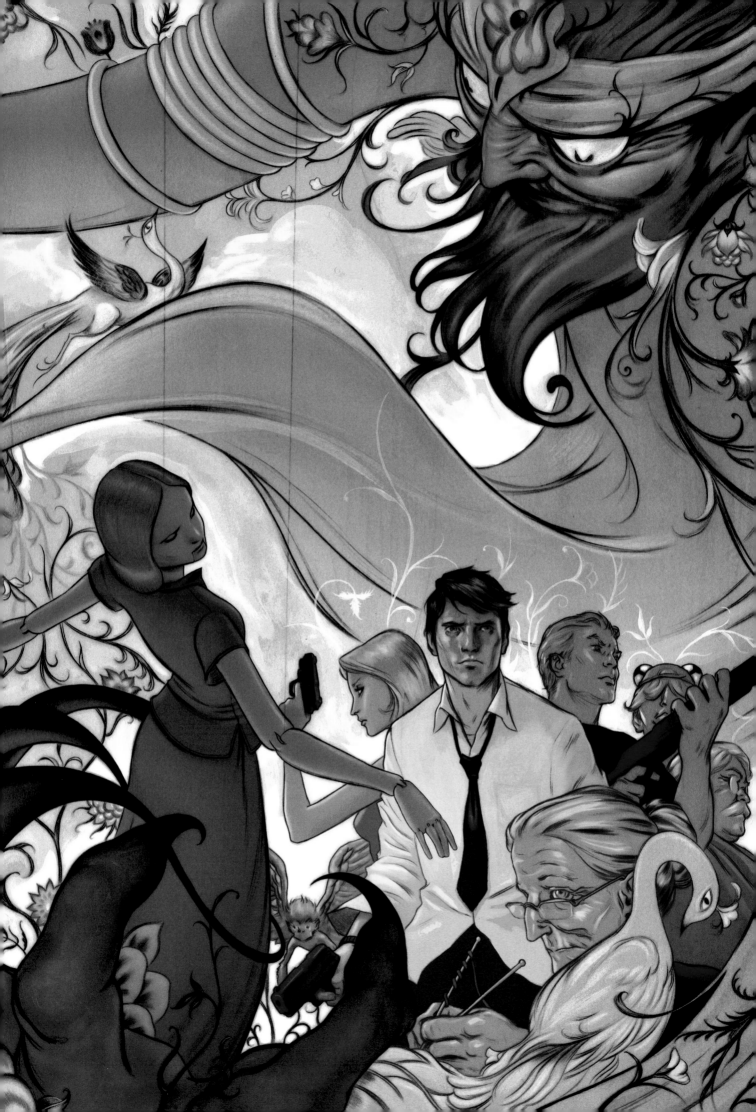

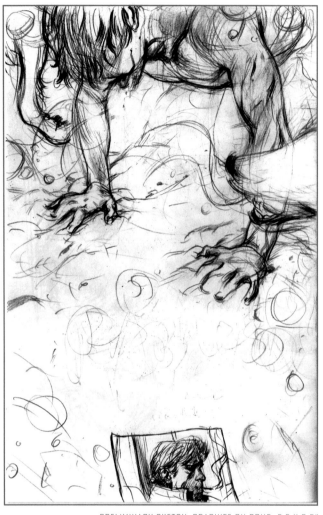

PRELIMINARY SKETCH, GRAPHITE ON BOND, 5.5 X 8.5"

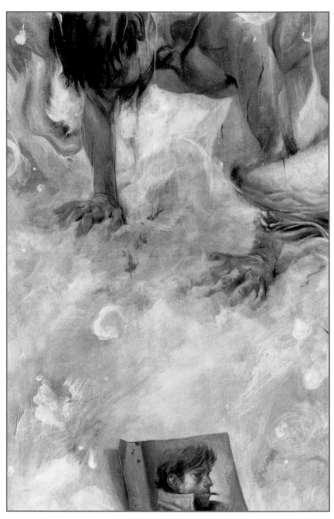

PAINTING, ACRYLIC ON 300LB. WC PAPER, 12 X 17"

No. 48 | WOLVES | 1/2

"The fight continues. Now, continuing the maneuver, Mowgli (still holding Tukar by his two ruined front legs) brings Tukar's body down hard against a jagged rock in the ground, gruesomely breaking Tukar's back. Blood flies from Mowgli's wounds as he does this. The watching wolves rear back in horror.

Sfx: Snap!

Panel Three
The fight is over. Tukar is alive but lying helpless with a broken back and two broken legs. Mowgli is alive but lying near Tukar, bleeding from his arm, chest and from every place he was bumped and scraped and cut on the fall down off of the council rock. The wolves surrounding them don't know what to do."

MEDIA: ACRYLIC, DIGITAL.

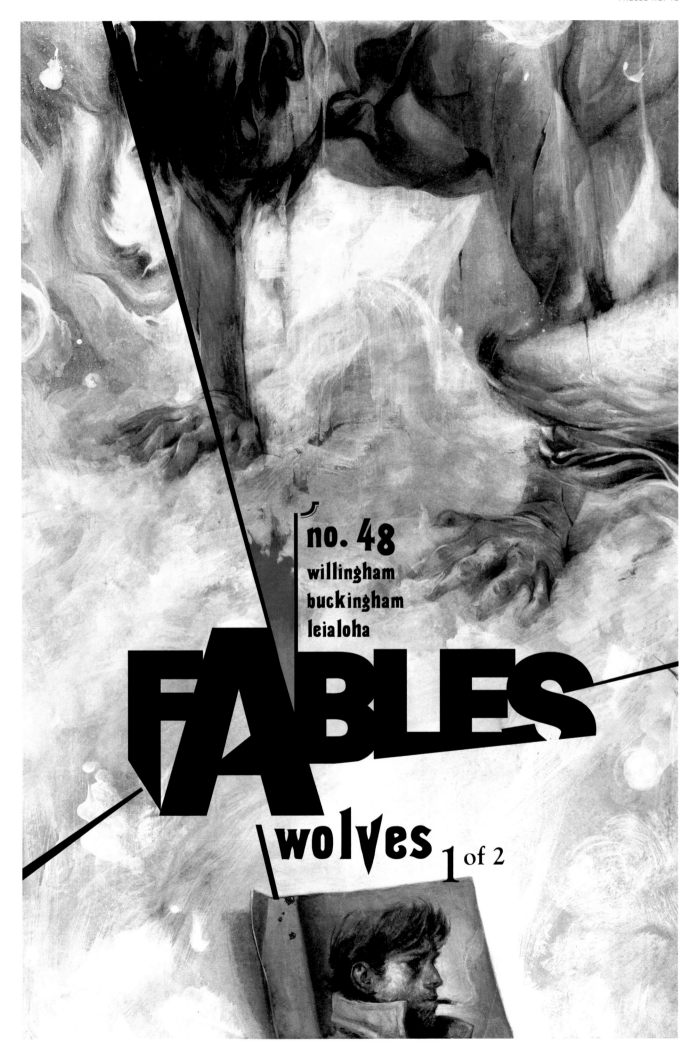

no. 48
willingham
buckingham
leialoha

FABLES

wolves 1 of 2

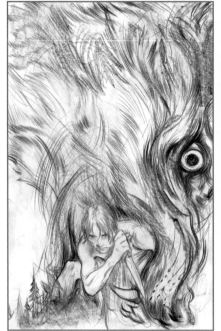

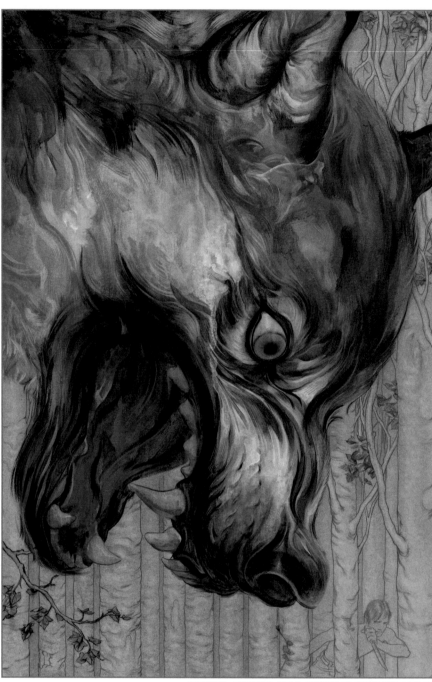

PRELIMINARY SKETCHES, GRAPHITE ON BOND, 5.5 X 8.5"

PAINTING, GRAPHITE, INK & ACRYLIC ON RIVES BFK, 14 X 21"

No. 49	WOLVES	2/2

"**Wolf # 4:** You have to go on alone from here, Mowgli. We're allowed no closer than this to the den made of dead trees.

Wolf # 1: Surely now the Great and Terrible Lord will punish you for pretending kinship to wolves."

MEDIA: GRAPHITE, INK, ACRYLIC, DIGITAL.

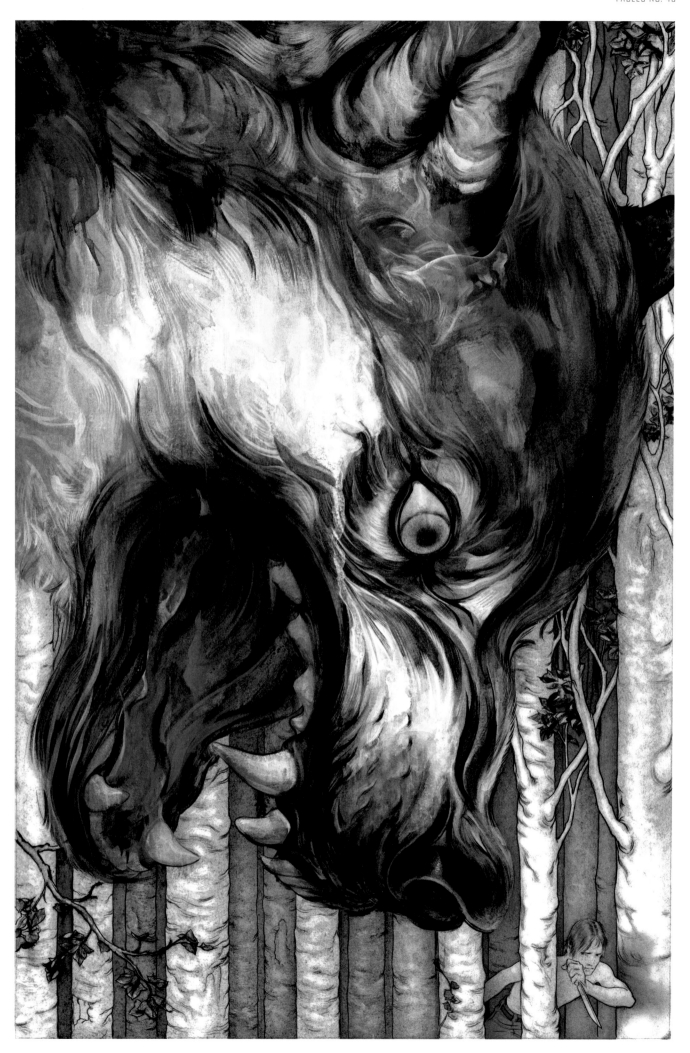

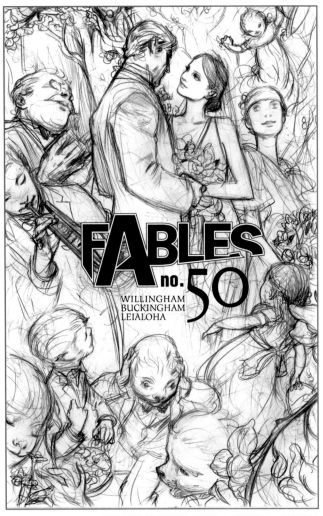

PRELIMINARY SKETCH/DIGITAL, GRAPHITE, 5.5 X 8.5"

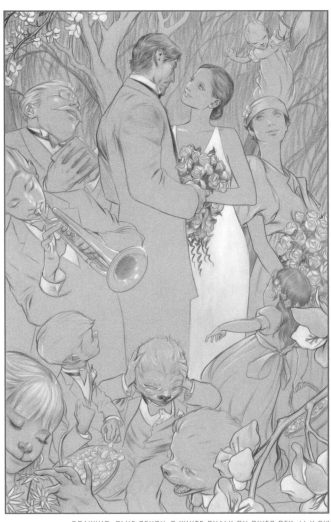

DRAWING, BLUE PENCIL & WHITE CHALK ON RIVES BFK, 14 X 21"

No. 50	HAPPILY EVER AFTER	1/1

"Panel Five

Same scene. They kiss. This is the truest of true love's kisses since the beginning of time. It's every poem ever written and every song ever sung. This is the one panel at which every female reader of Fables' dream has come true. Each and every one of them must be made to cry or squeal or swoon like a character in a Jane Austen novel. Don't blow it, Buckingham. We sort of, kind of, know where you live."

MEDIA: BLUE PENCIL, WHITE CHALK, WATERCOLOR, DIGITAL.

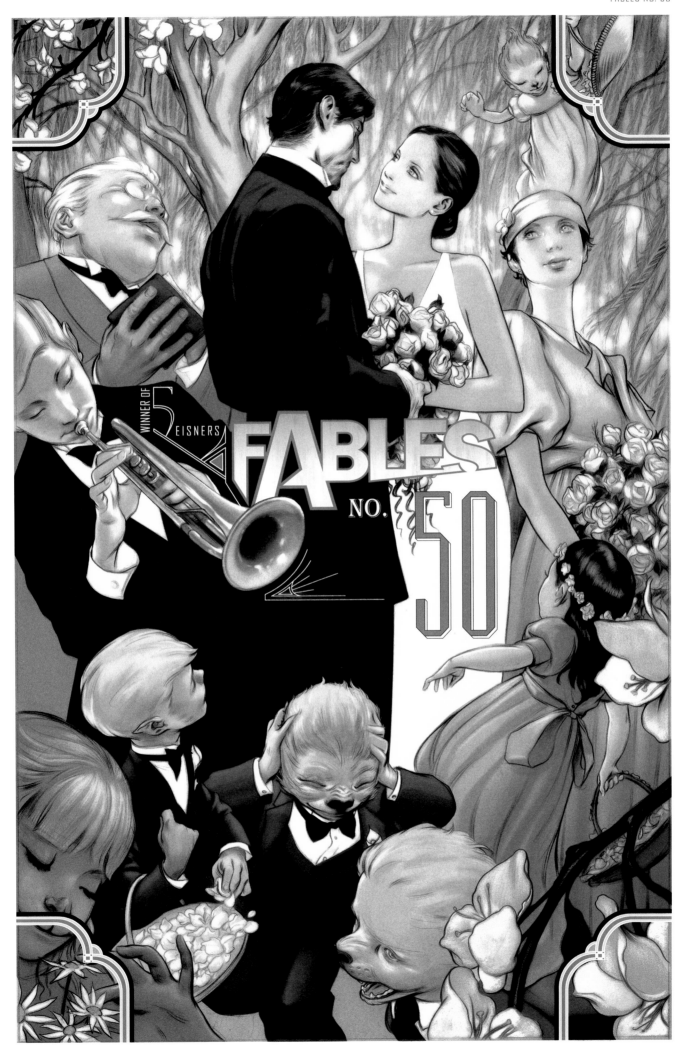

PRELIMINARY SKETCH, GRAPHITE, 5.5 X 8.5"

DRAWING, BLUE PENCIL & WHITE CHALK ON RIVES BFK, 14 X 21"

No. 51	BIG AND SMALL	1/1

"Radiskop (the squirrel): I've never seen Doctor Jolimump so angry.

Cinderella: I have that effect on most men. He'll get over it."

MEDIA: BLUE PENCIL, WHITE CHALK, DIGITAL.

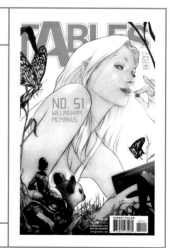

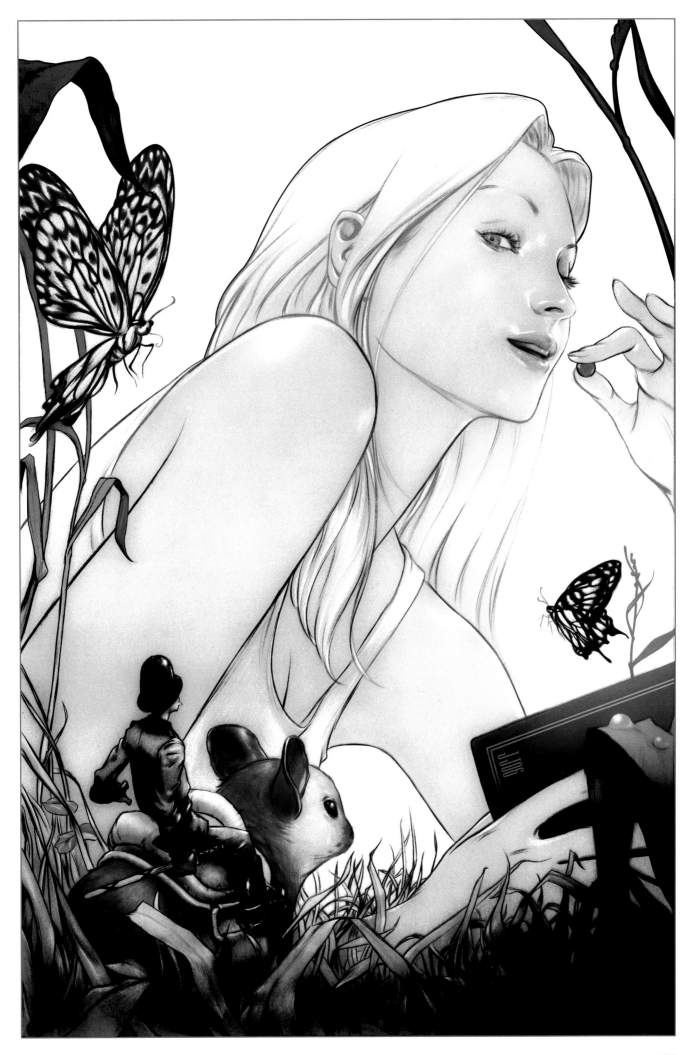

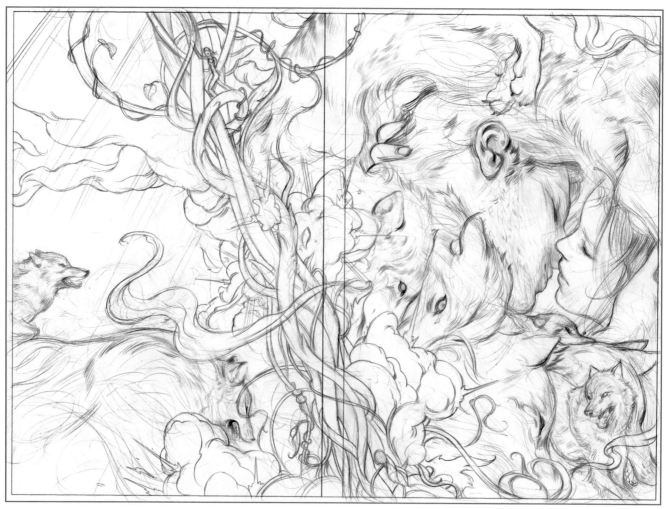

PRELIMINARY SKETCH, GRAPHITE ON BOND, 7.5 X 10"

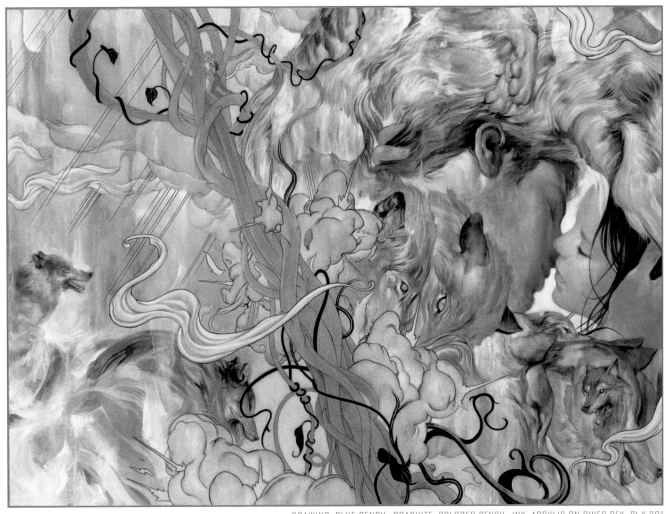

DRAWING, BLUE PENCIL, GRAPHITE, COLORED PENCIL, INK, ACRYLIC ON RIVES BFK, 21 X 29"

TPB 08	WOLVES

COLLECTED MATERIAL: ISSUES 48 - 51

MEDIA: BLUE PENCIL, GRAPHITE, COLORED PENCIL, INK, ACRYLIC, DIGITAL COLOR.

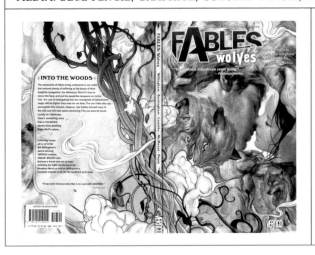

"JJ: I used the marks and texture created by the dripping paint to describe the charging wolf pack as they frame the embrace of Snow and Bigby. The graphic quality of the beanstalk and clouds provide another layer to the composition, a counterpoint to the messiness of the paint. A very small figure of Cinderella helps create a full range of scale in the composition."

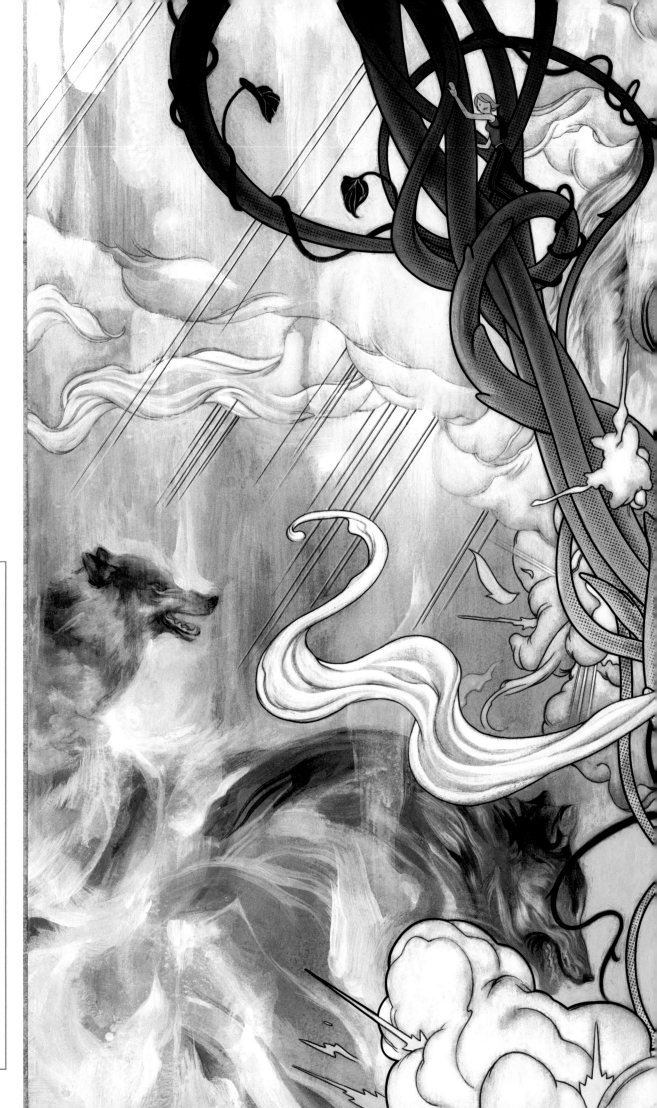

TPB 08 | WOLVES

COLLECTED MATERIAL: ISSUES 48 - 51

MEDIA: BLUE PENCIL, GRAPHITE, COLORED PENCIL, INK, ACRYLIC, DIGITAL COLOR.

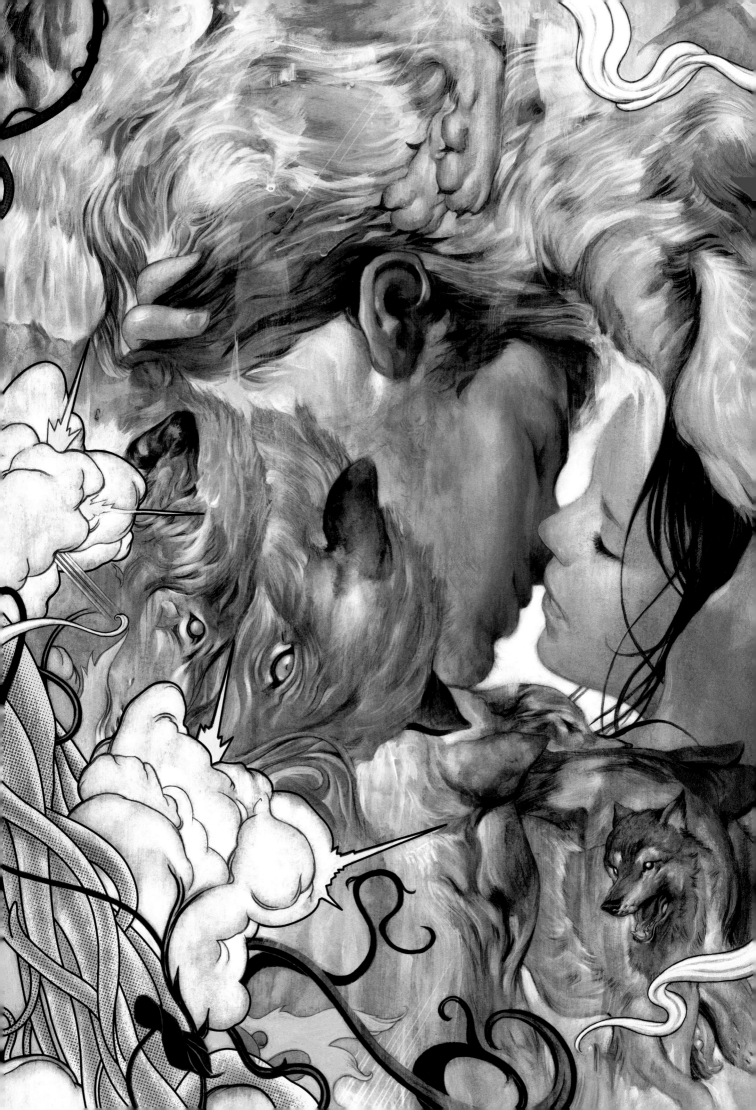

PRELIMINARY SKETCH, GRAPHITE, 5.5 X 8.5"

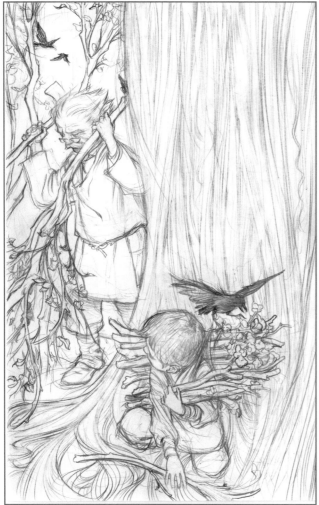

PRELIMINARY SKETCH, GRAPHITE, 5.5 X 8.5"

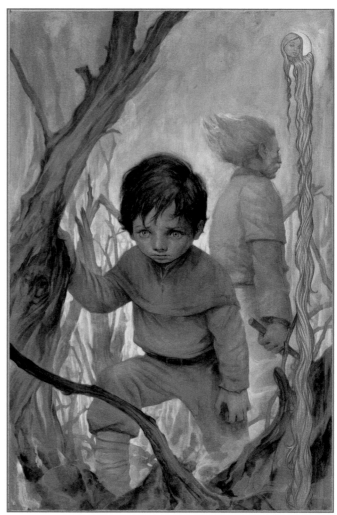

PAINTING, ACRYLIC ON RIVES BFK, 14 X 21"

No. 52 | SONS OF EMPIRE | 1/4

"Panel Four
Same scene. They pause as Geppetto gives his son the grim facts of life.

Geppetto: You're my first son and that means you'll always have a special place in my heart, but a child has to show respect to his father.
Geppetto: And so know this as an absolute certainty: whatever I decide here, you'll help us accomplish it – with enthusiasm.

Panel Five
Same scene – and the last panel in this scene. With an indulgent smile on his face, Pinocchio takes his father by the arm again and continues leading him towards the unburnt area of the woods and the big encampment. Now we are out of the burnt area.

Pinocchio: Come on, Pop. I smell soup. You like a good bowl of soup, doncha?"

MEDIA: GRAPHITE, ACRYLIC, DIGITAL.

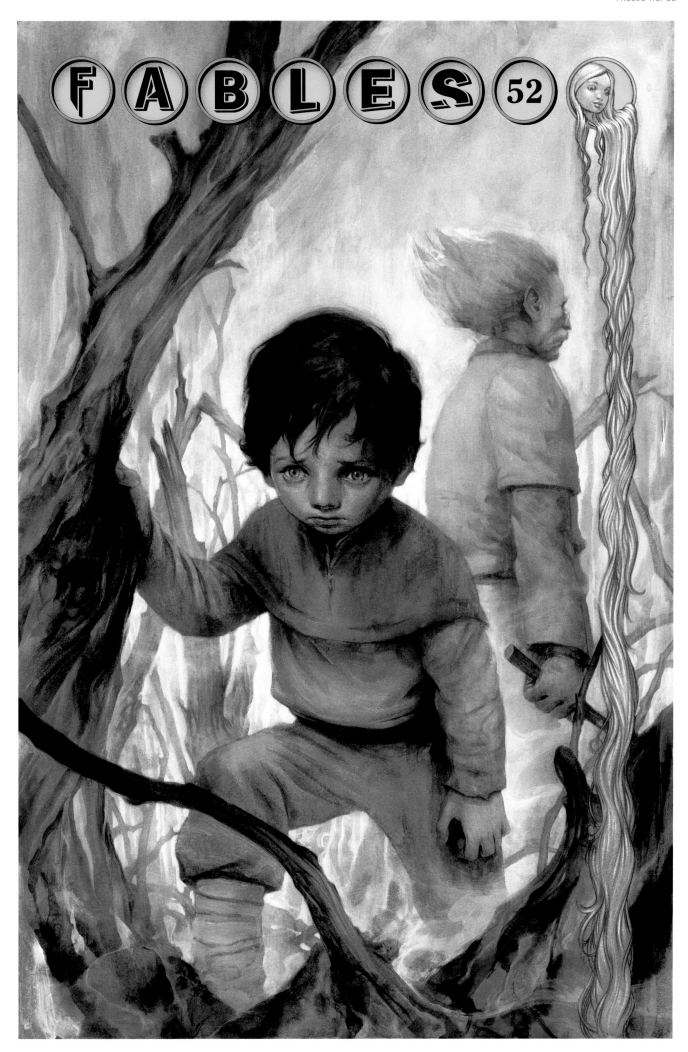

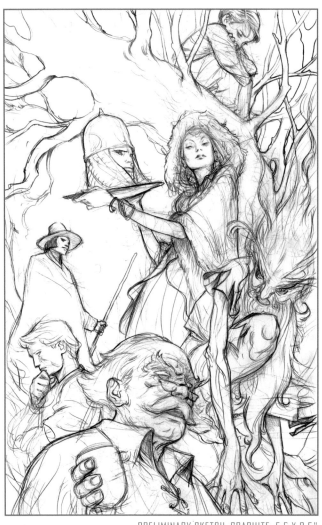

PRELIMINARY SKETCH, GRAPHITE, 5.5 X 8.5"

PAINTING, ACRYLIC ON RIVES BFK, 14 X 21"

No. 53	SONS OF EMPIRE	2/4

"Cap (Snow Queen): This is how the world ends."

MEDIA: GRAPHITE, ACRYLIC, DIGITAL.

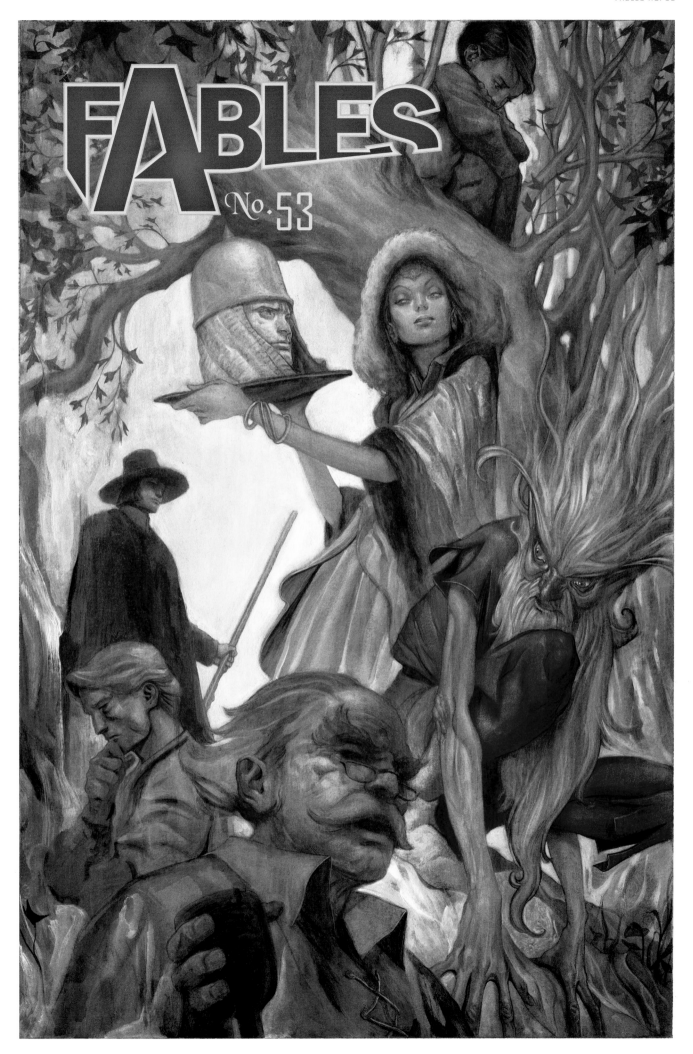

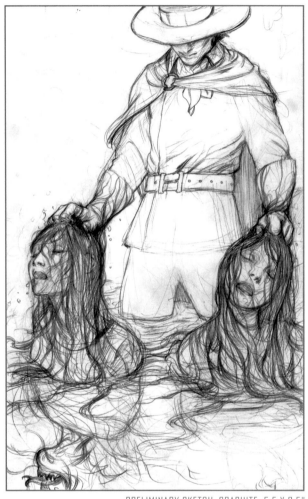

PRELIMINARY SKETCH, GRAPHITE, 5.5 X 8.5"

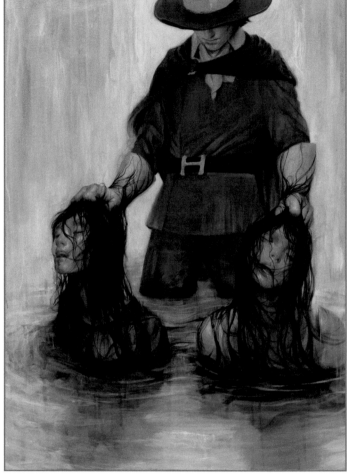

PAINTING, ACRYLIC ON RIVES BFK, 20 X 30"

No. 54 | SONS OF EMPIRE | 3/4

"**Gretel:** Now let's run away from this terrible place!

Hansel: Not yet, dear sister!

Panel Three
Flashback panel. Now Hansel steps back a bit and watches the oven door with fascination, as the witch begins to burn within. Gretel looks worried at her brother, who seems too enchanted at the moment.

Cap (Totenkinder): I believe Hansel's lifelong fascination with killing witches was born that day.

Hansel: I want to tarry and watch for awhile.

Hansel: To make sure she burns complete."

MEDIA: GRAPHITE, ACRYLIC, DIGITAL.

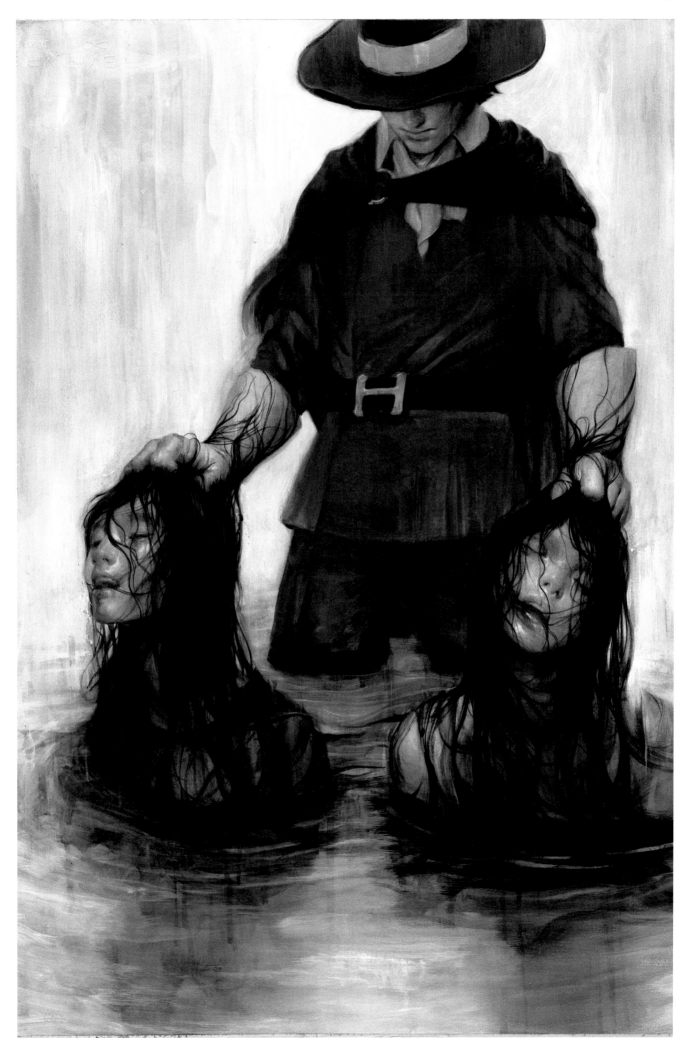

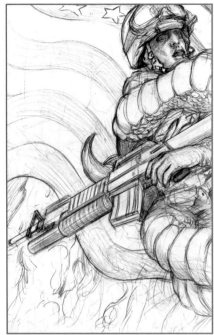

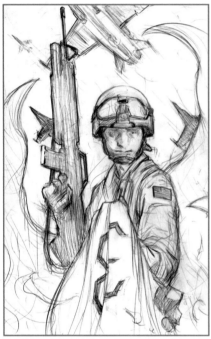

PRELIMINARY SKETCHES, GRAPHITE, 5.5 X 8.5"

PAINTING, ACRYLIC ON RIVES BFK, 14 X 21"

| No. 55 | SONS OF EMPIRE | 4/4 |

"Voice (from Woodland Building): The Adversary has started a war, not just against us, but against the entire mundy world."

MEDIA: ACRYLIC, DIGITAL.

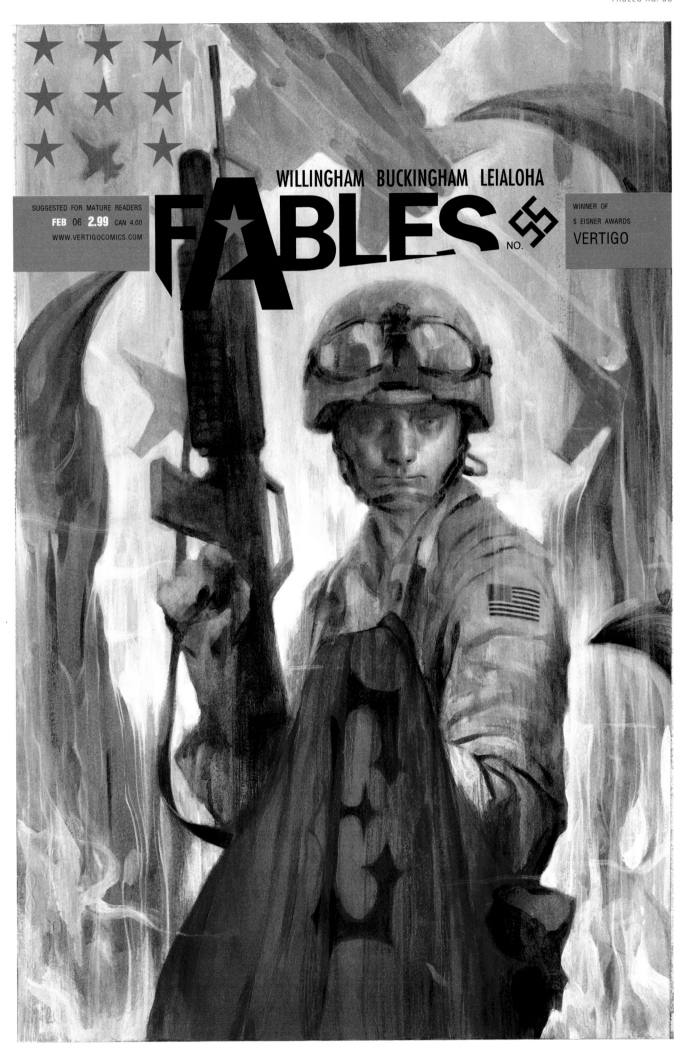

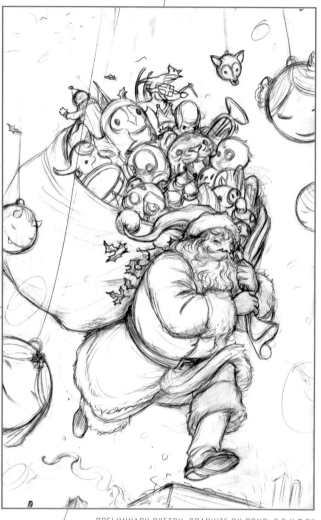

PRELIMINARY SKETCH, GRAPHITE ON BOND, 5.5 x 8.5"

PAINTING, BLUE PENCIL & ACRYLIC ON RIVES BFK, 14 x 21"

No. 56 JIMINY CHRISTMAS

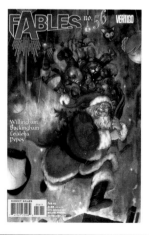

MEDIA: BLUE PENCIL, ACRYLIC, DIGITAL.

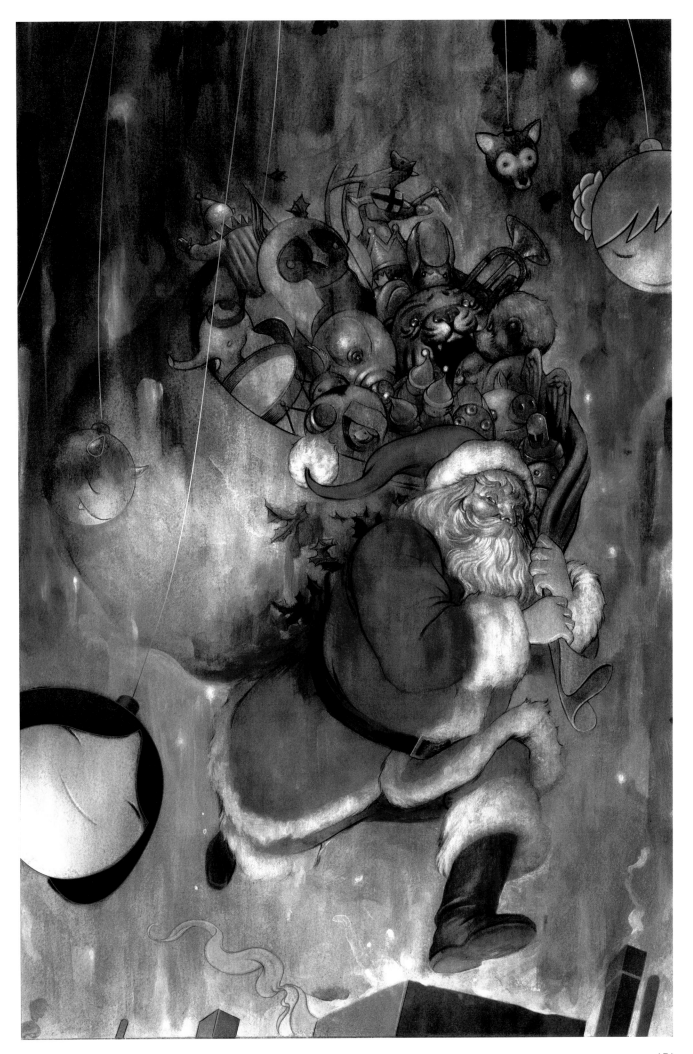

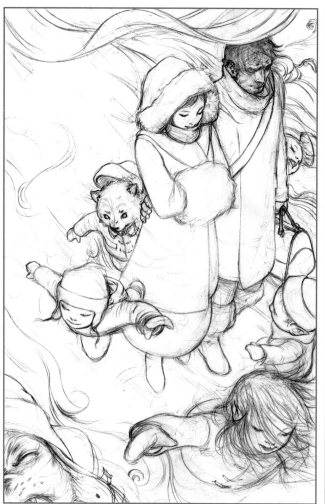

PRELIMINARY SKETCH, GRAPHITE ON BOND, 5.5 X 8.5"

DRAWING, GRAPHITE ON BRISTOL, 10.5 X 16"

COMP FLATTING COLOR & TEXTURE WIND SNOW

No. 57	FATHER AND SON	1/2

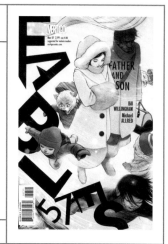

"**Bigby:** This is not fun.

Snow: Well, there's your father's castle now. We're almost down safe.

Darien: Daddy's making his scared face again!

Therese: Because he can't fly!

Ambrose: I'll bet you could learn to if you wanted to, Daddy.

Blossom: Yeah, Grandpa could teach you good! Just like he taught us to become people or wolves, or in between!

Conner: Or other kinds of way cool monsters!

Bigby: Daddy thinks being a Big Bad Wolf is way cool enough, especially since wolves live entirely on the solid ground where God intended all good creatures to dwell."

MEDIA: GRAPHITE, WATERCOLOR, INK, DIGITAL.

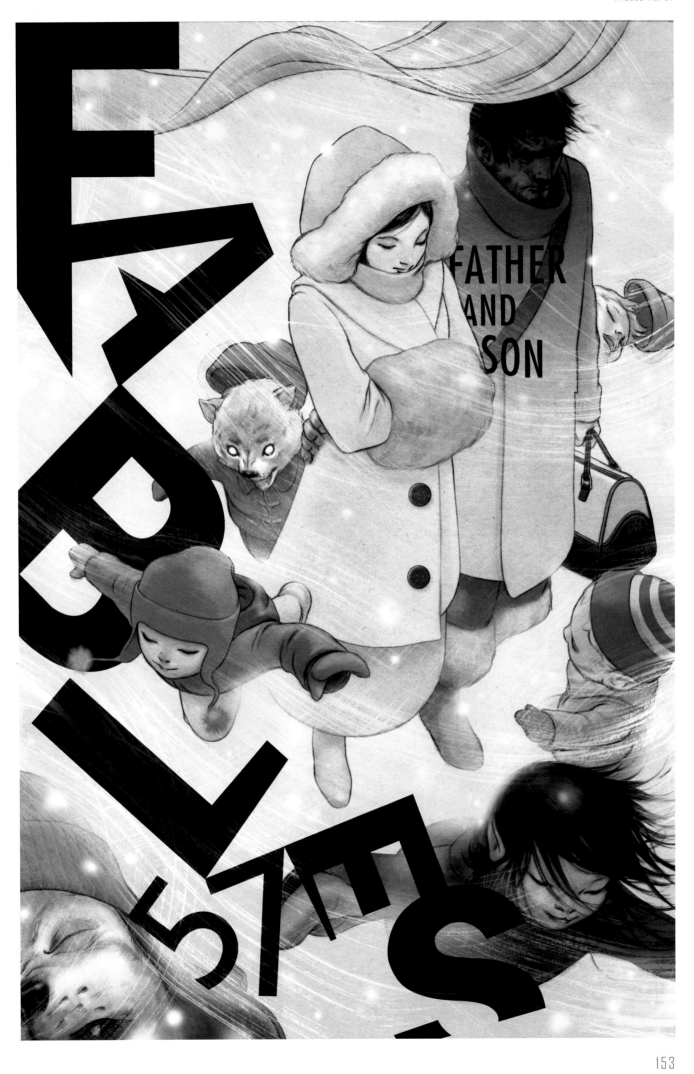

FATHER
AND
SON

PRELIMINARY SKETCH, GRAPHITE ON BOND, 5.5 X 8.5" DRAWING, GRAPHITE & BLUE PENCIL ON RIVES BFK, 14 X 21"

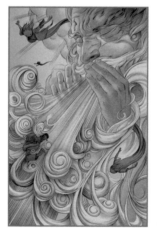

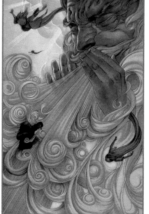

No. 58 FATHER AND SON 2/2

"Cap (Ambrose): Let me instead say, if I may be forgiven some literary extravagance, that it was an epic struggle that spawned terrible legends and bred raw, wild mythologies."

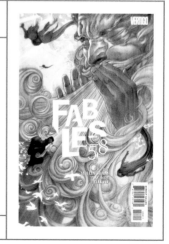

MEDIA: GRAPHITE, BLUE PENCIL, WATERCOLOR, DIGITAL.

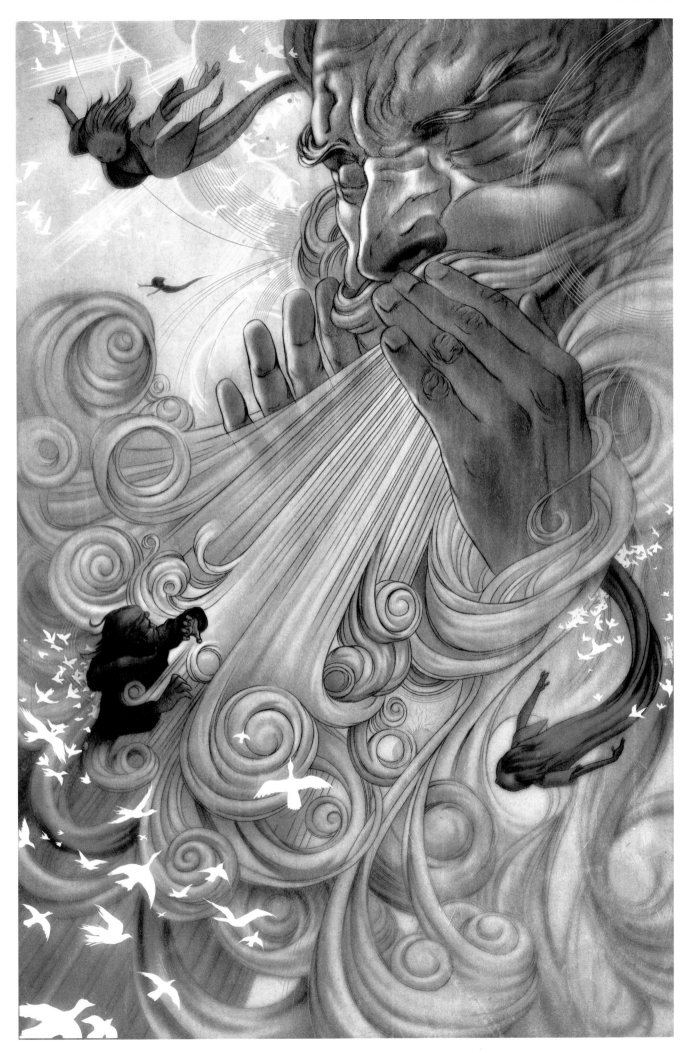

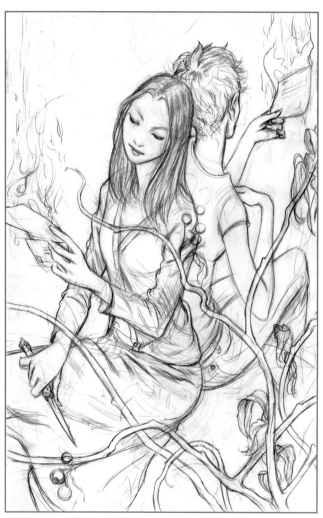

PRELIMINARY SKETCH, GRAPHITE ON BOND, 5.5 X 8.5"

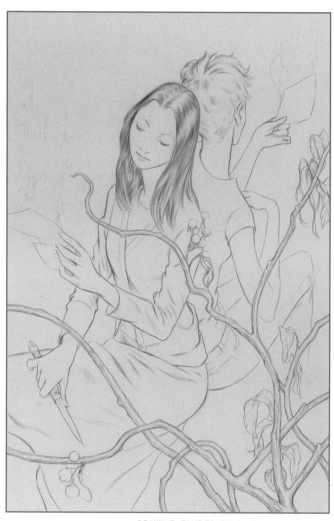

DRAWING, BLUE PENCIL ON RIVES BFK, 14 X 21"

No. 59 | BURNING QUESTIONS | 1/1

"In which we take a break from our gathering storm of troubles, tumults, and dangers to dwell for just a small time on a modest cluster of heretofore unanswered, albeit humble, mysteries."

MEDIA: BLUE PENCIL, ACRYLIC, INK, DIGITAL.

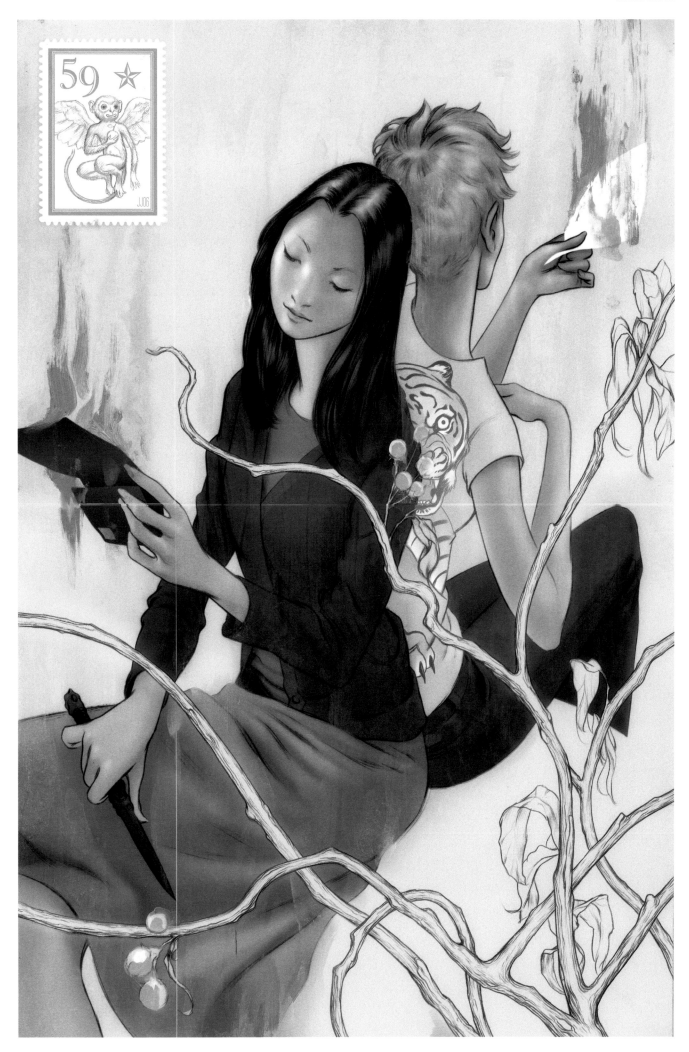

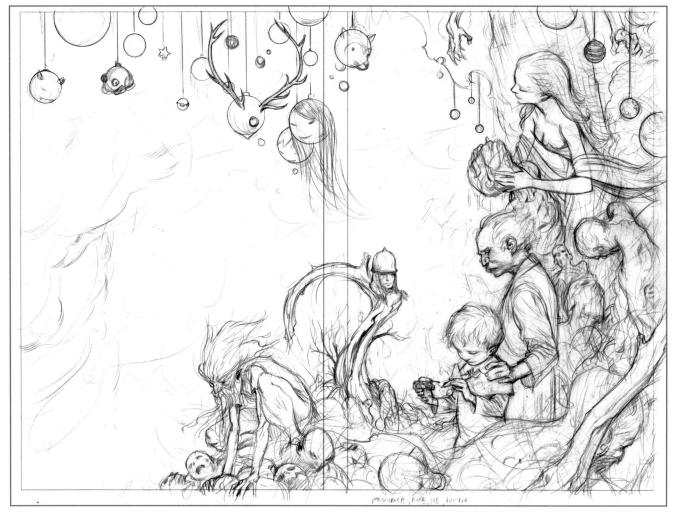

PRELIMINARY SKETCH, GRAPHITE ON BOND, 7.5 X 10"

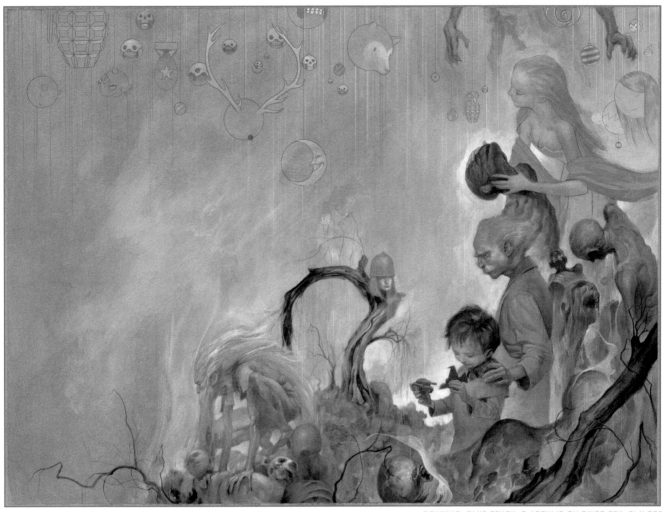

DRAWING, BLUE PENCIL & ACRYLIC ON RIVES BFK, 21 X 29"

TPB 09 | SONS OF EMPIRE

COLLECTED MATERIAL: ISSUES 52 - 59

MEDIA: BLUE PENCIL, ACRYLIC, DIGITAL COLOR.

"JJ: Pinocchio plays with a toy tank and a war plane, a motif repeated from the covers to no. 24 and TPB 4 where he holds a pair of toy soldiers in his hands. The grotesquery of the melting flesh is offset by the morbid cuteness of the Christmas ornaments. Hands play an important role in communicating intention and establishing relationships between characters in a narrative image. Geppetto's paternal touch is framed by hands that communicate death and destruction."

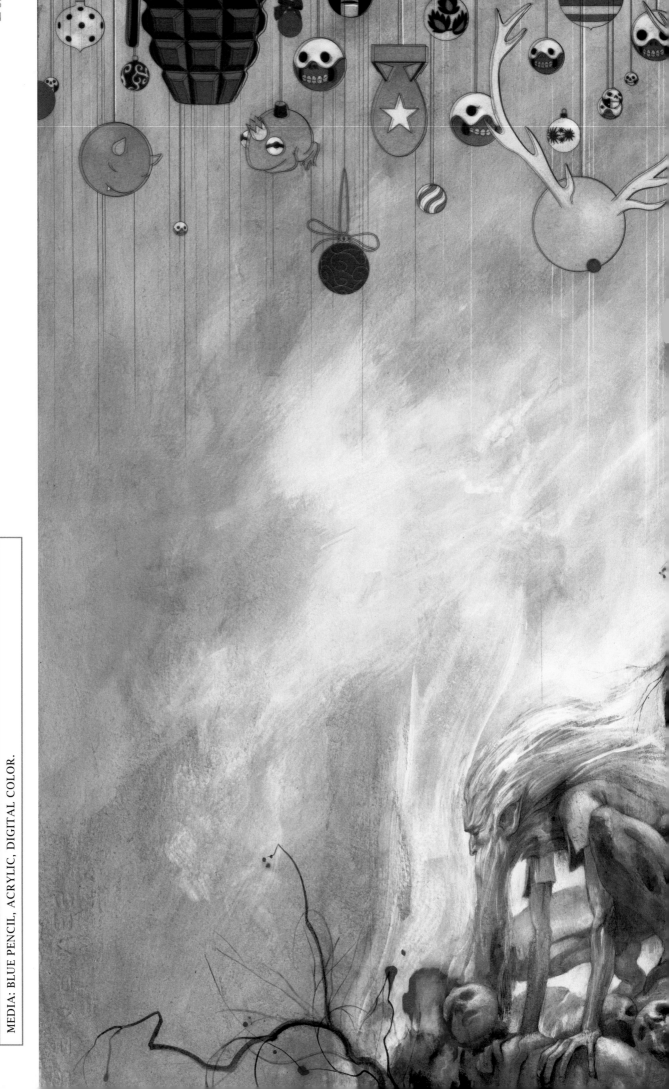

FABLES - COVERS
BY JAMES JEAN

TPB 09 | SONS OF EMPIRE

COLLECTED MATERIAL: ISSUES 52 - 59

MEDIA: BLUE PENCIL, ACRYLIC, DIGITAL COLOR.

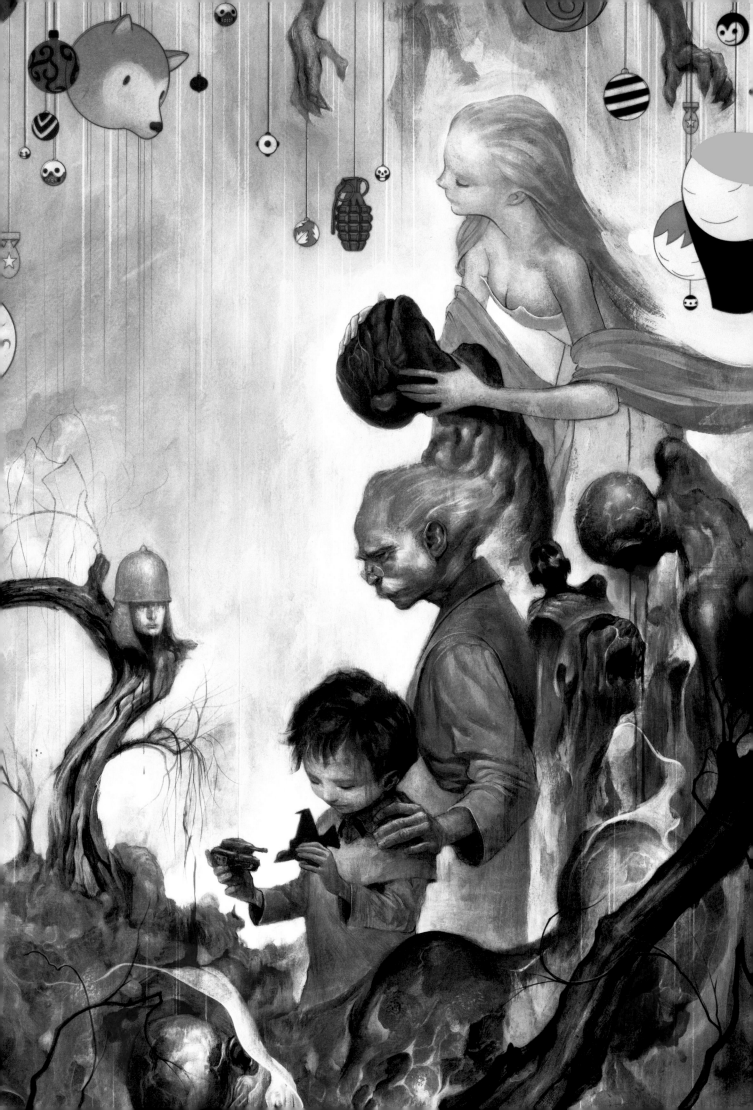

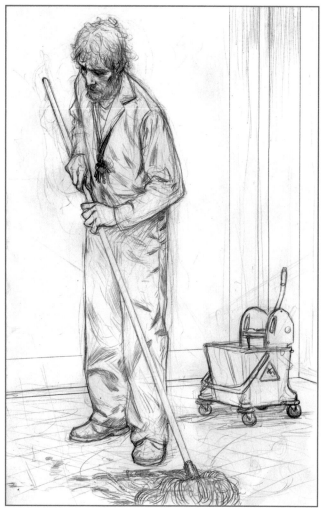

PRELIMINARY SKETCH, GRAPHITE ON BOND, 5.5 X 8.5"

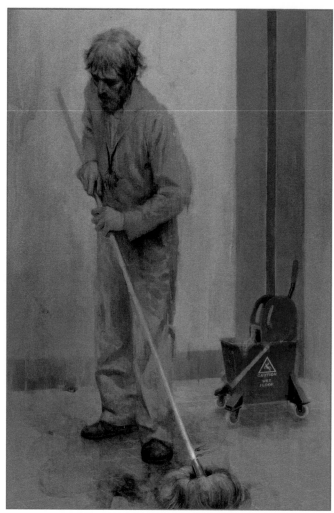

PAINTING, MIXED MEDIA ON RIVES BFK, 14 X 21"

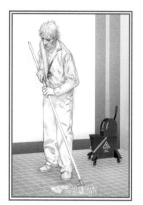

DIGITAL COMP

| No. 60 | THE GOOD PRINCE | 1/9 |

"Panel Two

Close on Fly as he raises his head to look at Riding Hood. Fly's face is a ruin of grief. His eyes are dark and shrunken with deep shadowed bags. His beard and hair are unkempt – almost wild. Think of Alan Moore at his most visually maniacal, or even a Passion of the Christ kind of scene. This panel needs to be shocking to the readers. This is a Fly they never expected to ever see. He's truly haunted. He hasn't been crying. He's at that point where he seems drained of all emotion and now is mostly just infinitely tired. He's ready to surrender and fade away."

MEDIA: ACRYLIC, PIGMENT INK, DIGITAL.

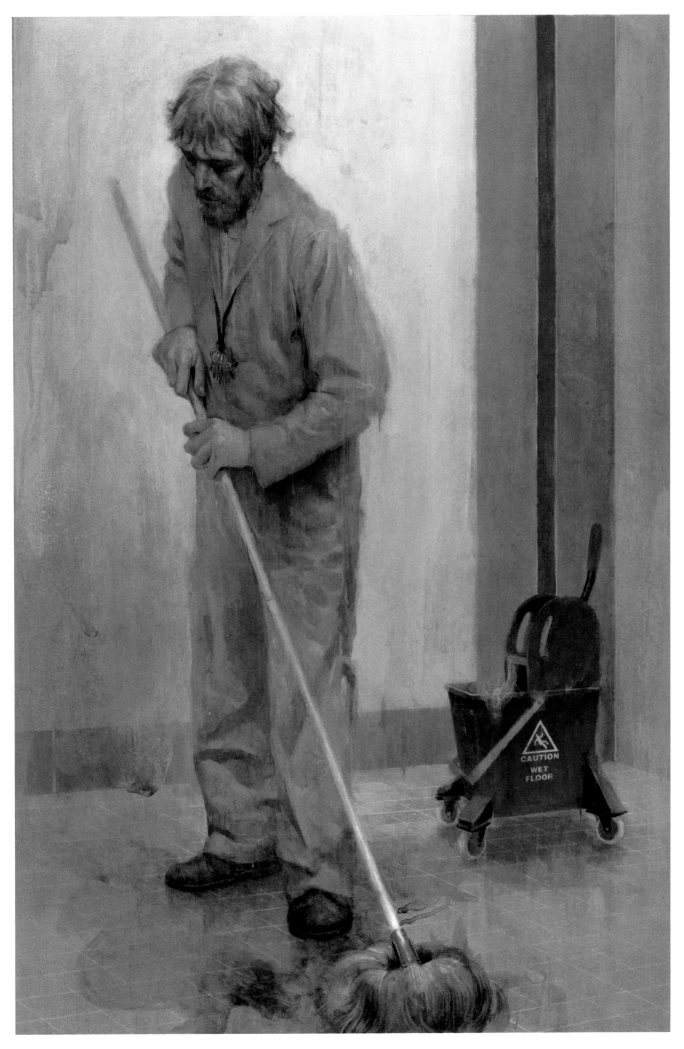

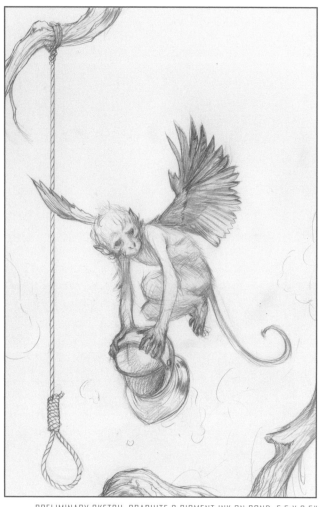

PRELIMINARY SKETCH, GRAPHITE & PIGMENT INK ON BOND, 5.5 X 8.5"

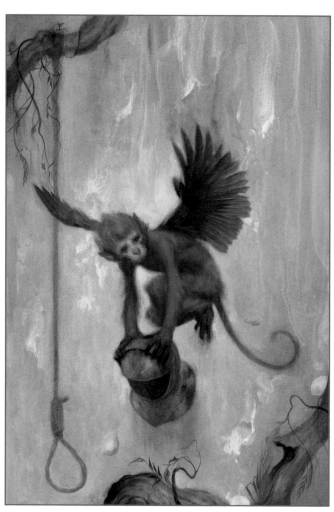

PAINTING, ACRYLIC ON RIVES BFK, 14 X 21"

No. 61	THE GOOD PRINCE	2/9

"**Bufkin**: From now on I promise to never forget to dust you every day. And I'll polish all the rust out of your armor.

...

Forsworn Knight: THE TIME IS COMING!"

MEDIA: ACRYLIC, DIGITAL.

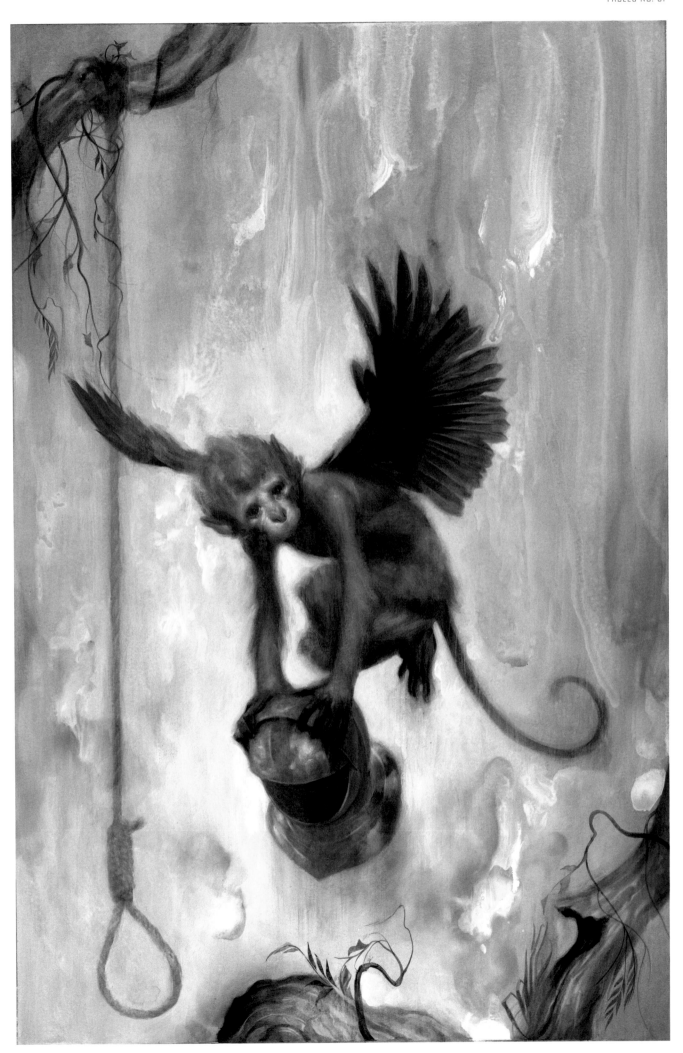

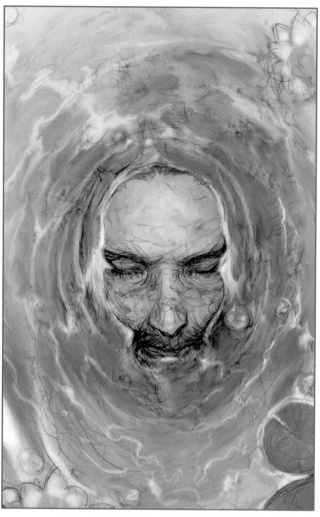

PRELIMINARY SKETCH, GRAPHITE & DIGITAL COLOR, 5.5 X 8.5"

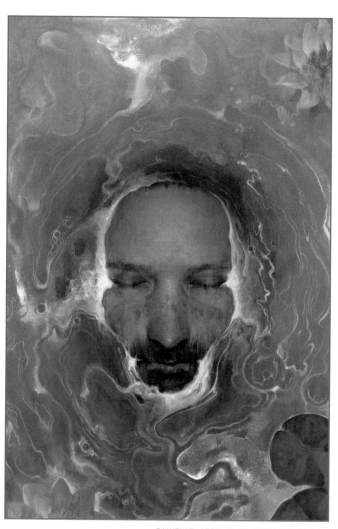

PAINTING, ACRYLIC ON RIVES BFK, 14 X 21"

No. 62	THE GOOD PRINCE	3/9

"He's holding his breath as all of his long hair billows above him, as if he's just plunged his head under water, so that his hair is trailing behind him in the plunge from the surface. Soap suds flow upward from his hair, as if he's just been washing it and now dunked his head under water to wash all of the soap out of it, which is exactly what he's just done.

...

Lance: You knelt a man and a prince of the blood, but now rise a knight."

MEDIA: ACRYLIC, DIGITAL.

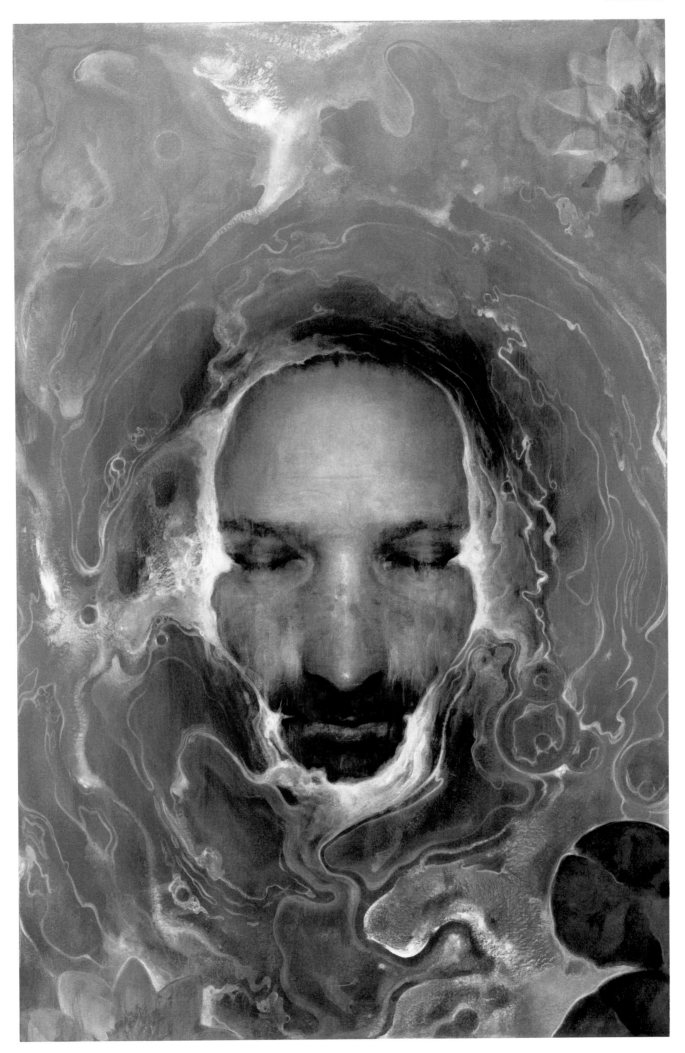

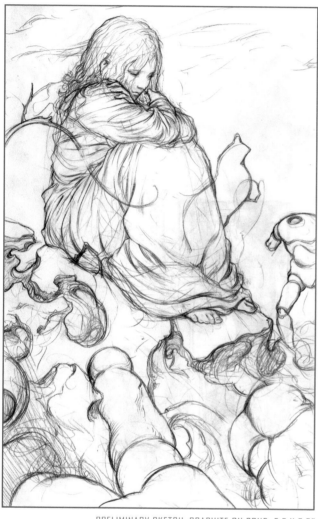

PRELIMINARY SKETCH, GRAPHITE ON BOND, 5.5 X 8.5"

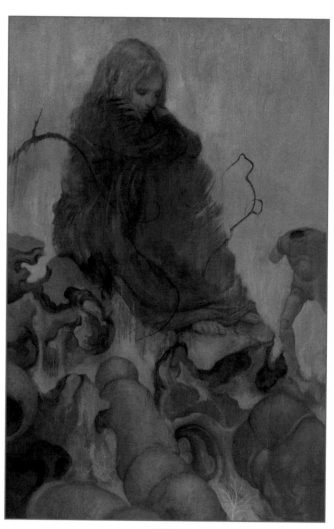

PAINTING, ACRYLIC ON RIVES BFK, 14 X 21"

No. 63 | THE GOOD PRINCE 4/9

"This is a wasteland of shadow and mist . . . In the foreground we see a wooden soldier's hips and legs assembly, walking/stumbling around, with no torso, arms or head. Remember that the wooden soldiers' bodies were dumped down the well, while the heads were saved above. Now some of those headless wooden soldier parts are down here, stumbling around in their mindless ways. By the way, all wooden soldiers (bits and pieces) in this multi-page scene will show some effects of the Battle of Fabletown – either some scorching, splintering, or both. In the background we see a young lady (approximately in her early twenties) sitting on some rocky outcropping holding her head in her hands – a pose of general weariness or sadness. She is Hansel's sister."

MEDIA: ACRYLIC, DIGITAL.

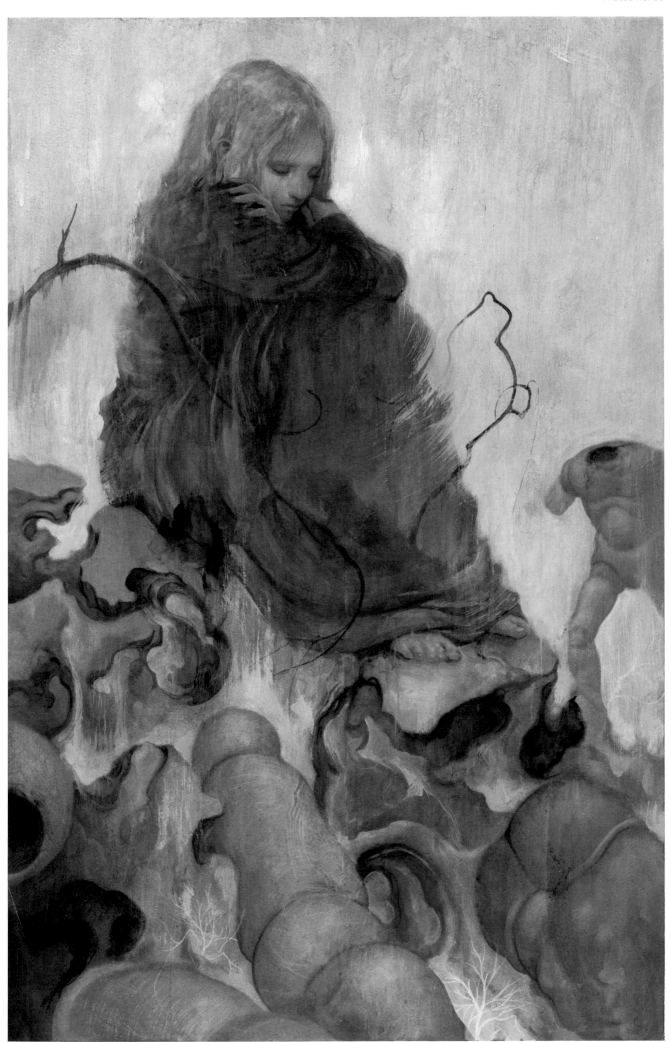

PRELIMINARY SKETCH, GRAPHITE ON BOND, 5.5 X 8.5"

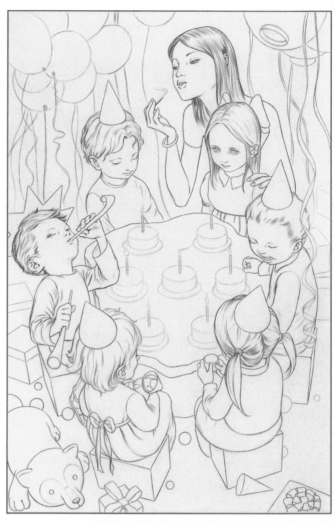

DRAWING, GRAPHITE & BLUE PENCIL ON RIVES BFK, 14 X 21"

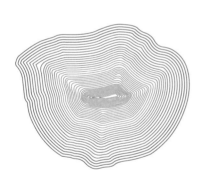

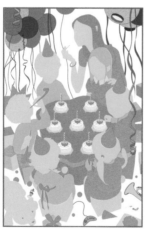

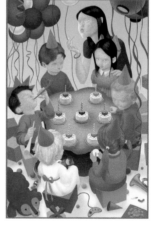

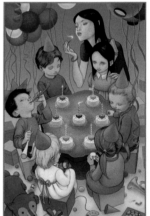

TREE RINGS. RIGHT: DIGITAL COLOR PROCESS

| No. 64 | THE BIRTHDAY SECRET | 1/1 |

"**Snow:** And you're all far too old to go running around naked in human form!

Change back to wolves this instant!

And then get home!"

MEDIA: GRAPHITE, BLUE PENCIL, CHARCOAL, DIGITAL.

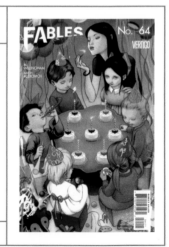

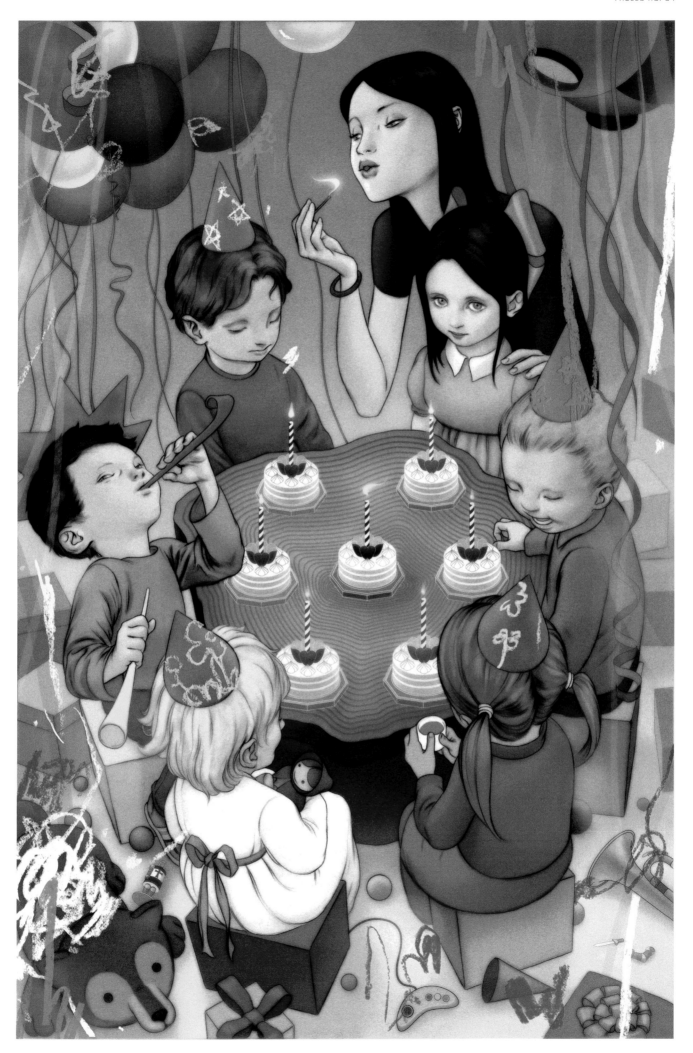

THUMBNAILS, GRAPHITE ON BOND, 1.5 X 2"

⊗ ⊗ ⊗ ✔

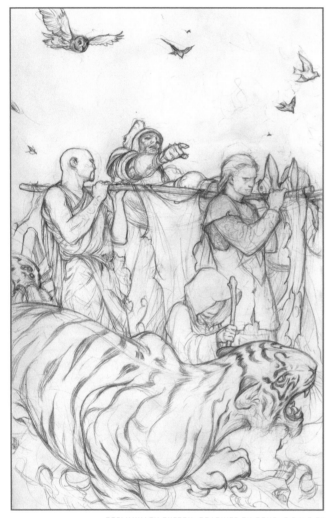

PRELIMINARY SKETCH, GRAPHITE ON BOND, 5.5 X 8.5"

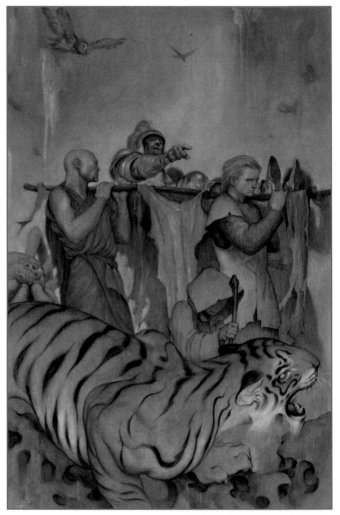

PAINTING, ACRYLIC ON RIVES BFK, 20 X 30"

No. 65 | THE GOOD PRINCE | 5/9

"We see Flycatcher leading his army of ghosts through these twilight lands, like a new Moses leading the Israelites through the wilderness.
...

Shere Khan: So I see you've become one of our insipid prince's litter bearers.
Bluebeard: It helps to ingratiate myself further into his confidence, and that serves my ultimate plans.
Panel Three
Same scene. Bluebeard scowls while Shere Khan smiles a sly and slippery smile.
Shere Khan: Even so, why stop there? When he grows so feeble he can't even wipe his own pale freckled ass, will you do that for him as well?"

MEDIA: ACRYLIC, DIGITAL.

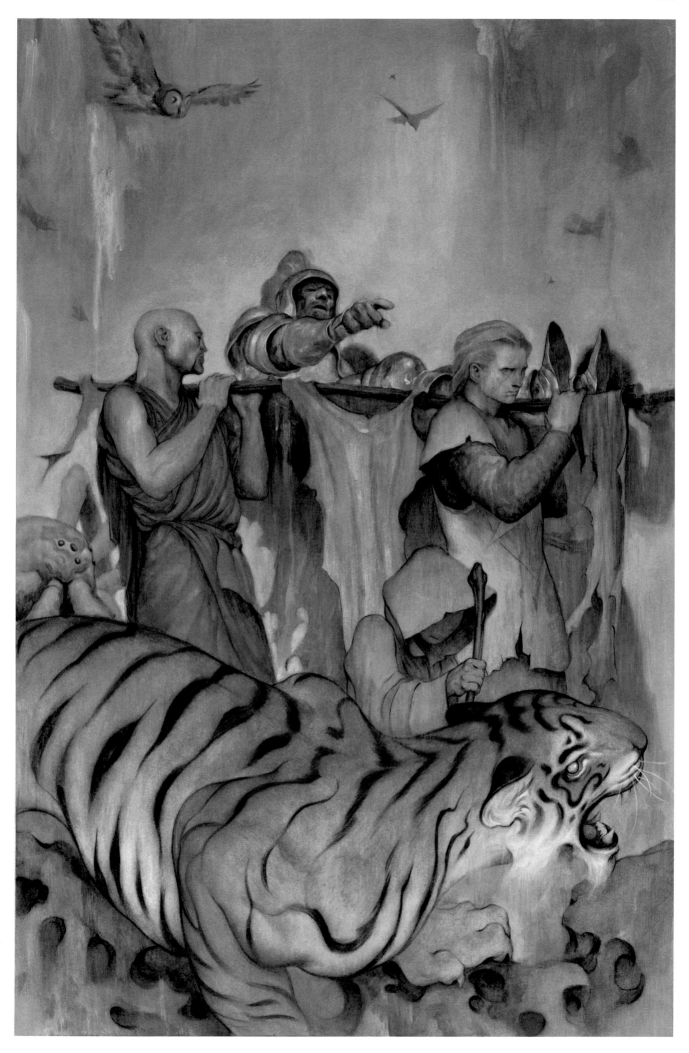

THUMBNAIL, GRAPHITE ON BOND, 2 X 3"

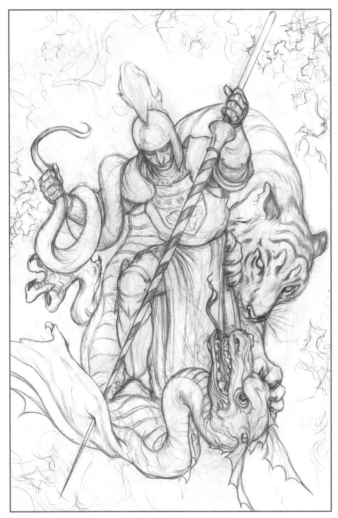

PRELIMINARY SKETCH, GRAPHITE AND PIGMENT INK ON BOND, 5.5 X 8.5"

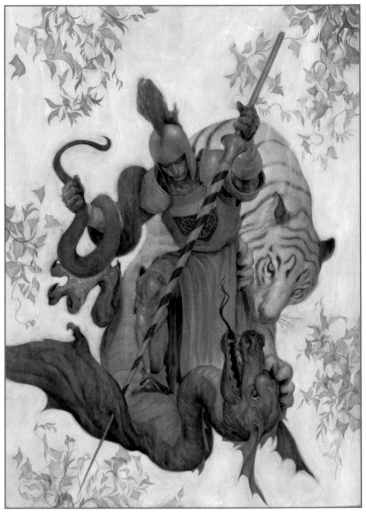

PAINTING, ACRYLIC ON RIVES BFK, 22 X 30"

No. 66 | THE GOOD PRINCE | 6/9

"**Shere Khan:** You've shown yourself to be nothing but a paper tiger, while I'm a real one.

Big panel. Now we see what they see: We see John's hands holding the poster for us (the readers) to see. It's basically a re-creation of this issue's cover, with Fly in his armor piercing a dragon under his feet. The only difference from the cover is that Shere Khan doesn't appear in this poster – not biting Fly's leg and he's not pictured at all. It's just Fly piercing the dragon (the empire) with his lance.

Blue (from off-panel): Pretty good likeness, don't you think? The dragon you're killing represents the Empire of course."

MEDIA: ACRYLIC, DIGITAL.

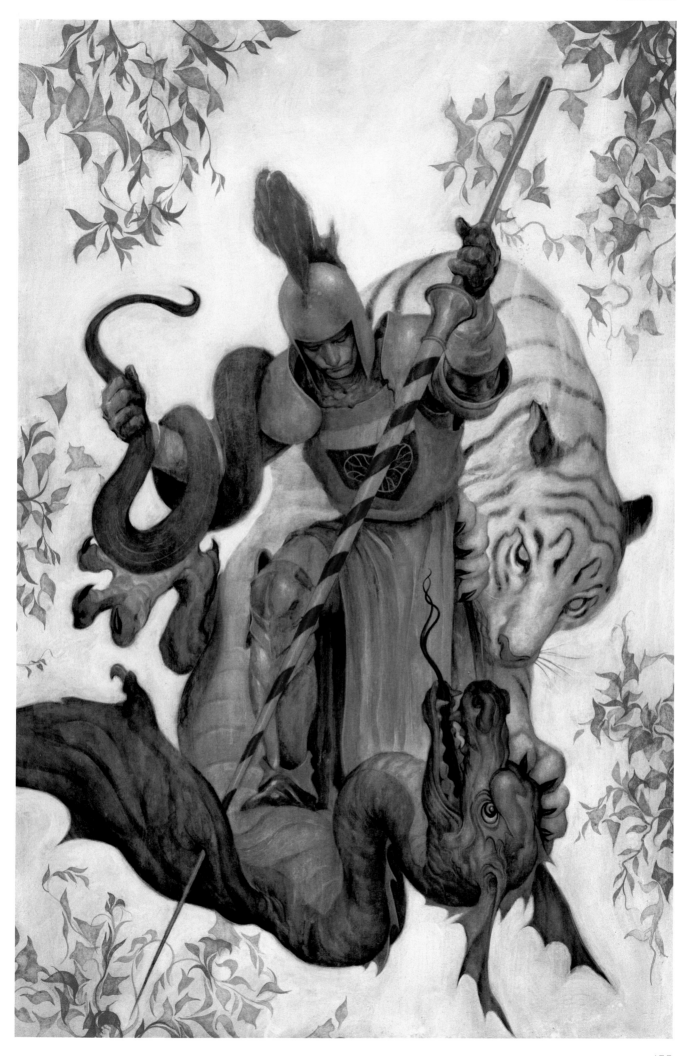

THUMBNAILS, GRAPHITE ON BOND, 1.5 X 2"

⊗ ⊗ ⊗ ✔

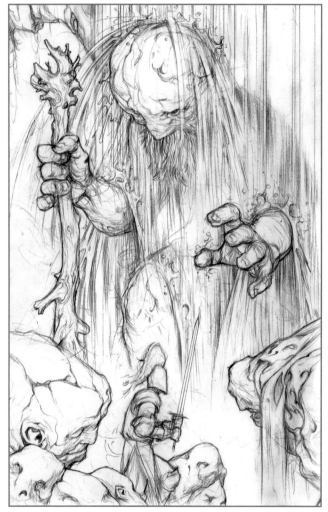

PRELIMINARY SKETCH, GRAPHITE ON BOND, 5.5 X 8.5"

PAINTING, ACRYLIC ON RIVES BFK, 14 X 21"

No. 67	THE GOOD PRINCE	7/9

"**General Hildebrand:** The Emperor would have my head if I surrendered, before any battle was actually fought – and the heads of all of my officers too.
Fly: I suspected as much, so allow me to offer an alternative to so much needless slaughter. I propose a combat of champions.

Panel Three

Same scene, but closer on Fly.

Fly: I'll represent my side. And if I win, you and all of your forces will depart my lands never to return.
Fly: But if your champion beats me, we will all surrender ourselves into your hands, to do with us as you see fit."

MEDIA: ACRYLIC, DIGITAL.

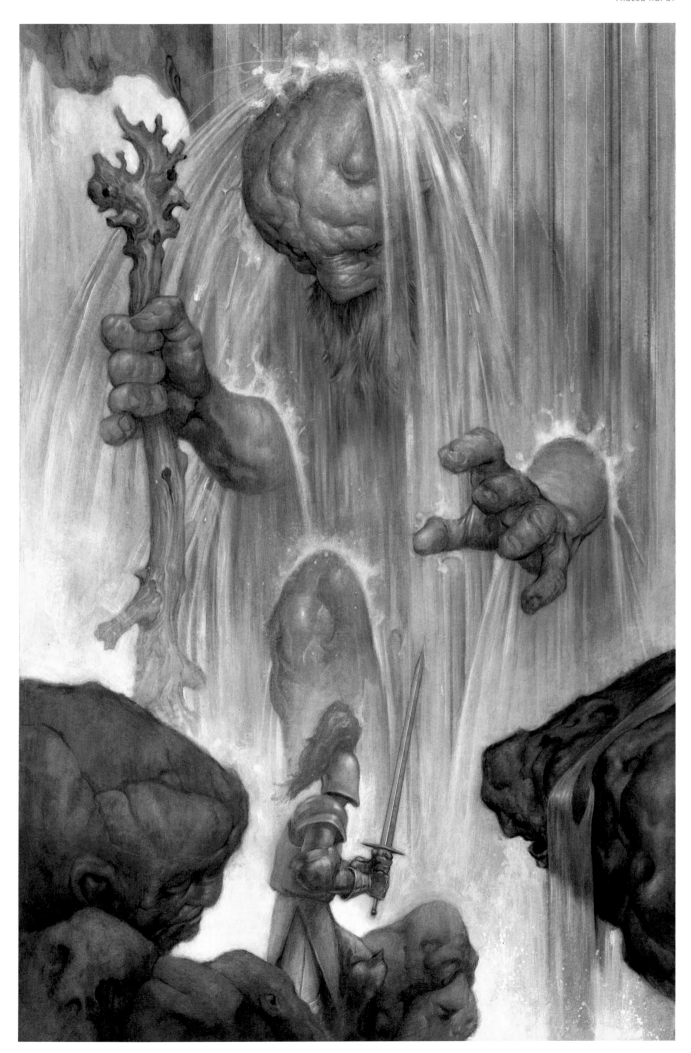

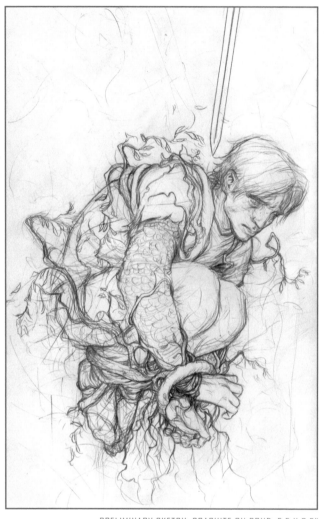

PRELIMINARY SKETCH, GRAPHITE ON BOND, 5.5 X 8.5"

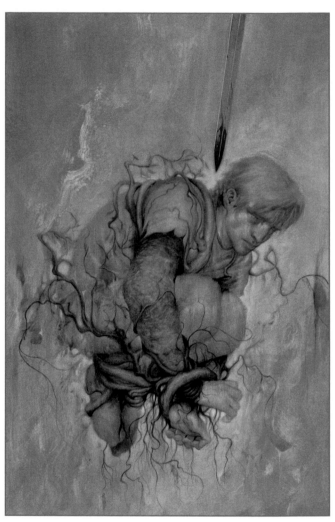

PAINTING, ACRYLIC ON RIVES BFK, 14 X 21"

No. 68	THE GOOD PRINCE	8/9

"**Fly:** My ghosts can't do aught to frighten such as you, nor can any magic of mine hope to conquer the raw power of the Sacred Grove.

Fly: So I willingly surrender myself and all of my magic to you, to add its power to increase your own arboreal magic."

MEDIA: ACRYLIC, DIGITAL.

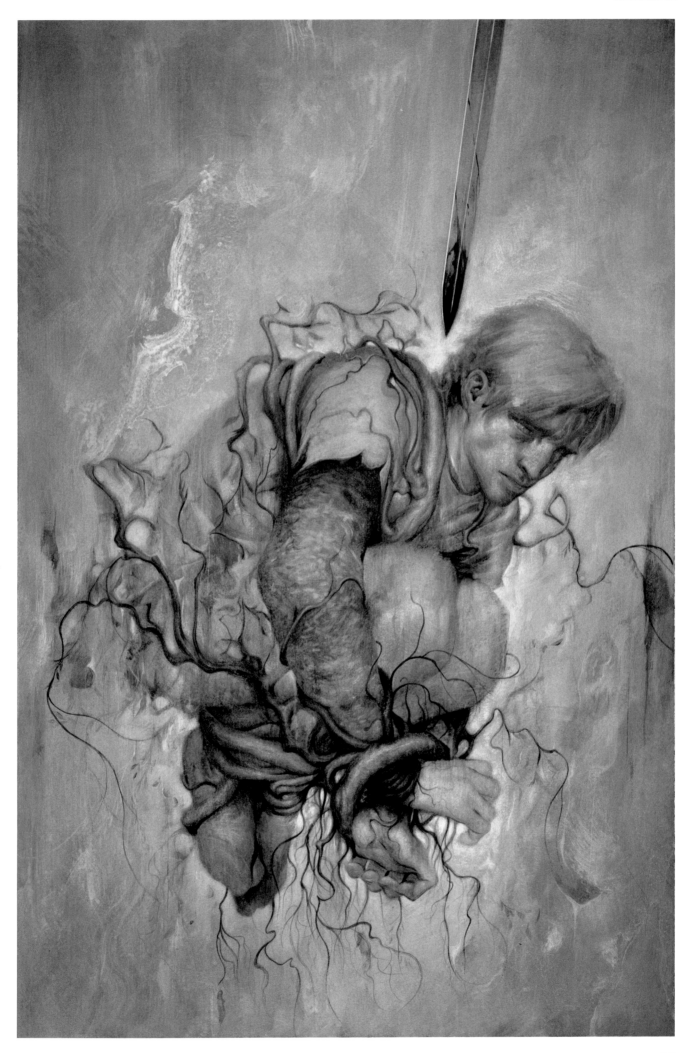

PRELIMINARY SKETCH, GRAPHITE ON BOND, 5.5 X 8.5"

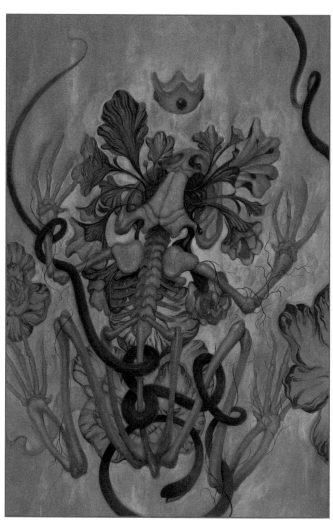

PAINTING, ACRYLIC ON RIVES BFK, 14 X 21"

No. 69	THE GOOD PRINCE	9/9

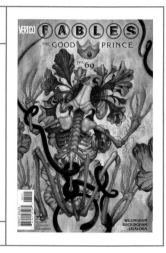

"**Fly:** This isn't an attack. It's a gift – a new beginning."

MEDIA: ACRYLIC, DIGITAL.

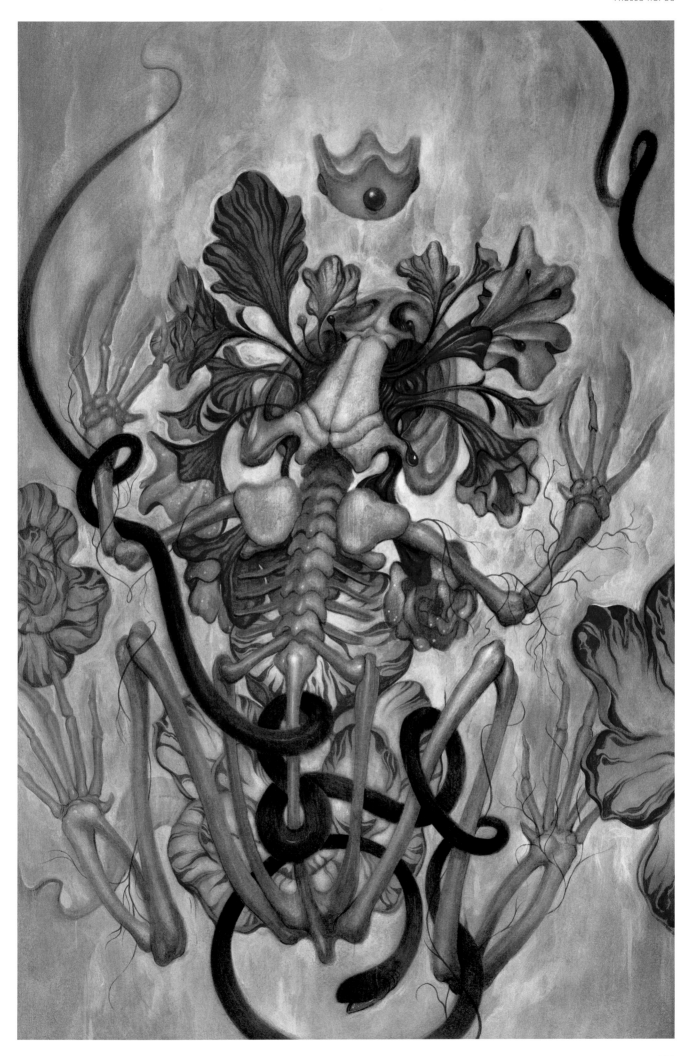

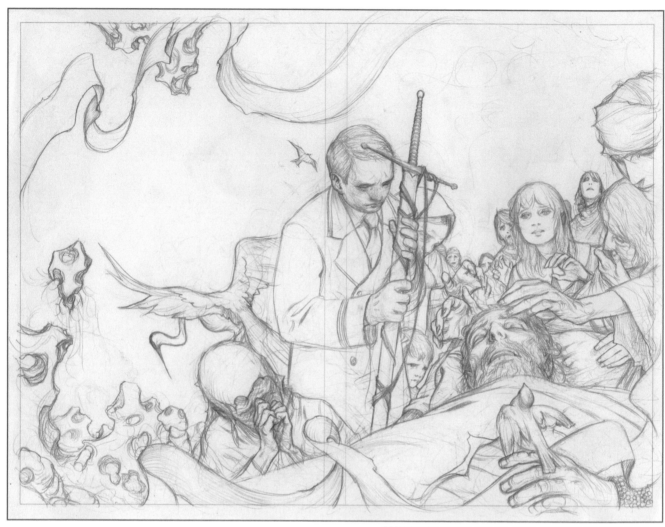

PRELIMINARY SKETCH/DIGITAL COMP, GRAPHITE ON BOND, 7.5 X 10"

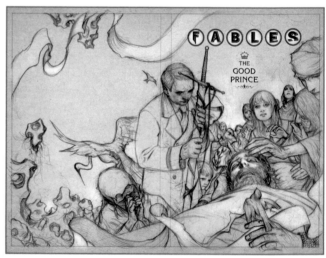

PRELIMINARY SKETCH, DIGITAL COMP, 7.5 X 10"

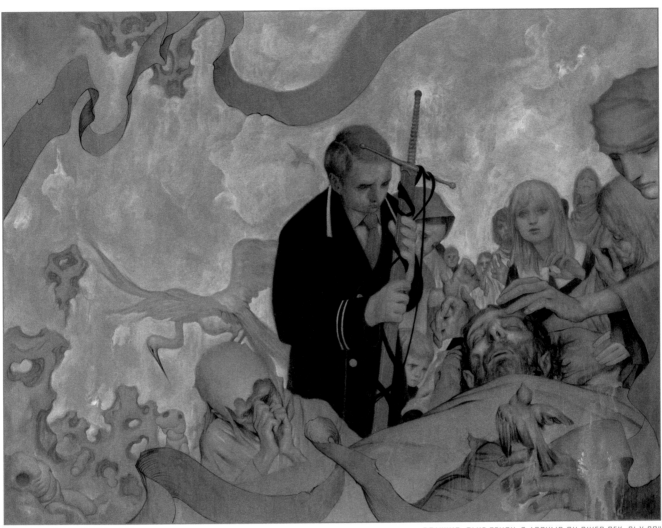

DRAWING, BLUE PENCIL & ACRYLIC ON RIVES BFK, 21 X 29"

TPB 10 | THE GOOD PRINCE

COLLECTED MATERIAL: ISSUES 60 - 69

MEDIA: BLUE PENCIL, ACRYLIC, DIGITAL COLOR.

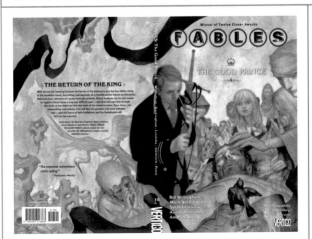

"JJ: The idea behind this composition was inspired by the Lamentation over the Dead Christ painted by Andrea Mantegna. Trusty John bears Excalibur like a cross, and the laying on of hands from Ambrose's retinue evokes a sense of spiritual healing, of togetherness through adversity."

TPB 10 | THE GOOD PRINCE

COLLECTED MATERIAL: ISSUES 60 - 69

MEDIA: BLUE PENCIL, ACRYLIC, DIGITAL COLOR.

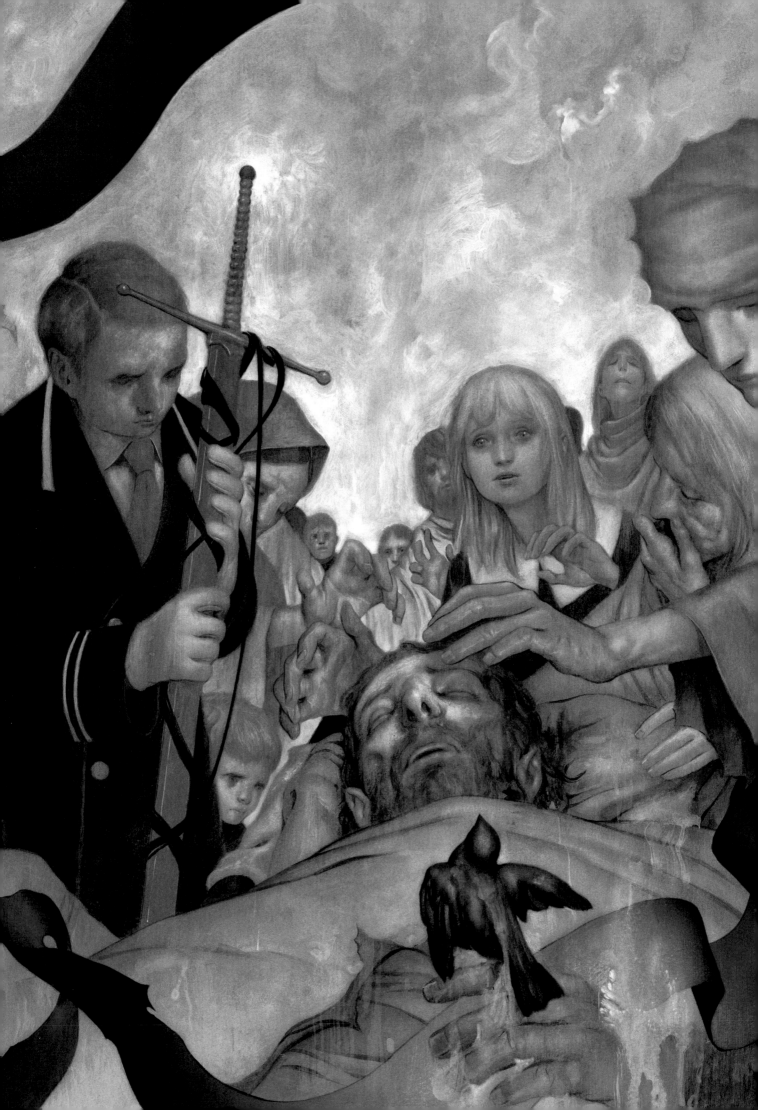

THUMBNAILS, GRAPHITE ON BOND, 1.5 X 2"

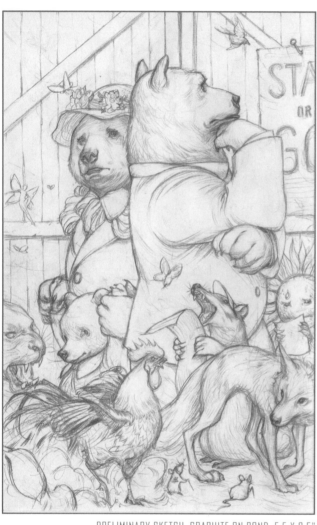

PRELIMINARY SKETCH, GRAPHITE ON BOND, 5.5 X 8.5"

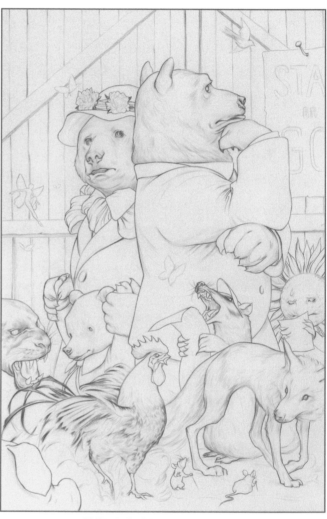

DRAWING, BLUE PENCIL & GRAPHITE ON RIVES BFK, 14 X 21"

No. 70 | KINGDOM COME | 1/1

"Panel Four
Same scene, but closer on Chicken Little.

Chicken Little: I'll bet they've run out of mundy chickens and pigs and cows –
Chicken Little: – and this meeting is to inform us that they've decided Fable chickens and pigs and cows are now approved food items for all these new human Fables!

Panel Five
Same scene, but now Mama Bear looks sarcastically at Chicken Little.

Mama Bear: It's good to start panicking early every day. Saves so much time."

MEDIA: GRAPHITE, BLUE PENCIL, DIGITAL.

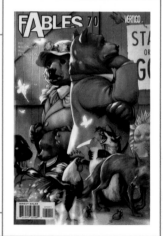

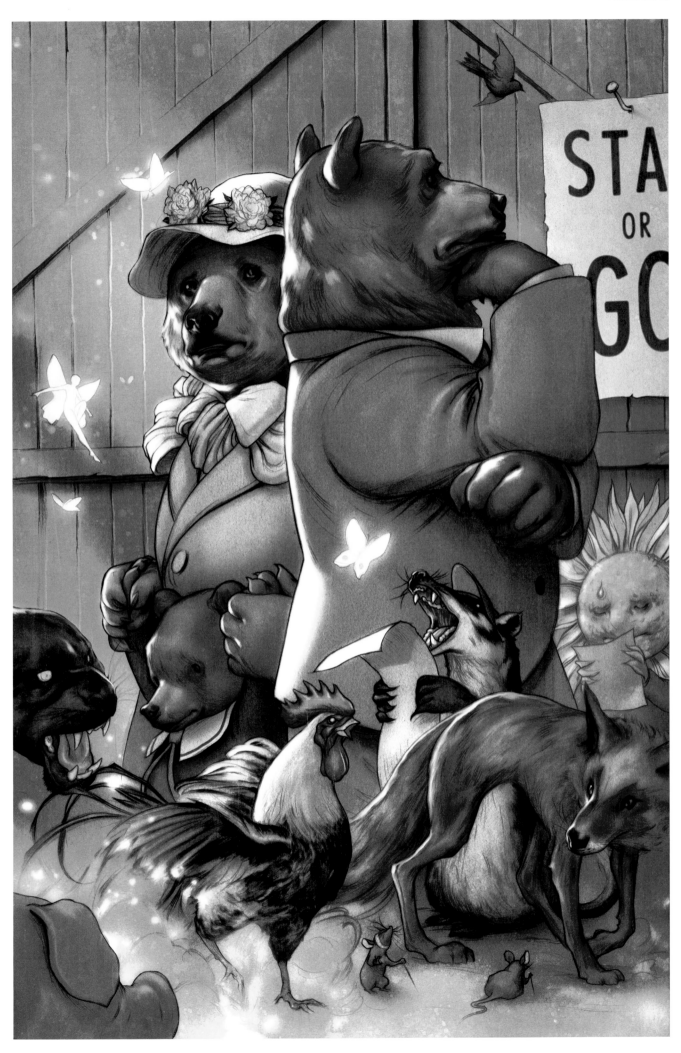

PRELIMINARY SKETCH, GRAPHITE ON BOND, 5.5 X 8.5"

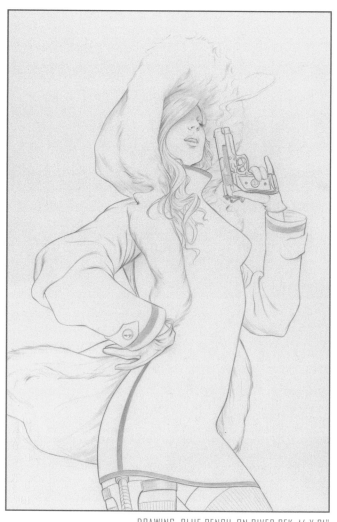

DRAWING, BLUE PENCIL ON RIVES BFK, 14 X 21"

 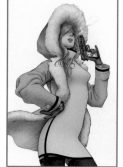

DIGITAL COLOR PROCESS

| No. 71 | SKULDUGGERY | 1/2 |

"**Cindy:** So it's to be a kidnapping, is it?

Orundellico: Of course. You are very lovely, Miss. I have clients who'll pay handsomely for a woman of your qualities."

MEDIA: BLUE PENCIL, DIGITAL.

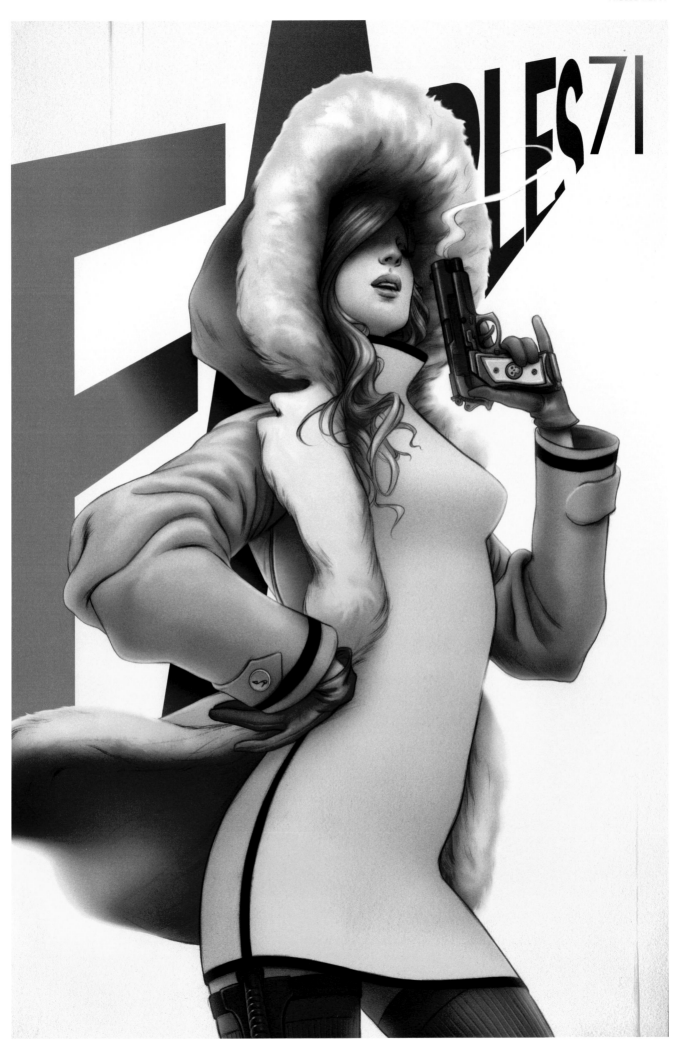

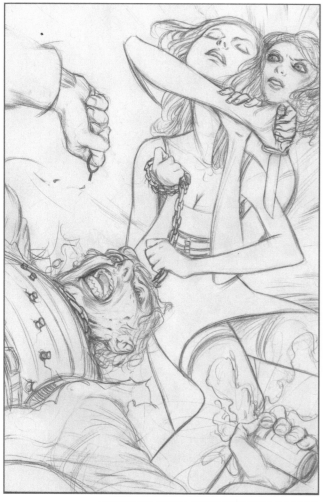

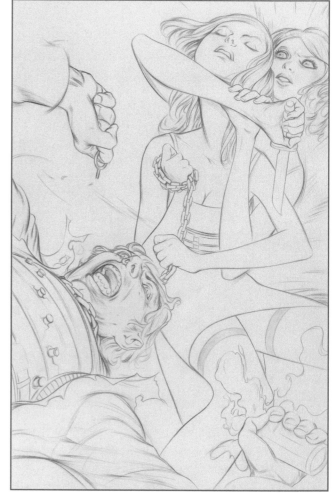

PRELIMINARY SKETCH, GRAPHITE ON BOND, 5.5 X 8.5"

DRAWING, BLUE PENCIL ON RIVES BFK, 14 X 21"

DIGITAL COLOR PROCESS

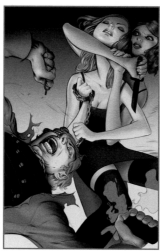

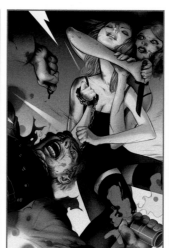

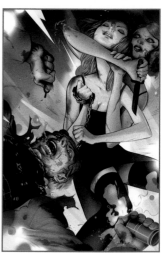

No. 72 SKULDUGGERY 2/2

"June: You gather the guns and knives and grenades, honey, while I call for Mrs. Higgenbottom to come over and baby-sit Junebug."

MEDIA: BLUE PENCIL, DIGITAL.

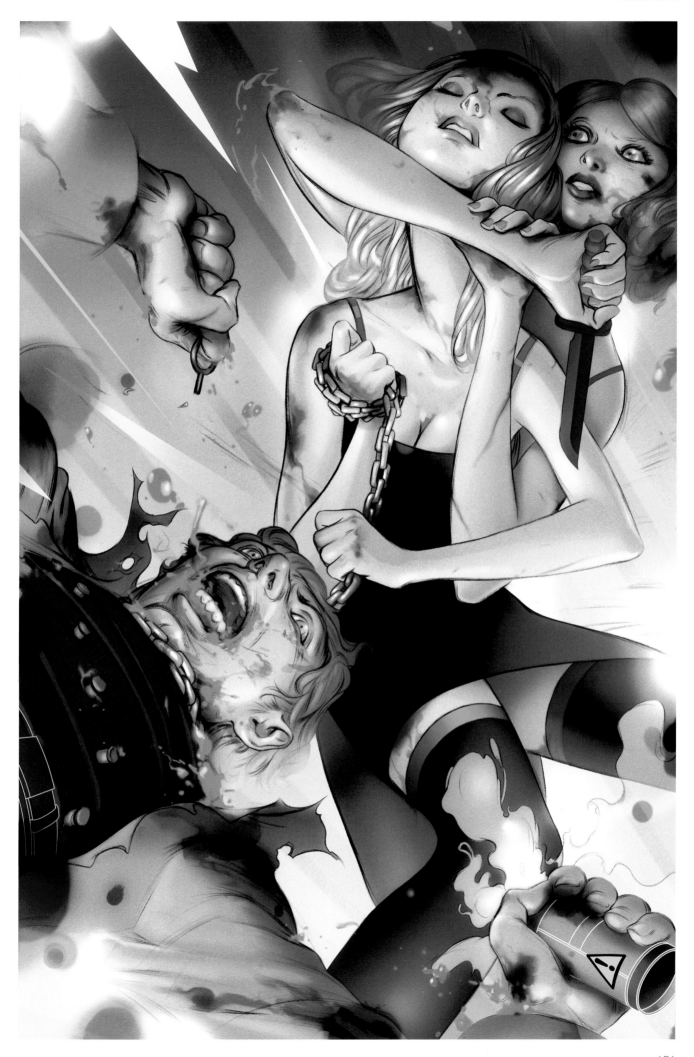

THUMBNAIL, GRAPHITE ON BOND, 1 X 2"

PRELIMINARY SKETCH, GRAPHITE ON BOND, 5.5 X 8.5"

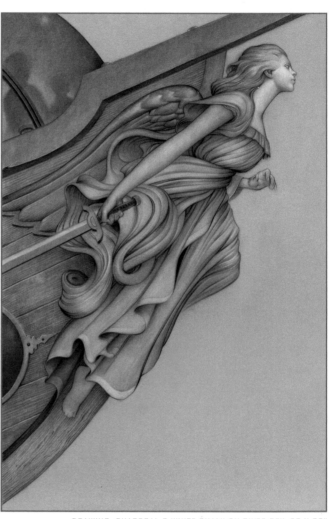

DRAWING, CHARCOAL & WHITE CHALK ON RIVES BFK, 20 X 30"

No. 73	WAR AND PIECES	1/3

"Cap (Blue): The ship is called Glory of Baghdad. It was constructed by the free Arabian Fables, with occasional advice and nudging from Fabletown.

. . .

Cap (Blue): It's basically a big wooden barrel kept aloft by the more than three hundred flying carpets pressed between the inner and outer hulls."

MEDIA: CHARCOAL, WHITE CHALK, DIGITAL.

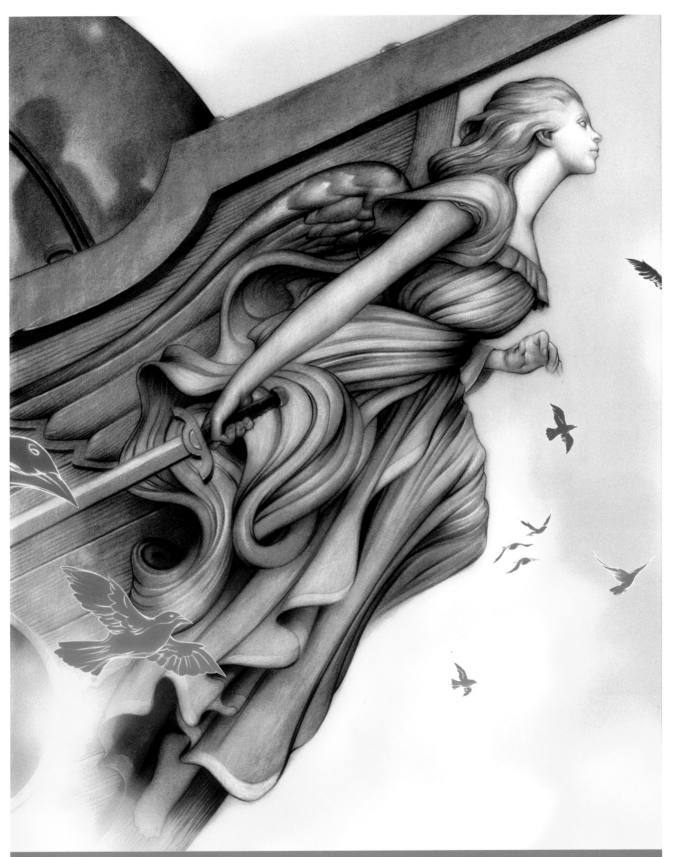

FABLES

NO.73

WILLINGHAM BUCKINGHAM LEIALOHA

WAR & PIECES

PART ONE OF THREE

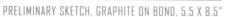
PRELIMINARY SKETCH, GRAPHITE ON BOND, 5.5 X 8.5"

DRAWING, CHARCOAL & WHITE CHALK ON RIVES BFK, 20 X 30"

No. 74 | WAR AND PIECES | 2/3

"**Cap (Blue):** One tiny drop of Briar Rose's blood was all it took.

Panel Two

Same scene. The city goes to sleep.

. . .

Cap (Blue): The enchantment designed to ruin her life became, under the command of some truly devious minds, a terrific weapon of very potent spellcraft."

MEDIA: CHARCOAL, WHITE CHALK, DIGITAL.

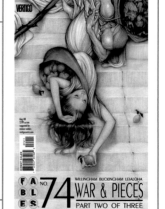

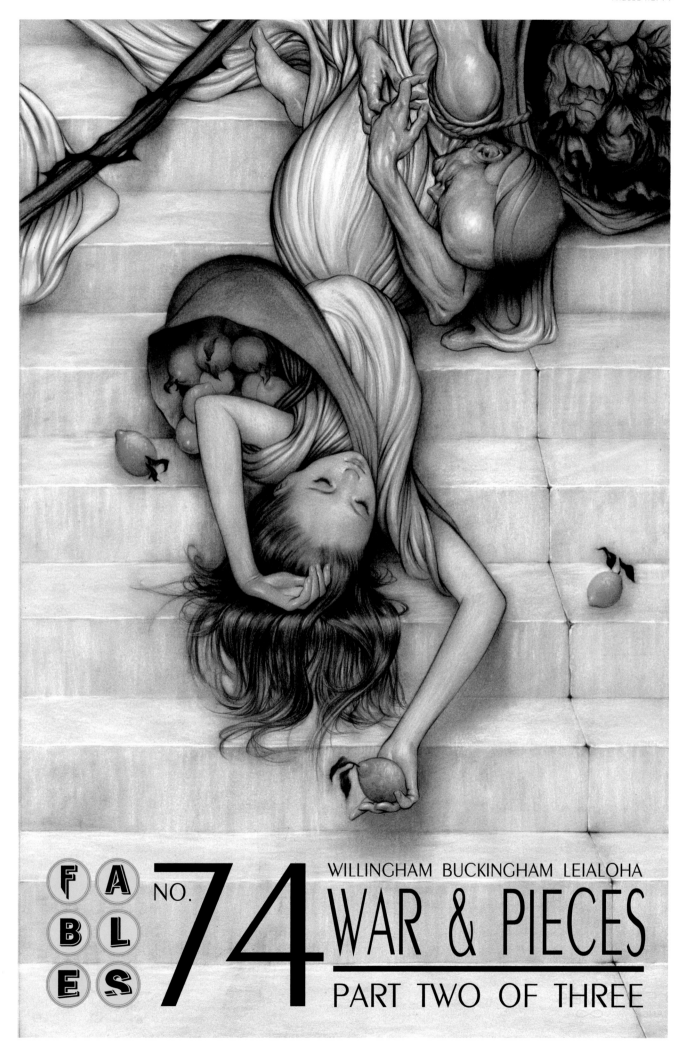

PRELIMINARY SKETCH, GRAPHITE ON BOND, 5.5 X 8.5"

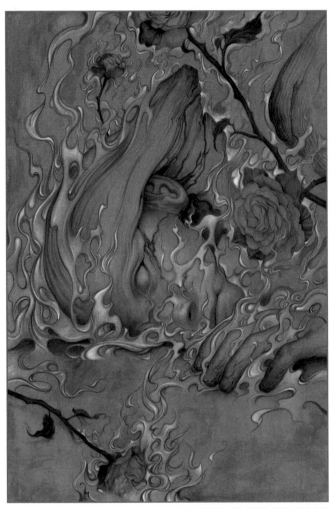

PAINTING, ACRYLIC & COLORED PENCIL ON RIVES BFK, 20 X 30"

No. 75	WAR AND PIECES	3/3

"The ship dies in flames. Many escape on flying carpets but not nearly enough."

MEDIA: GRAPHITE, ACRYLIC, COLORED PENCIL, DIGITAL.

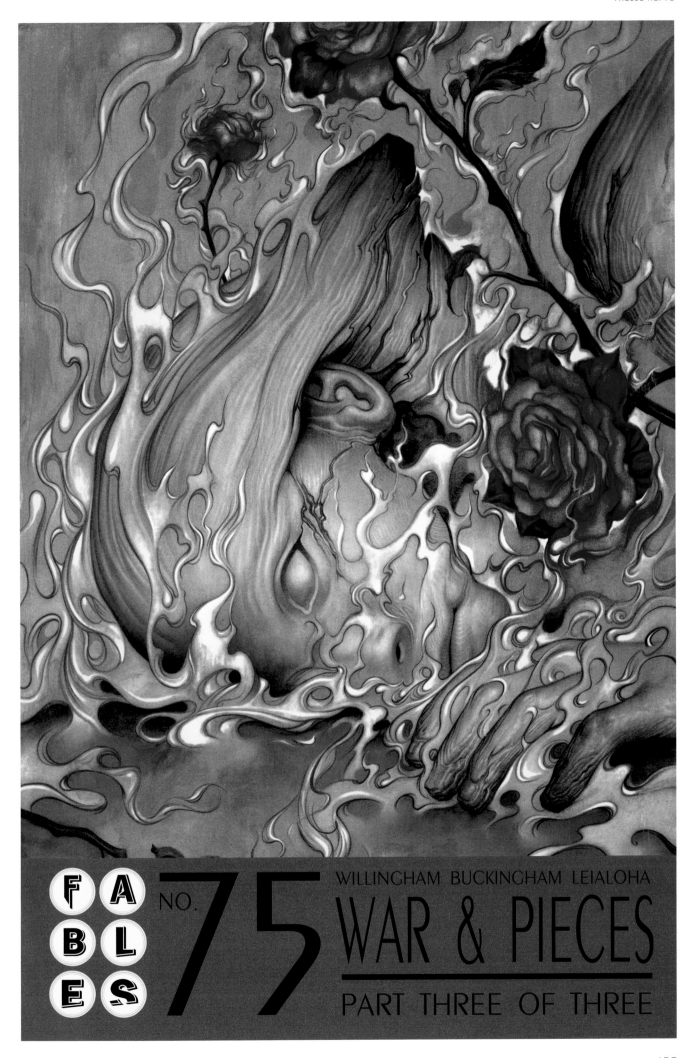

FABLES

NO. 75

WILLINGHAM BUCKINGHAM LEIALOHA

WAR & PIECES

PART THREE OF THREE

PRELIMINARY SKETCH, GRAPHITE ON BOND, 5.5 X 8.5"

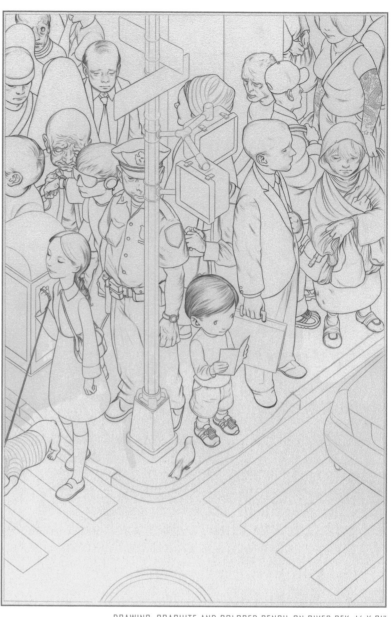

DRAWING, GRAPHITE AND COLORED PENCIL ON RIVES BFK, 14 X 21"

No. 76	AROUND THE TOWN	1/1

"**Geppetto:** Who else has ever accomplished so much? When again will so many enjoy such widespread safety for so long?

Mrs. Cornhusk: You're a monster! A bloody-handed monster!

Geppetto: Of course."

MEDIA: GRAPHITE, COLORED PENCIL, DIGITAL.

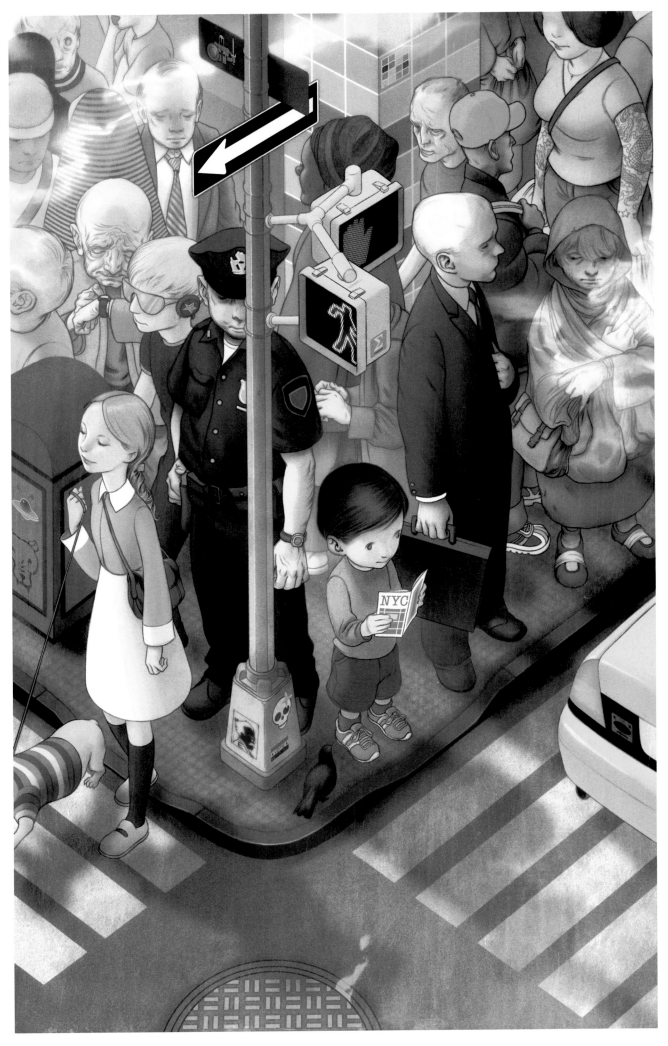

BUTTERFLY SKETCH,
GRAPHITE ON BOND, 7 X 4.5"

THUMBNAIL SKETCH, GRAPHITE ON BOND, 2.5 X 3.5"

PRELIMINARY SKETCH, GRAPHITE ON BOND, 5.5 X 8.5"

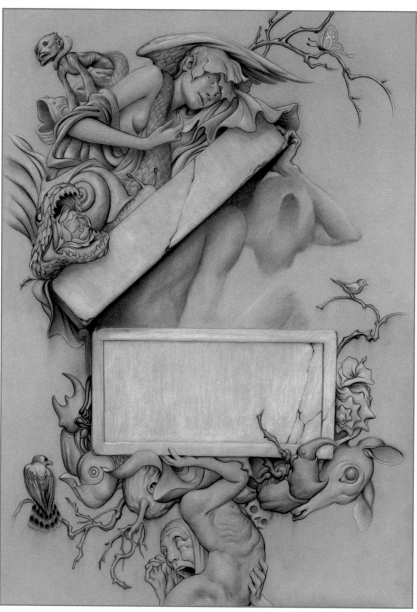
DRAWING, CHARCOAL AND CHALK ON RIVES BFK, 21 X 30"

No. 77	THE DARK AGES	1/5

"**Flycatcher:** Why does Blue have to keep going back, over and over, from one minor scratch?"

MEDIA: CHARCOAL, CHALK, GRAPHITE, DIGITAL.

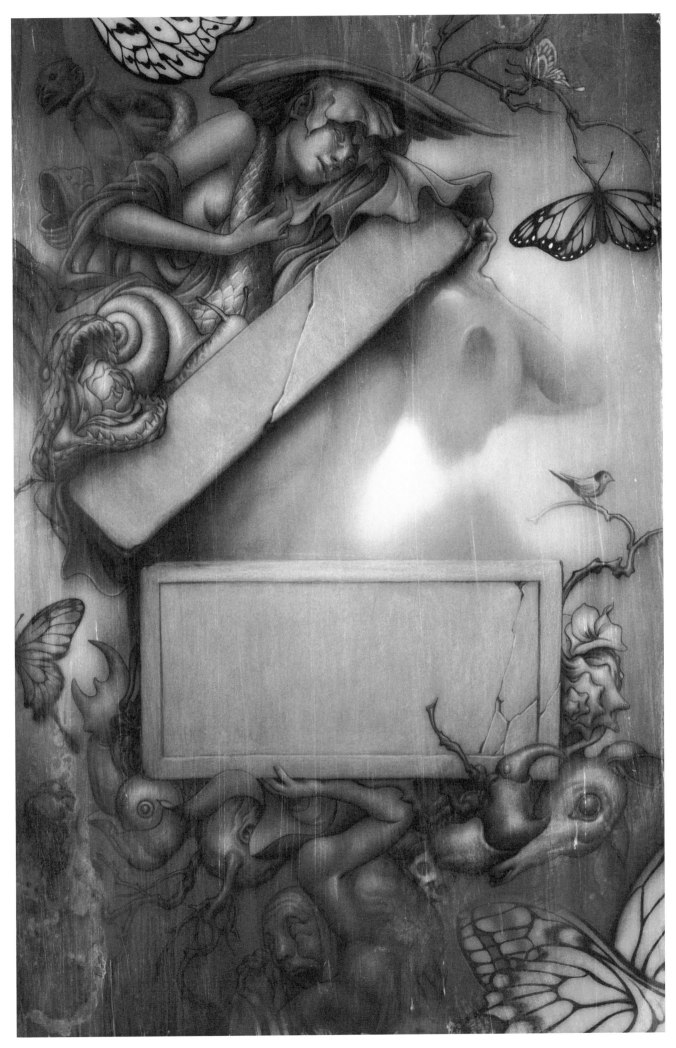

PRELIMINARY SKETCH,
GRAPHITE ON BOND, 5.5 X 8.5"

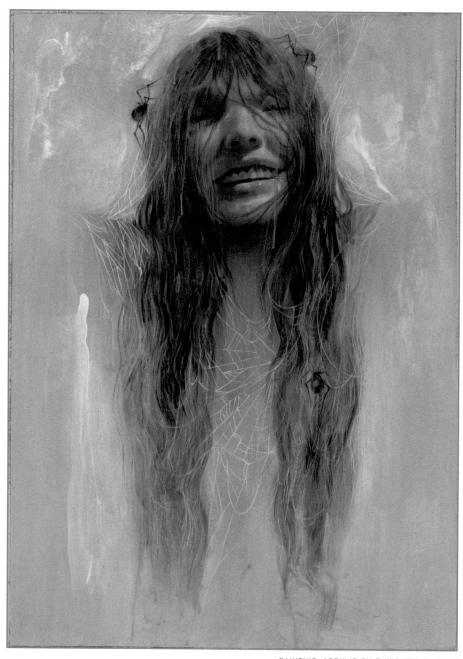

PAINTING, ACRYLIC ON RIVES BFK, 21 X 30"

| No. 78 | THE DARK AGES | 2/5 |

"**Mister Dark:** So, nimble Mister Mouse and stalwart Mister Freddy came in search of treasure and spoils.

Mister Dark: But what did they find?

Mister Dark: Well, I'm valuable enough, though it remains to be seen if you'll consider me much of a treasure."

MEDIA: ACRYLIC, DIGITAL.

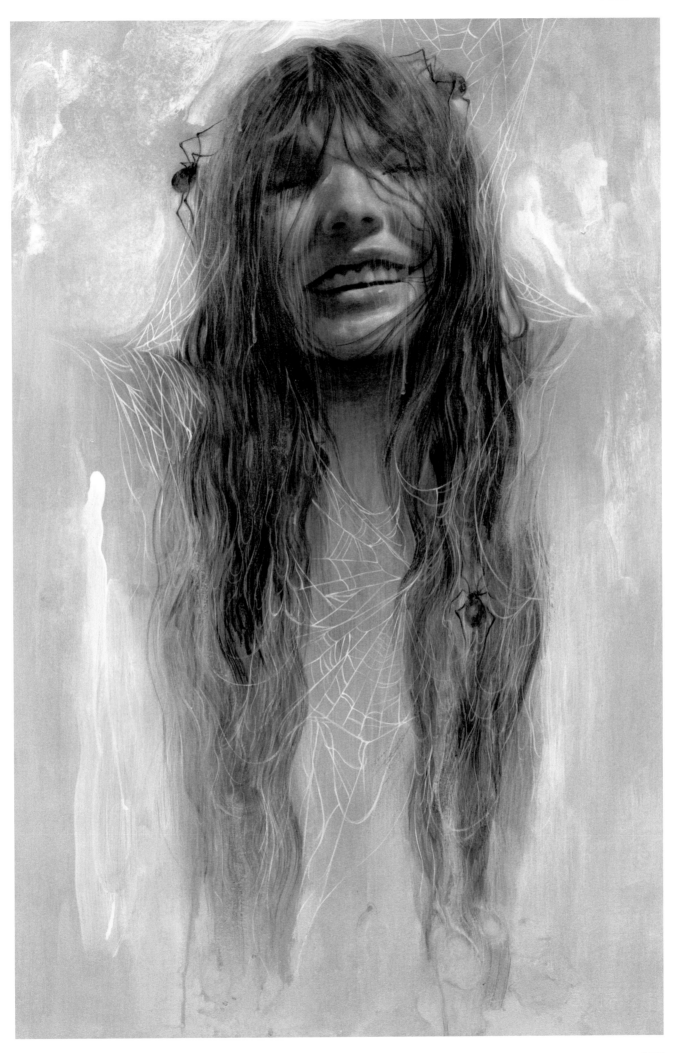

THUMBNAIL SKETCH, GRAPHITE ON BOND, 1.5 X 2.5"

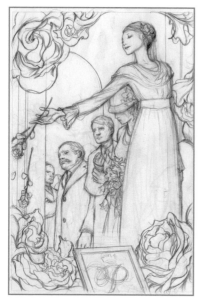

PRELIMINARY SKETCH, GRAPHITE ON BOND, 5.5 X 8.5"

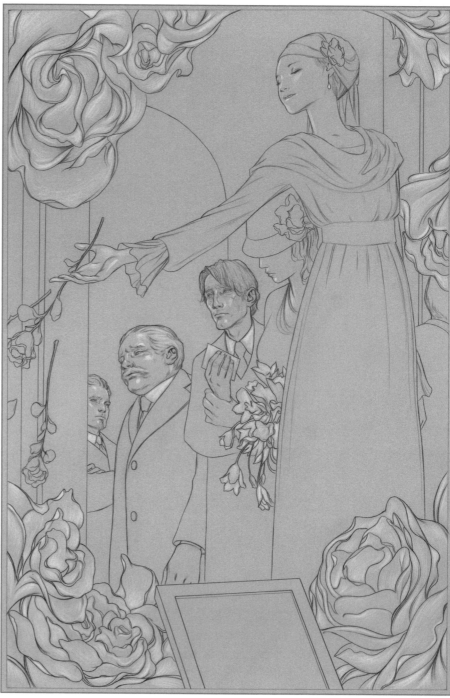

DRAWING, GRAPHITE AND CHALK ON RIVES BFK, 14 X 21"

No. 79 | THE DARK AGES | 3/5

"Snow White: He was here when we needed him, in our most uncertain hour, and gave the last full measure of himself for each of us.

Snow White: Ultimately, what greater thing could be said of any man, living or dead?"

MEDIA: GRAPHITE, CHALK, DIGITAL.

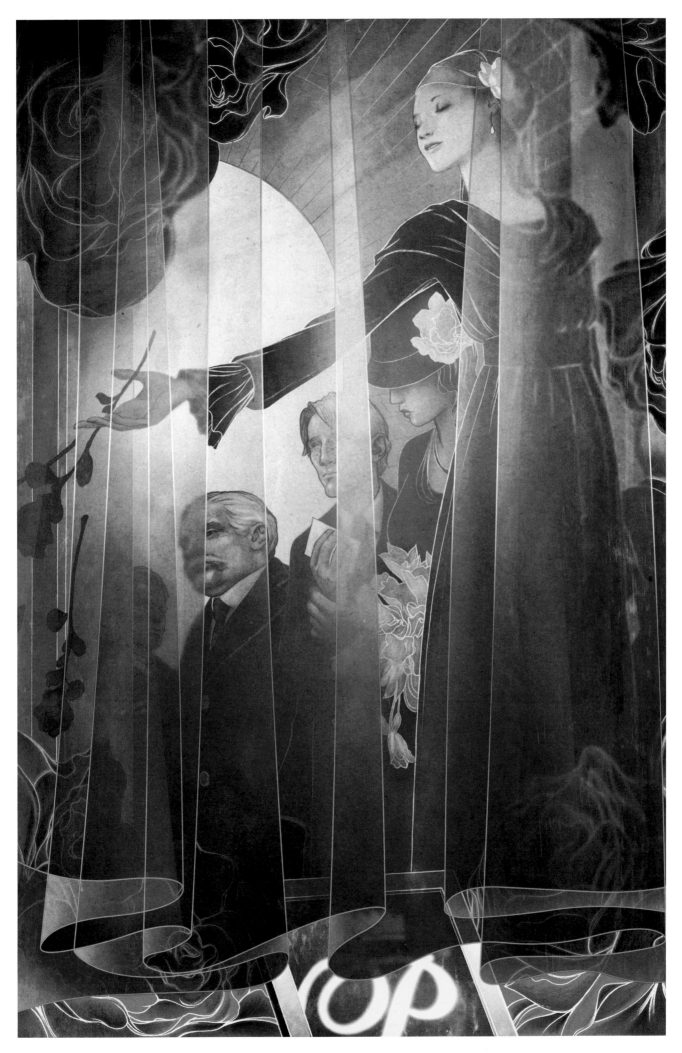

THUMBNAIL SKETCH, GRAPHITE ON BOND, 1.5 X 2.5" PRELIMINARY SKETCH, GRAPHITE ON BOND, 5.5 X 8.5"

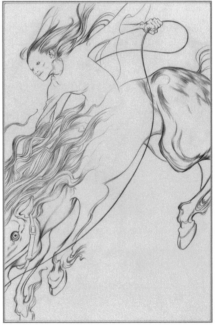

DRAWING, GRAPHITE ON RIVES BFK, 14 X 21" DRAWING, GRAPHITE ON RIVES BFK, 14 X 21"

No. 80	THE DARK AGES	4/5

"Frau Totenkinder: This isn't as bad as it's going to get, Mr. Mayor. Whatever caused this is on its way here now. I can feel him coming closer with every heartbeat.

Mayor Cole: Who is it? Who could've done this to us?

Frau Totenkinder: I don't know.

Frau Totenkinder: I can't get much of a sense of him, except that he's a destroyer, he's more powerful than we can handle. And he's on his way."

MEDIA: GRAPHITE, WATERCOLOR, DIGITAL.

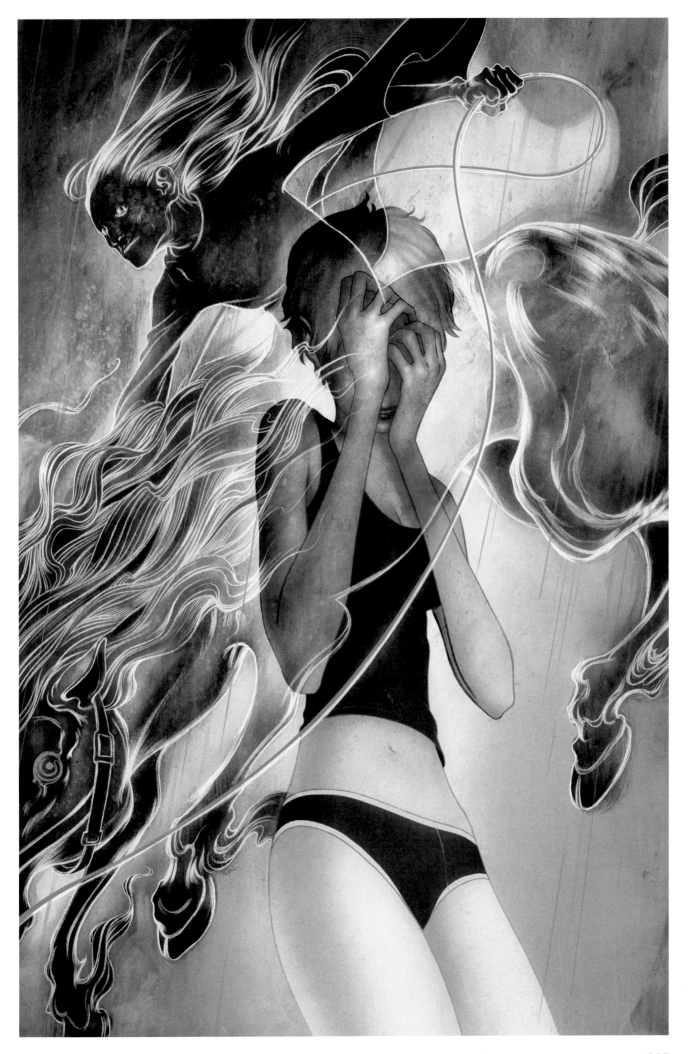

THUMBNAIL SKETCH,
GRAPHITE, 1.5 X 2"

THUMBNAIL SKETCH, GRAPHITE, 7 X 10.5"

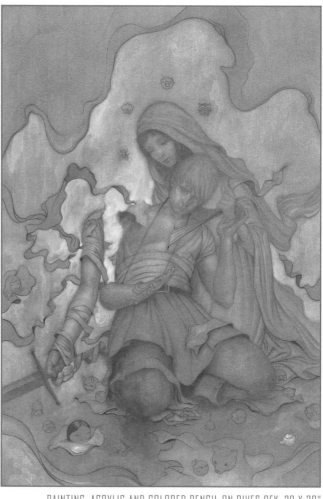

FLOWER SKETCH, GRAPHITE & INKJET, 7 X 10.5"

PAINTING, ACRYLIC AND COLORED PENCIL ON RIVES BFK, 20 X 30"

No. 81	THE DARK AGES	5/5

"**Boy Blue:** When I showed up here again, bravely dying, Sinbad didn't stand a chance. I was once again the most interesting man in the room.

Boy Blue: In any room.

Boy Blue: How could you resist? And this time it's better than ever, since I'll be dead long before the excitement is in any danger of fading.

Boy Blue: This time I'm your perfect man."

MEDIA: ACRYLIC, COLORED PENCIL, GRAPHITE, DIGITAL.

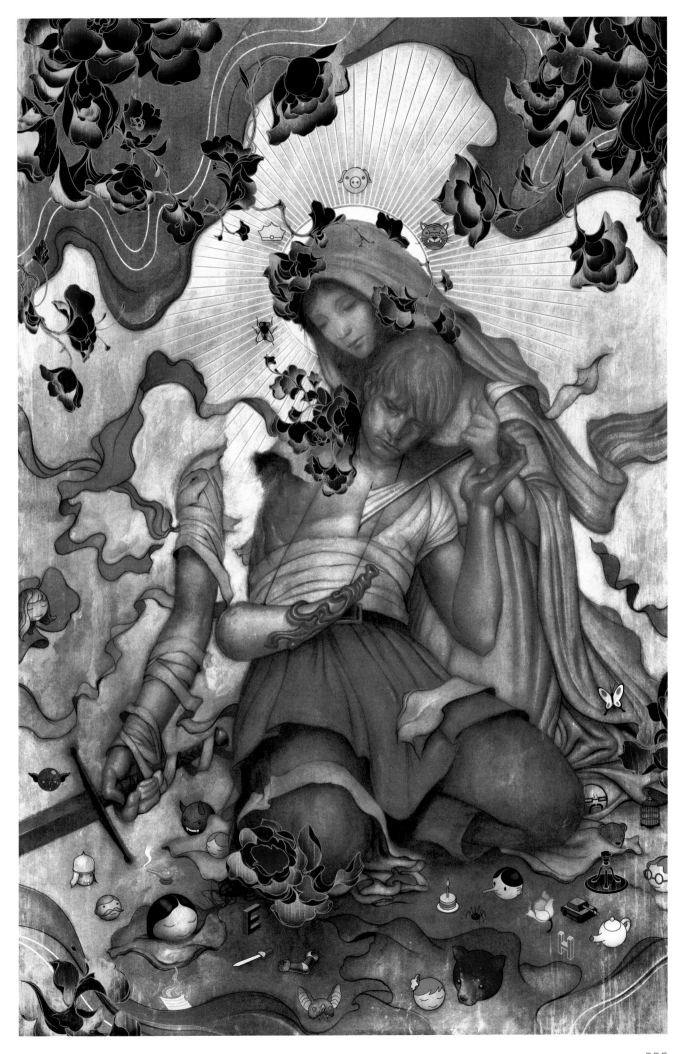

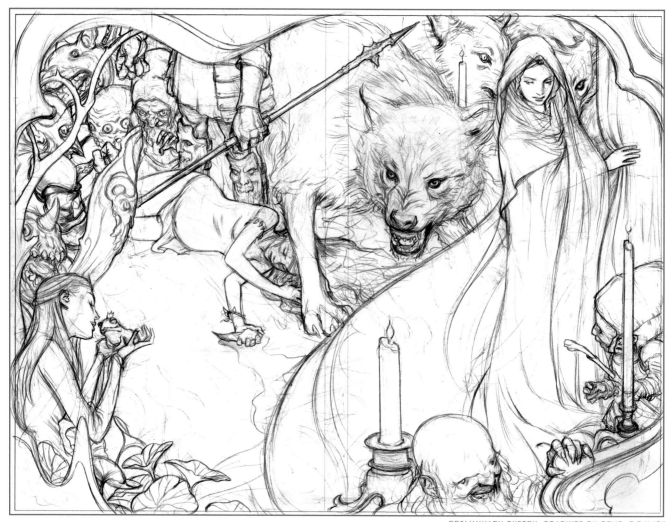

PRELIMINARY SKETCH, GRAPHITE ON BOND, 7.5 X 10"

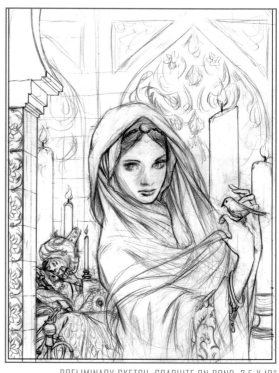

PRELIMINARY SKETCH, GRAPHITE ON BOND, 7.5 X 10"

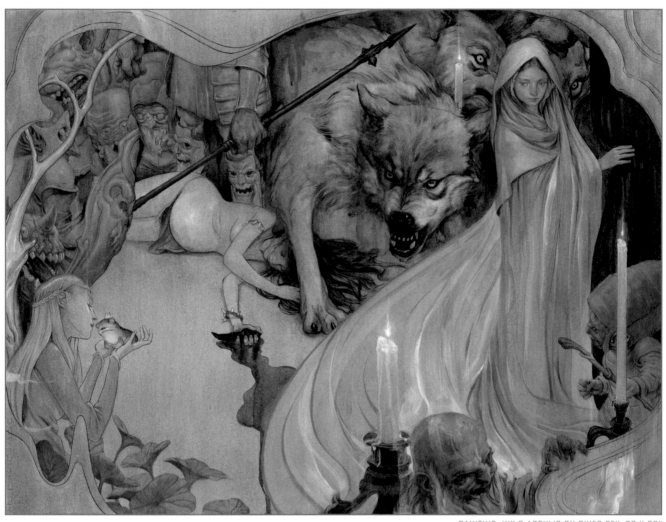

PAINTING, INK & ACRYLIC ON RIVES BFK, 20 X 30"

OGN	1001 NIGHTS OF SNOWFALL	
FABLES ORIGINAL GRAPHIC NOVEL		

MEDIA: INK, ACRYLIC, DIGITAL COLOR.

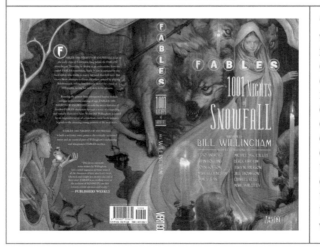

"JJ: A good fairy tale is a well of danger and depravity, of cooked human flesh, crooked deals, and abandoned children. A sense of foreboding is created by carefully composing the characters on a metaphorical stage, the choreography of gazes punctuated by the triangular configuration of candles. Snow White draws the curtain aside to reveal the strange and dark tales within."

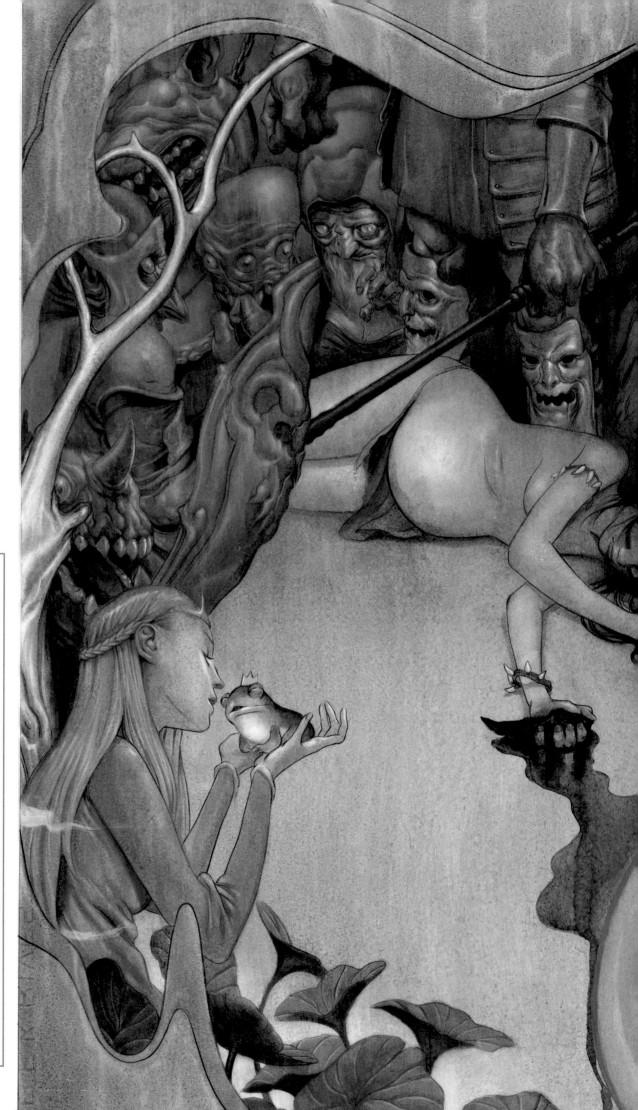

OGN | 1001 NIGHTS OF SNOWFALL

FABLES ORIGINAL GRAPHIC NOVEL

MEDIA: INK, ACRYLIC, DIGITAL COLOR.

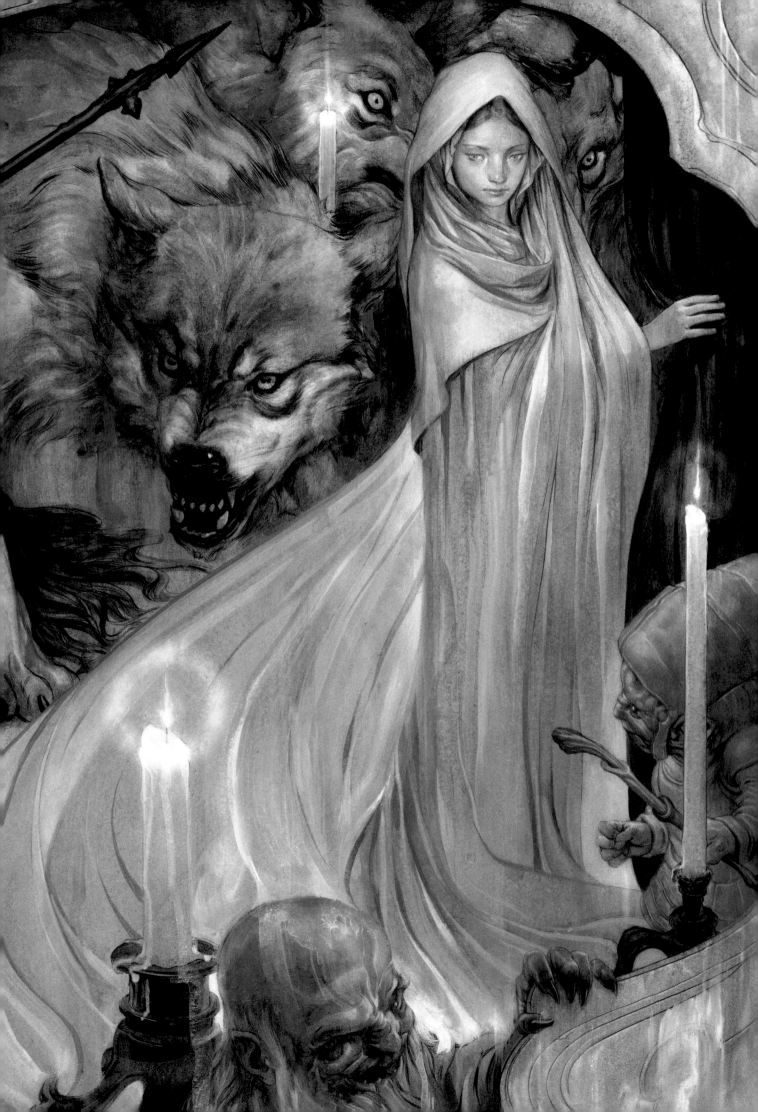

THUMBNAIL SKETCHES, GRAPHITE ON BOND, 2.5 X 3.5" PRELIMINARY SKETCHES, GRAPHITE ON BOND, 11 X 8.5"

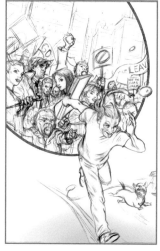
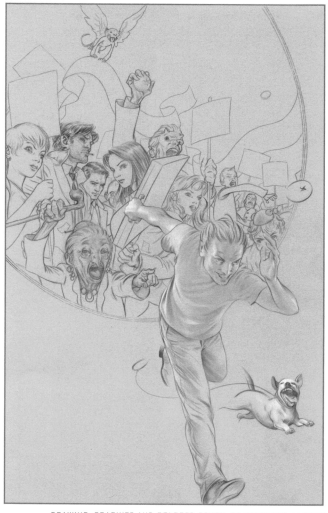

PRELIMINARY SKETCHES,
GRAPHITE, 5.5 X 8.5"

PRELIMINARY SKETCHES,
GRAPHITE & DIGITAL, 6 X 9"

DRAWING, GRAPHITE AND COLORED PENCIL ON RIVES BFK, 14 X 21"

| JACK OF FABLES No. 1 | THE LONG HARD FALL OF HOLLYWOOD JACK | 1 / 1 |

"**Jack:** Well, guess what, boys and girls? We really exist, we're immortal and we've been secretly living among you for centuries.

Jack: And yes, we're better than you.

Jack: So one of you insignificant mundys show me a little respect and pull over!"

MEDIA: GRAPHITE, COLORED PENCIL, WATERCOLOR, PIGMENT INK, DIGITAL.

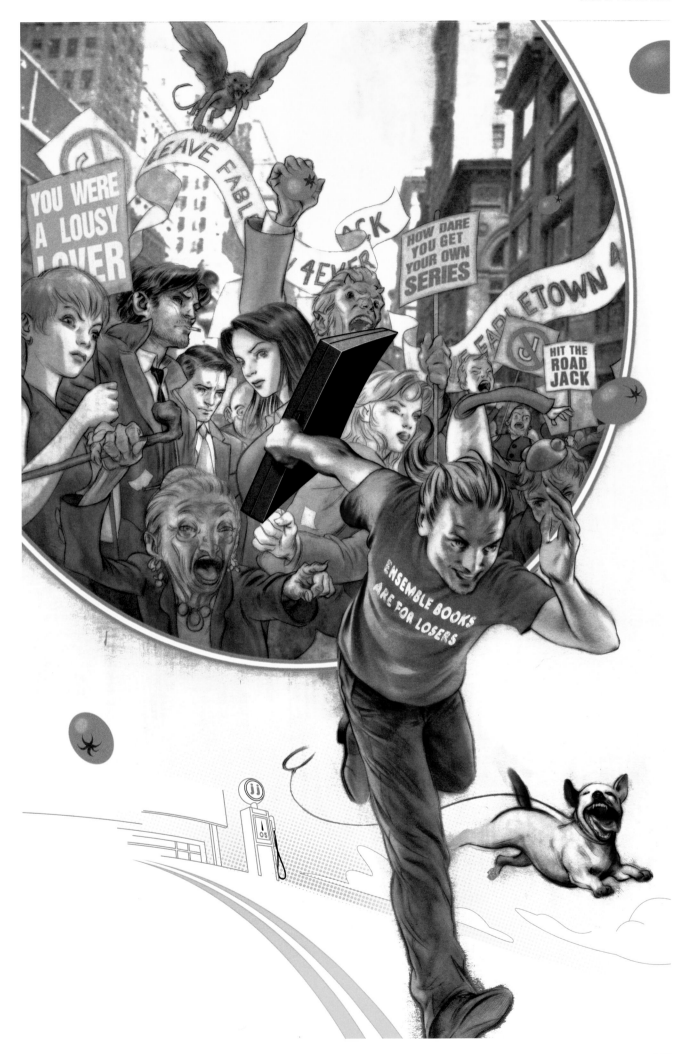

PRELIMINARY SKETCH,
GRAPHITE, 5.5 X 8.5"

PRELIMINARY SKETCH,
GRAPHITE & DIGITAL, 5.5 X 8.5"

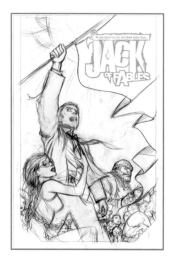

PRELIMINARY SKETCHES, GRAPHITE & INKJET, 5.5 X 8.5"

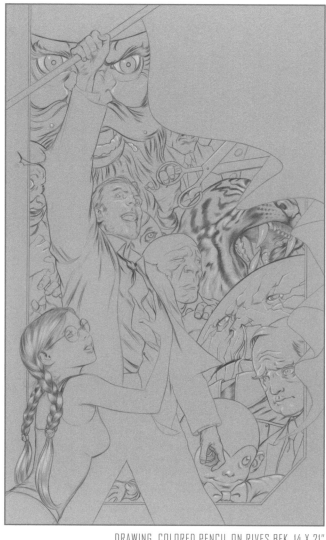

DRAWING, COLORED PENCIL ON RIVES BFK, 14 X 21"

JACK OF FABLES No. 2	JACK IN THE BOX	1/1

"**Goldilocks:** Remember, Jack, I am the unsilenced voice of the oppressed masses, and we have power you can't imagine!

Jack: Okey doke. Sorry you couldn't stay."

MEDIA: COLORED PENCIL, ACRYLIC, PIGMENT INK, DIGITAL.

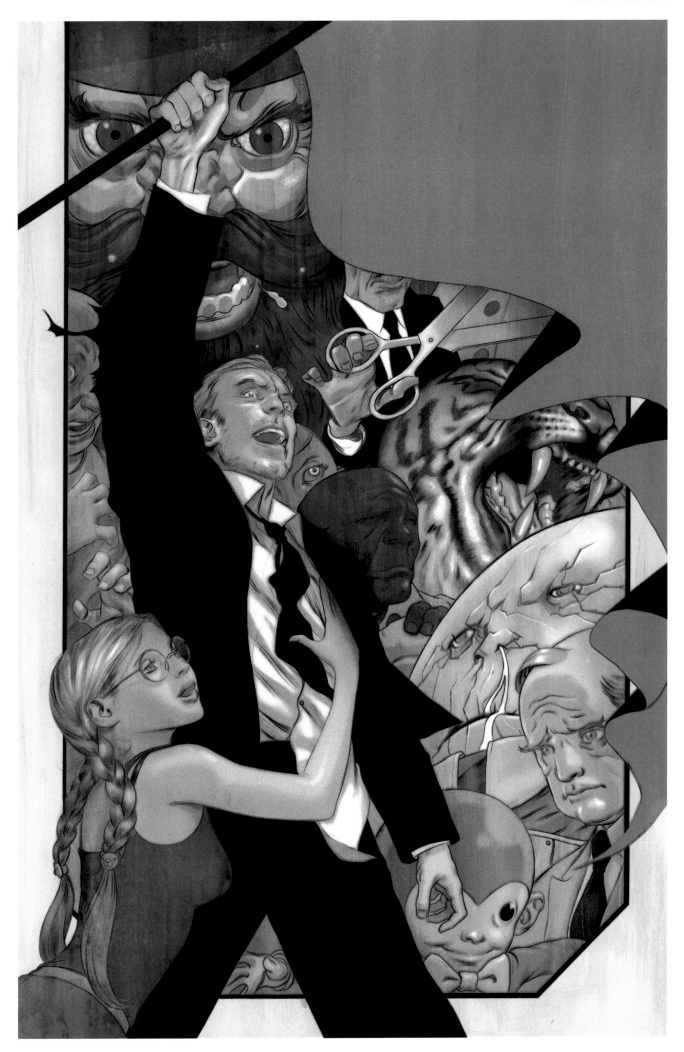

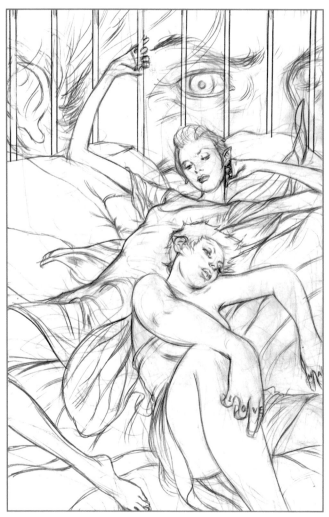

PRELIMINARY SKETCH, GRAPHITE ON BOND, 5.5 X 8.5"

DRAWING, GRAPHITE AND ACRYLIC ON RIVES BFK, 14 X 21"

| JACK OF FABLES No. 3 | YOU DON'T KNOW JACK | 1 / 1 |

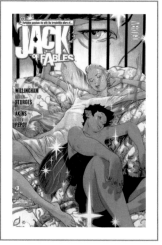

"Jack: What is it about fables that we can't ever give straight, simple answers to straight, simple questions?

Jack: Ask a fable a question and you get a spooky story."

MEDIA: GRAPHITE, ACRYLIC, INK, WATERCOLOR, PIGMENT INK, DIGITAL.

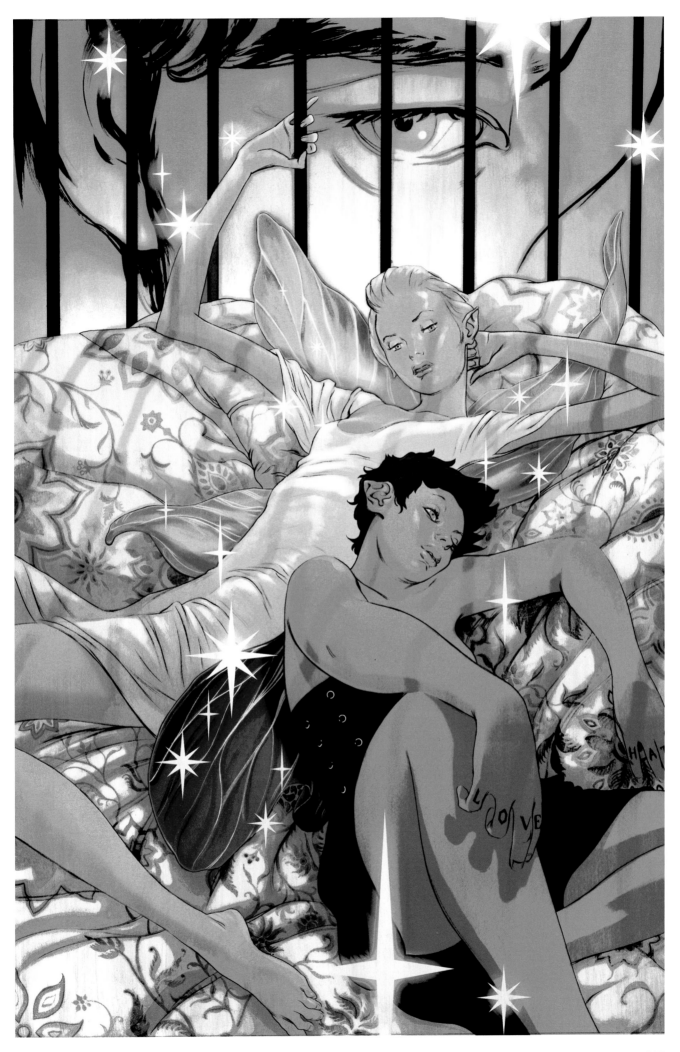

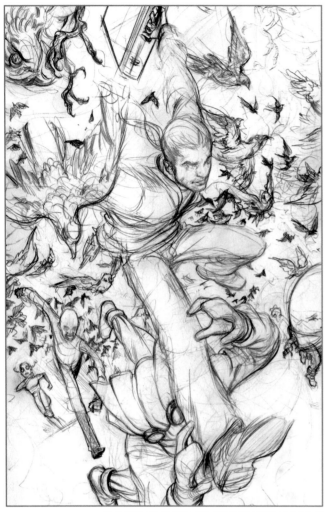

PRELIMINARY SKETCH, GRAPHITE ON BOND, 5.5 X 8.5"

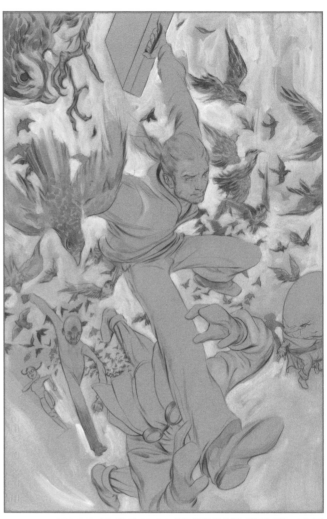

DRAWING, COLORED PENCIL AND ACRYLIC ON RIVES BFK, 14 X 21"

JACK OF FABLES No. 4	JACKRABBIT	1/1

"**Faery:** Then what happens?

Jack: Then, with any luck...

Jack: ...things get hectic."

MEDIA: COLORED PENCIL, ACRYLIC, WATERCOLOR, PIGMENT INK, DIGITAL.

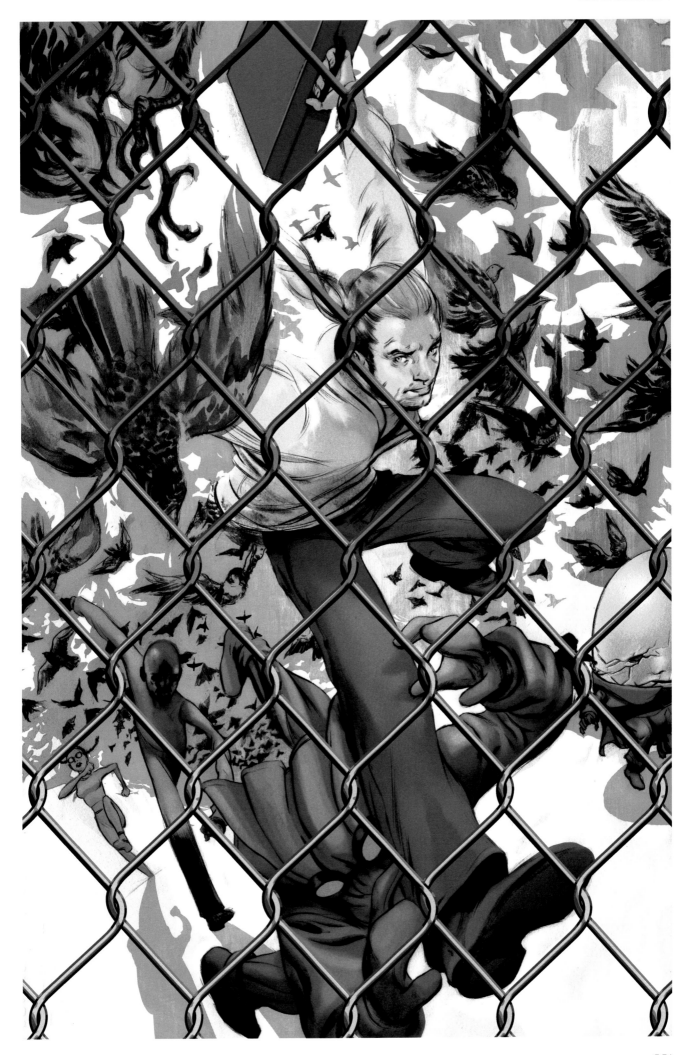

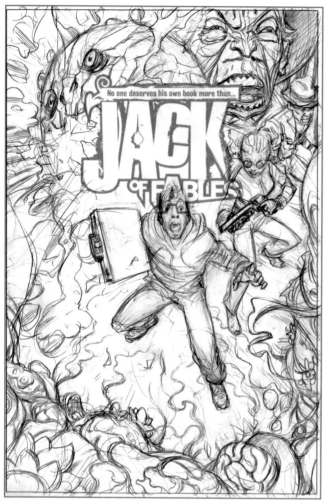

PRELIMINARY SKETCH, GRAPHITE ON BOND, 5.5 X 8.5"

DRAWING, COLORED PENCIL ON RIVES BFK, 14 X 21"

JACK OF FABLES No. 5	JACK, OFF	1 / 1

"Jack: Breathing's hard, raspy and it hurts. I can't see very well yet.

Jack: But the blurry blob in front of me looks like it may be the bad guy."

MEDIA: COLORED PENCIL, ACRYLIC, PIGMENT INK, DIGITAL.

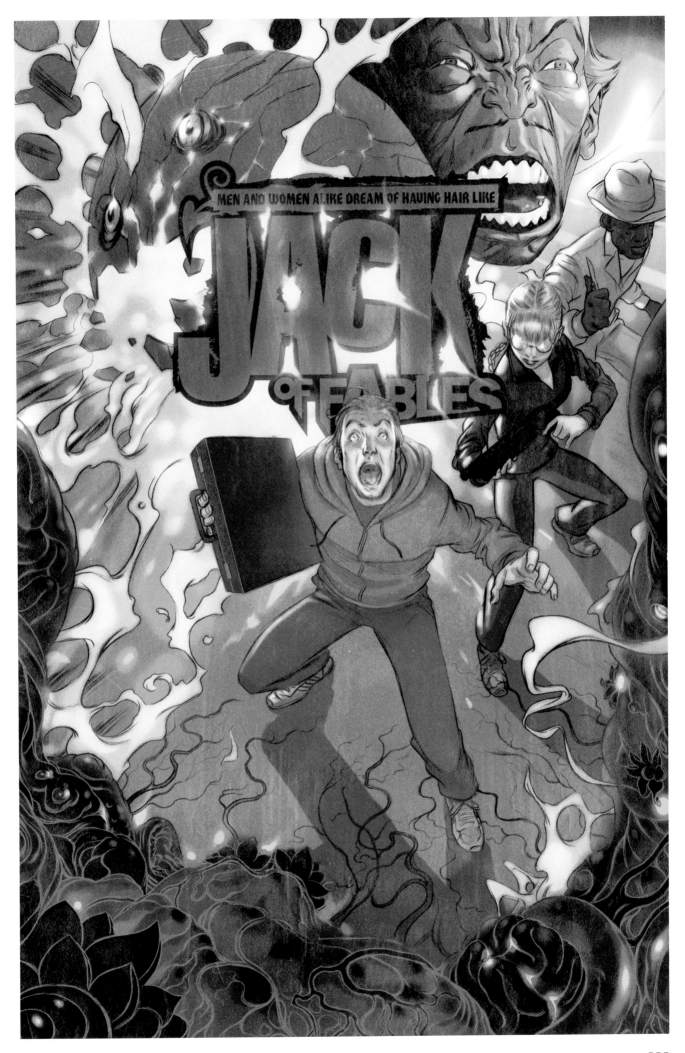

PRELIMINARY SKETCH, GRAPHITE ON BOND, 10.5 X 8"

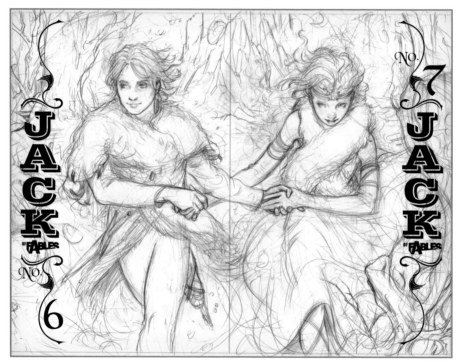

PRELIMINARY SKETCH, GRAPHITE AND DIGITAL, 10.5 X 8"

| JACK OF FABLES No. 6 | JACK FROST | 1/2 |

"**Jack:** And that, dear shivering comrades, is how I became Jack Frost, bringer of winter."

MEDIA: ACRYLIC, DIGITAL.

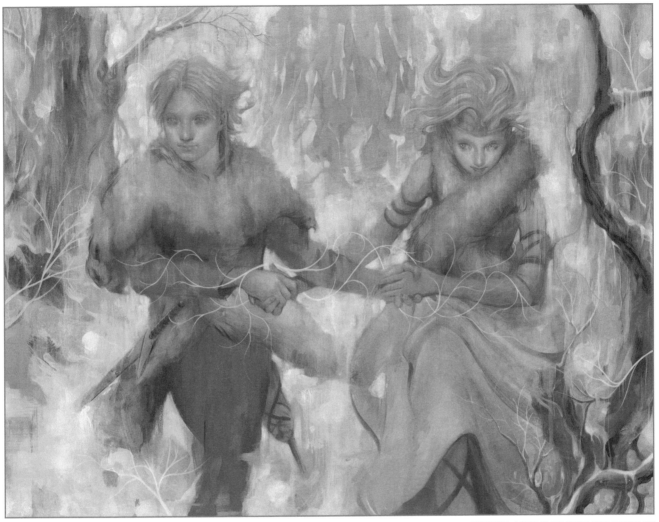

PAINTING, ACRYLIC ON RIVES BFK, 27.5 X 21"

JACK OF FABLES No. 11	JACK FROST	2/2

"Jack: And what do the gods do? Or, more important, what should they do? The answer, of course, was obvious: anything they like, for being gods, they set the template for right and wrong.

Jack: Anything they choose to do is, by definition, good and holy and proper.

Jack: At least that was my reasoning at the time."

MEDIA: ACRYLIC, DIGITAL.

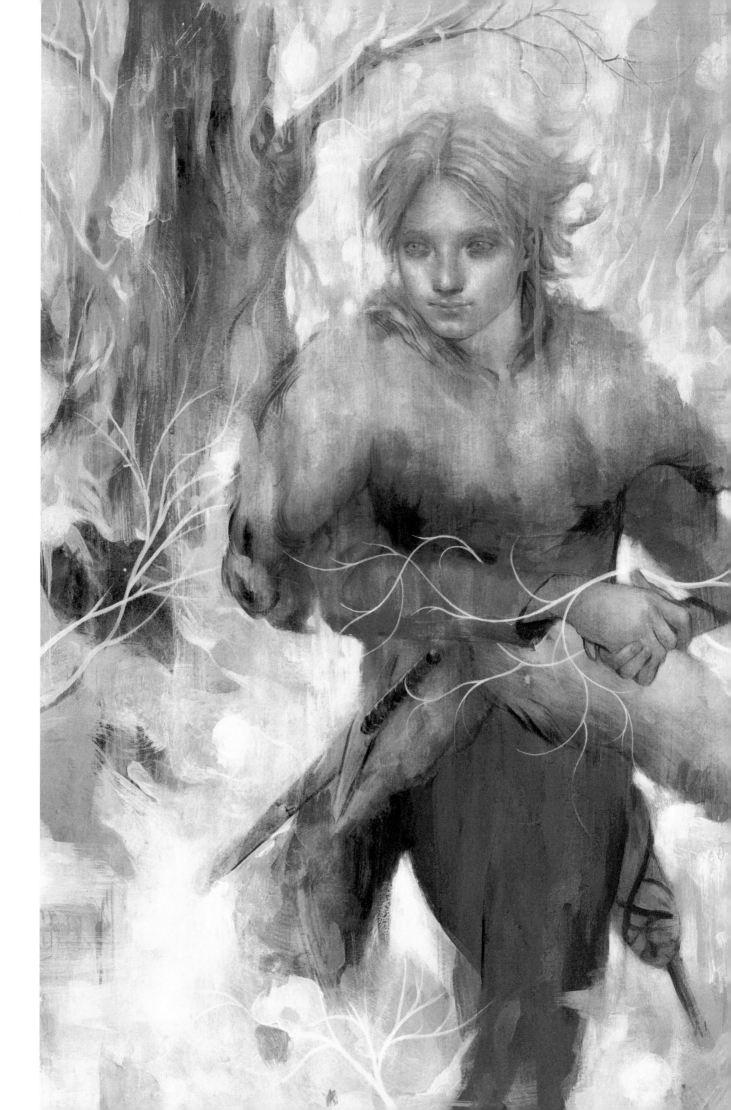

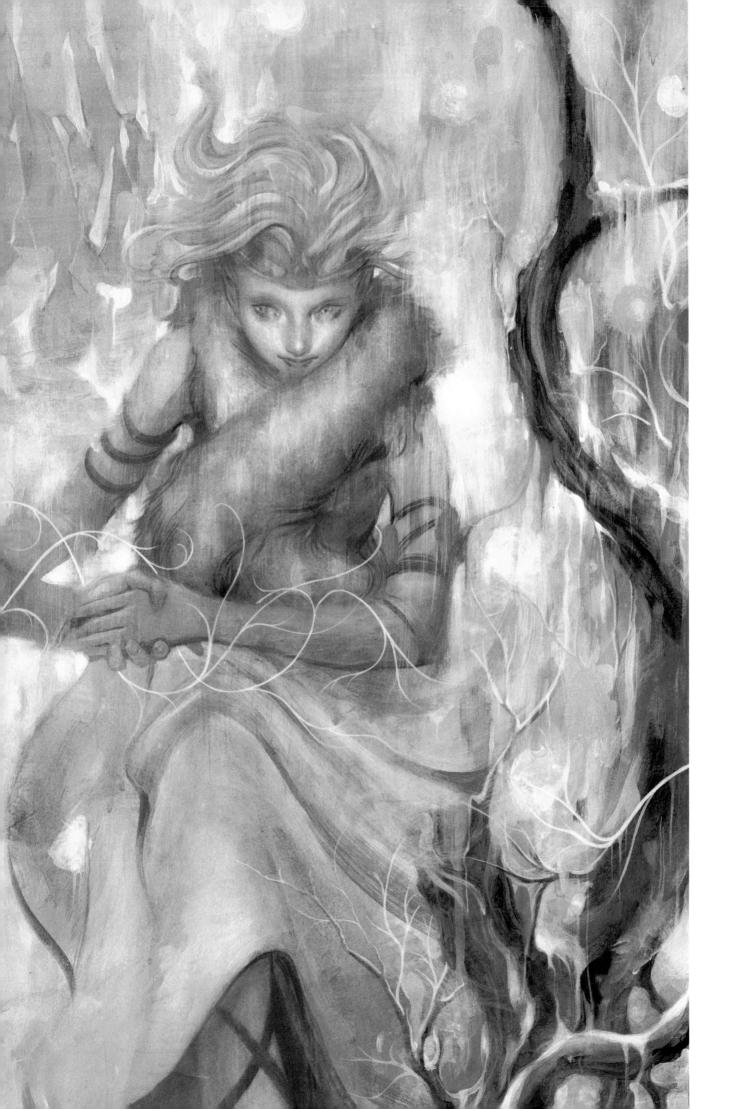

PRELIMINARY DIGITAL SKETCH.

JACK OF FABLES No. 7	JACK OF HEARTS	1/4

"Jack: What an astonishing and wholly unexpected run of good fortune!"

MEDIA: DIGITAL.

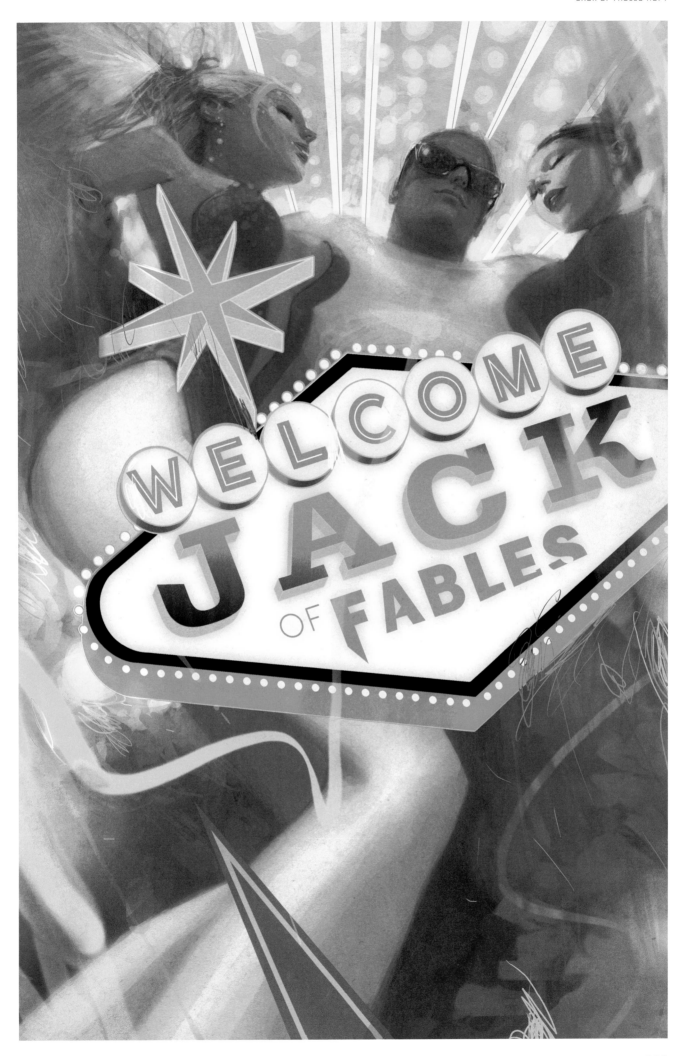

THUMBNAIL SKETCH,
GRAPHITE ON BOND, 5.5 X 8.5"

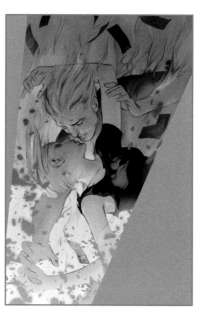

DIGITAL COLOR PROCESS

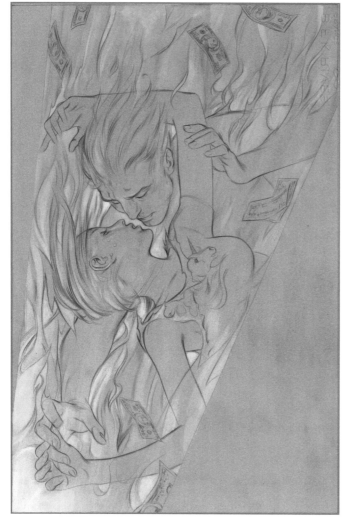

DRAWING, GRAPHITE AND ACRYLIC ON RIVES BFK, 14 X 21"

PAINTING, ACRYLIC & INKJET
ON PHOTO PAPER, 8.5 X 11"

JACK OF FABLES No. 8	JACK OF HEARTS	2/4

"**Jack:** This isn't the first time in my long life that I've woken up after a serious drunk married to some strange girl.

Jack: But it is the first time my new stranger wife turned out to be the absolutely hot daughter of a very rich casino owner. Can we all say, 'Hooray for me'?"

MEDIA: COLORED PENCIL, ACRYLIC, PIGMENT INK, DIGITAL.

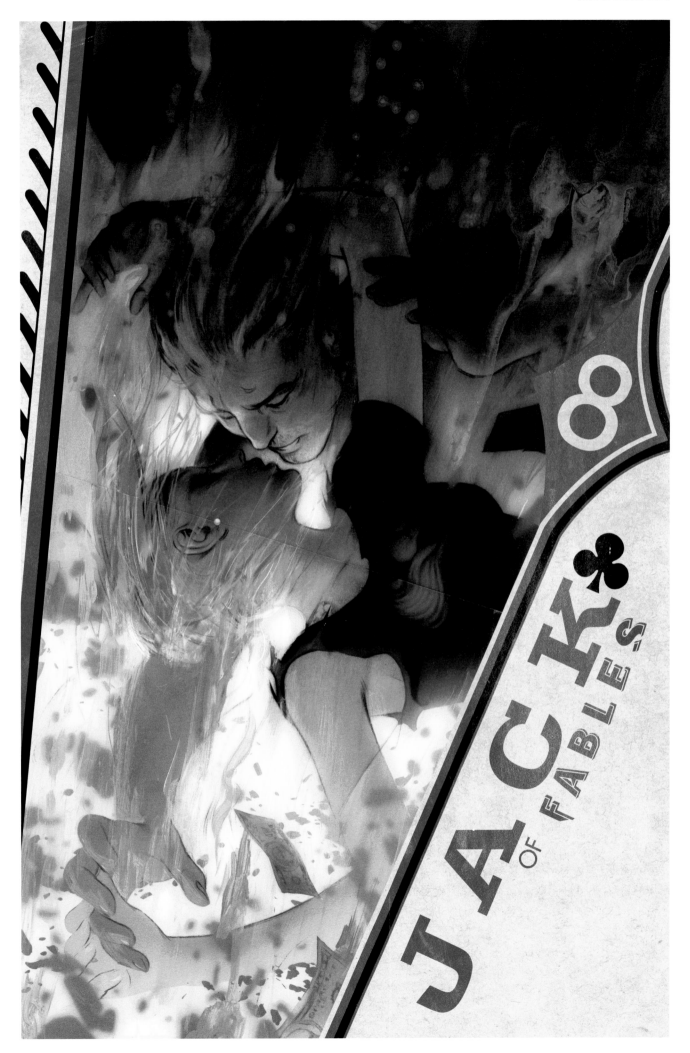

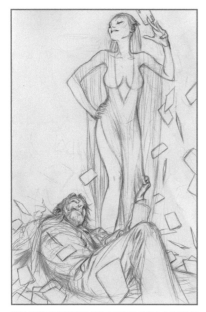

PRELIMINARY SKETCH, GRAPHITE ON BOND, 5.5 X 8.5"

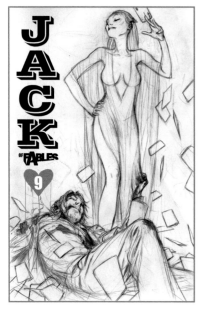

PRELIM. SKETCH, GRAPHITE & DIGITAL, 5.5 X 8.5"

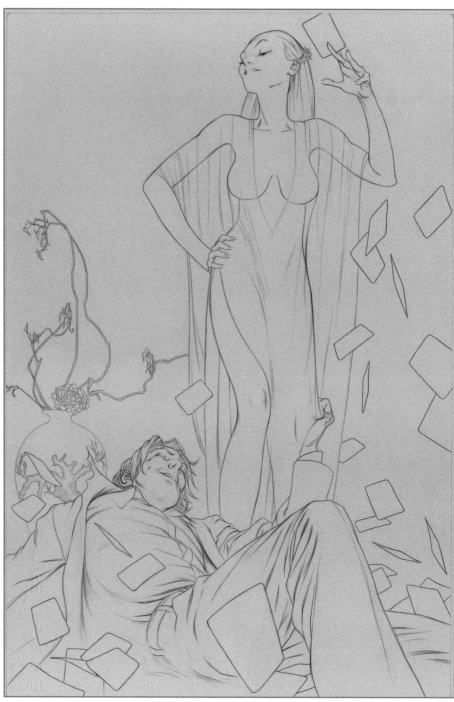

DRAWING, GRAPHITE AND COLORED PENCIL ON RIVES BFK, 14 X 21"

JACK OF FABLES No. 9	JACK OF HEARTS	3/4

"Jack: Goddammit! I can't turn around these days without some crazy fable broad trying to murder me.

Gary: I feel sick.

Jack: I left New York to get away from these people!"

MEDIA: GRAPHITE, COLORED PENCIL, ACRYLIC, PIGMENT INK, DIGITAL.

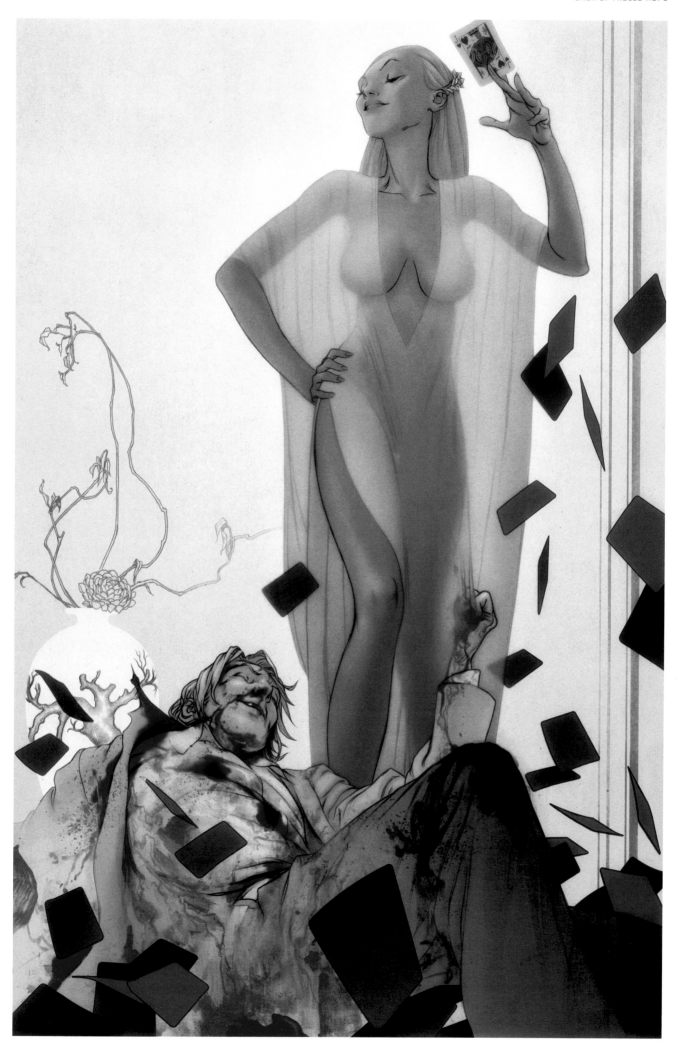

PRELIMINARY DIGITAL SKETCH

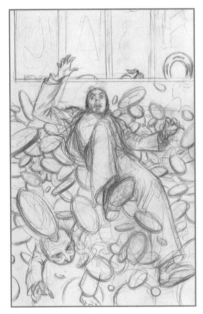

PRELIMINARY SKETCH, GRAPHITE ON BOND, 5.5 X 8.5"

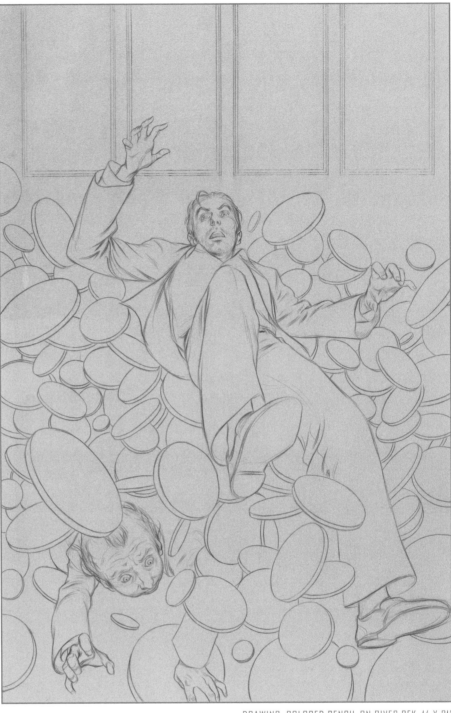

DRAWING, COLORED PENCIL ON RIVES BFK. 14 X 21"

JACK OF FABLES No. 10	JACK OF HEARTS	4 / 4

"**Remy:** I'll do anything you want! Just please don't kill me!

Jack: In the movies, everybody's a tough guy when they get dangled over a balcony. But in real life, most people just piss their pants."

MEDIA: COLORED PENCIL, DIGITAL.

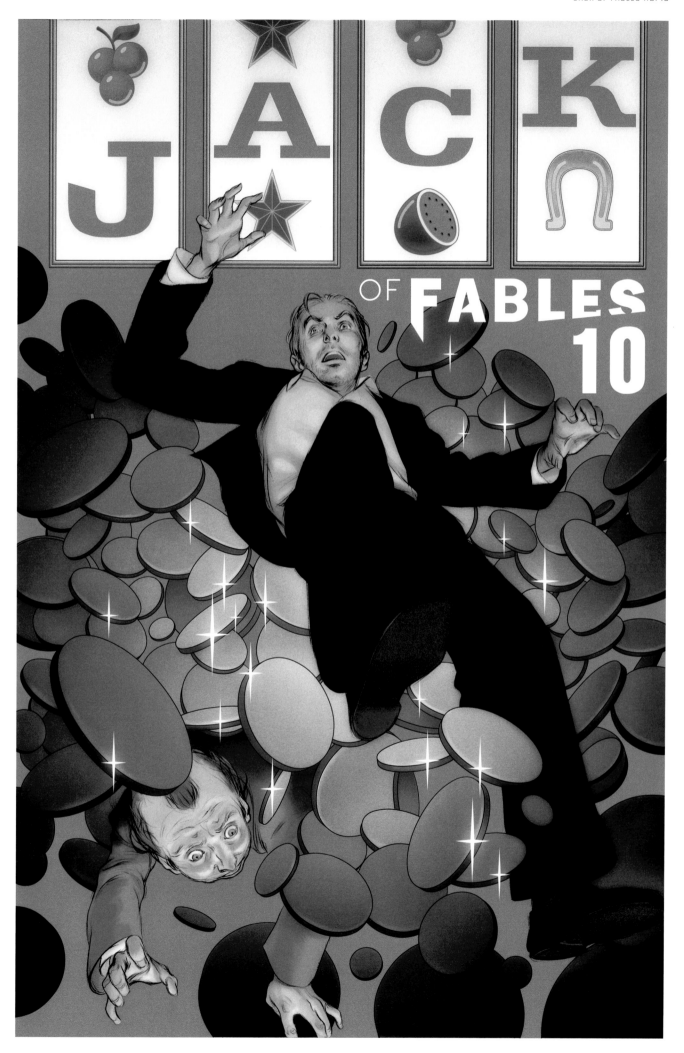

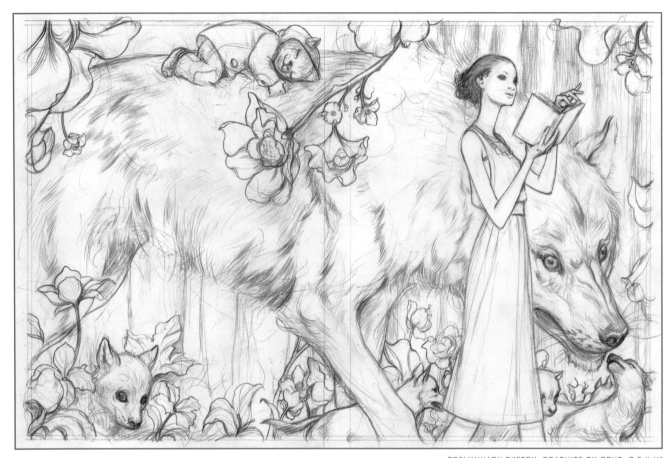

PRELIMINARY SKETCH, GRAPHITE ON BOND, 8.5 X 11"

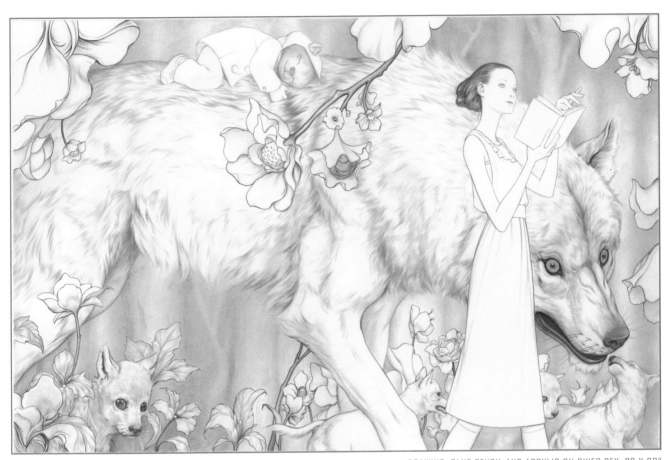

DRAWING, BLUE PENCIL AND ACRYLIC ON RIVES BFK, 20 X 30"

FABLES: COVERS BY JAMES JEAN

FIRST EDITION DUST JACKET

MEDIA: GRAPHITE, BLUE PENCIL, ACRYLIC, DIGITAL.

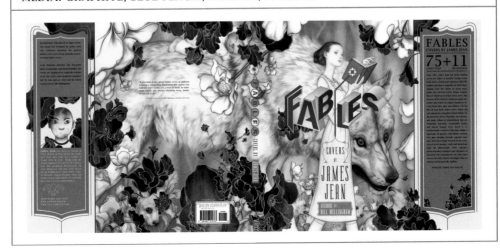

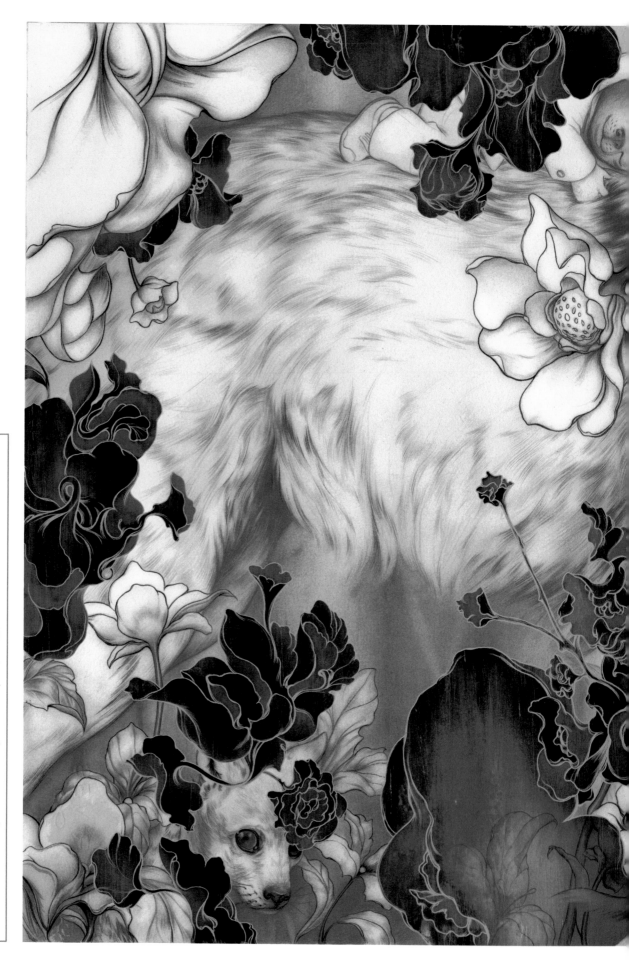

FABLES: COVERS BY JAMES JEAN

FIRST EDITION DUST JACKET

MEDIA: GRAPHITE, BLUE PENCIL, ACRYLIC, DIGITAL.

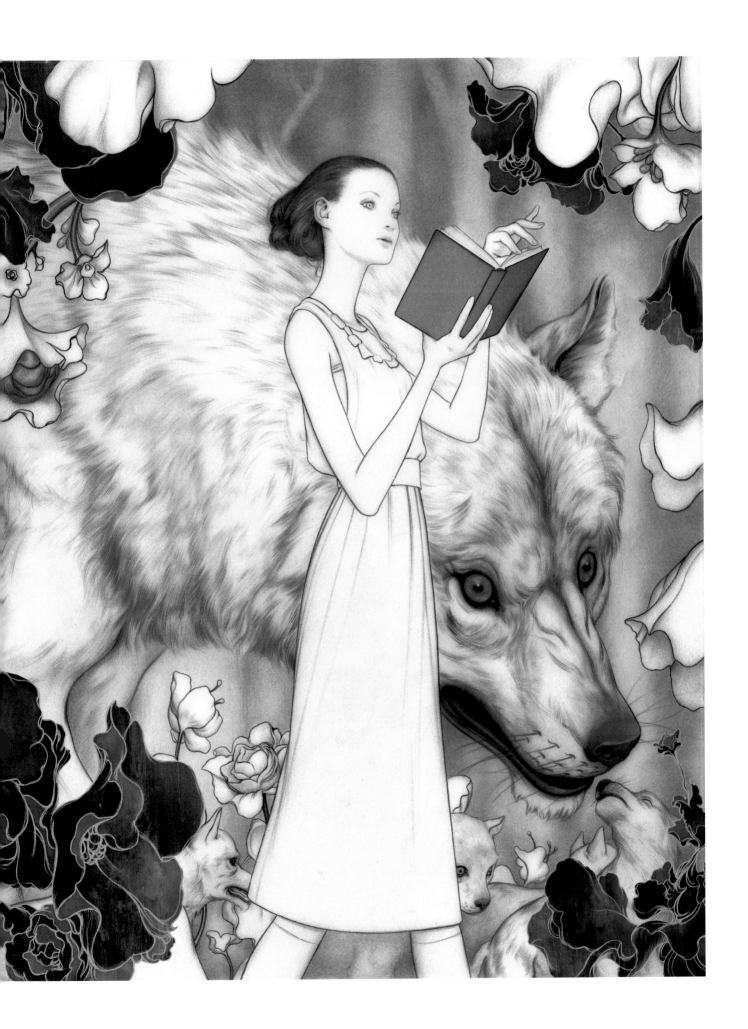

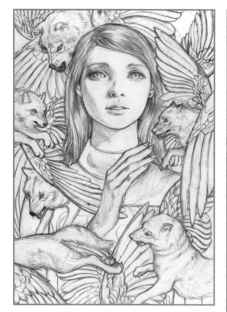

SKETCH, GRAPHITE ON BOND, 5.5 X 8.5"

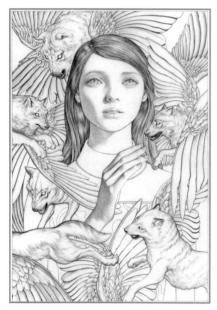

DRAWING, GRAPHITE ON BOND, 15 X 21"

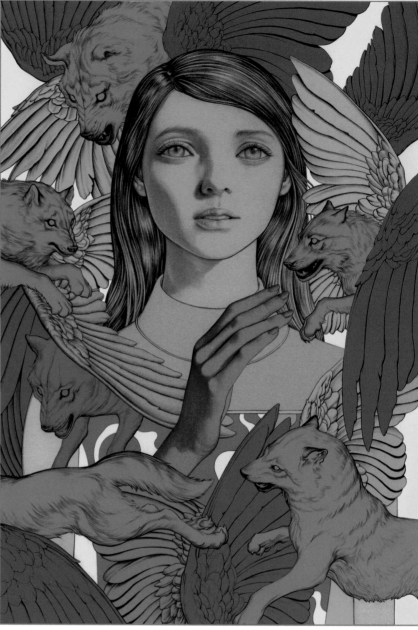

DIGITAL COLOR PROCESS

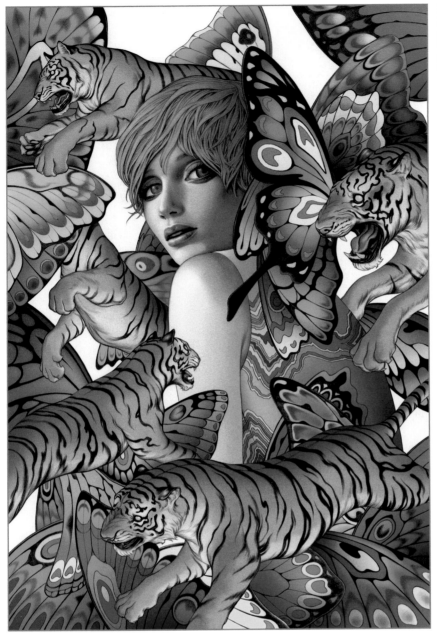

DIGITAL COLOR PROCESS

SKETCH, GRAPHITE ON BOND, 5.5 X 8.5"

DRAWING, GRAPHITE ON BOND, 15 X 21"

FABLES: THE COMPLETE COVERS BY JAMES JEAN

NEW EDITION DUST JACKET

MEDIA: GRAPHITE, DIGITAL.

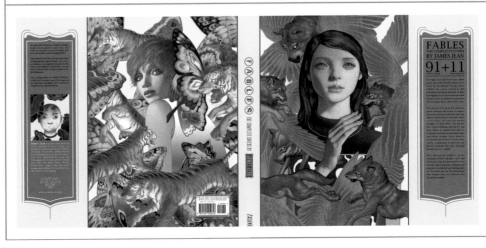

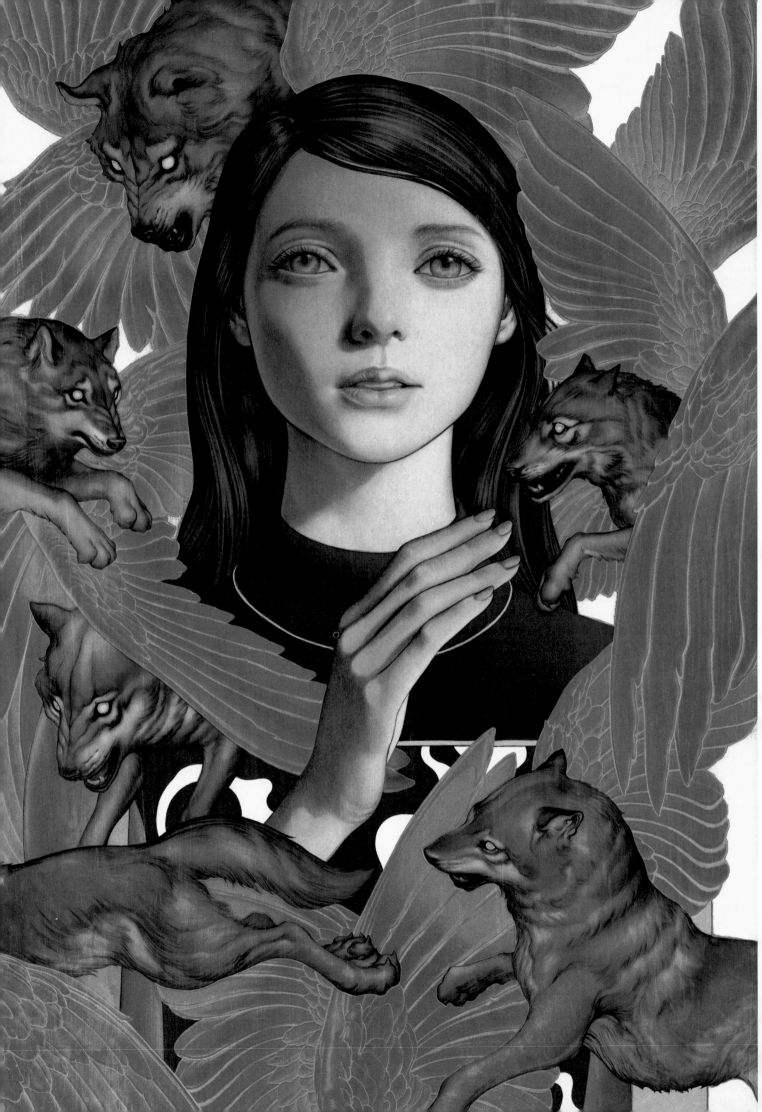

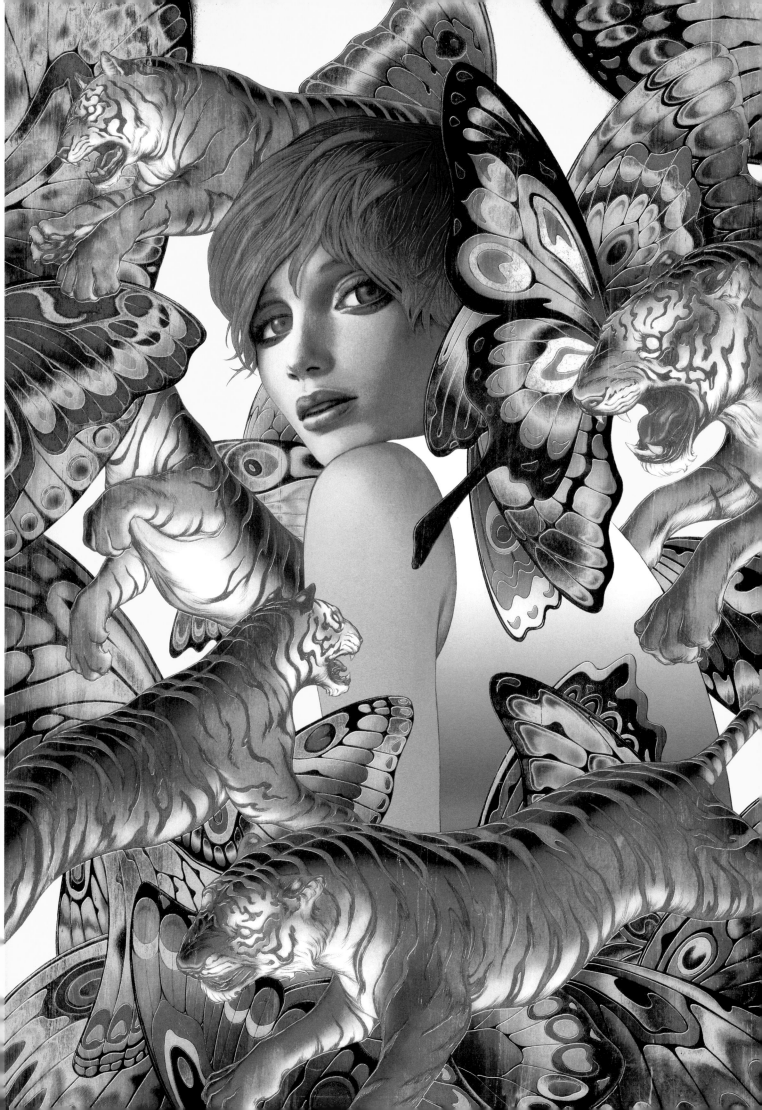

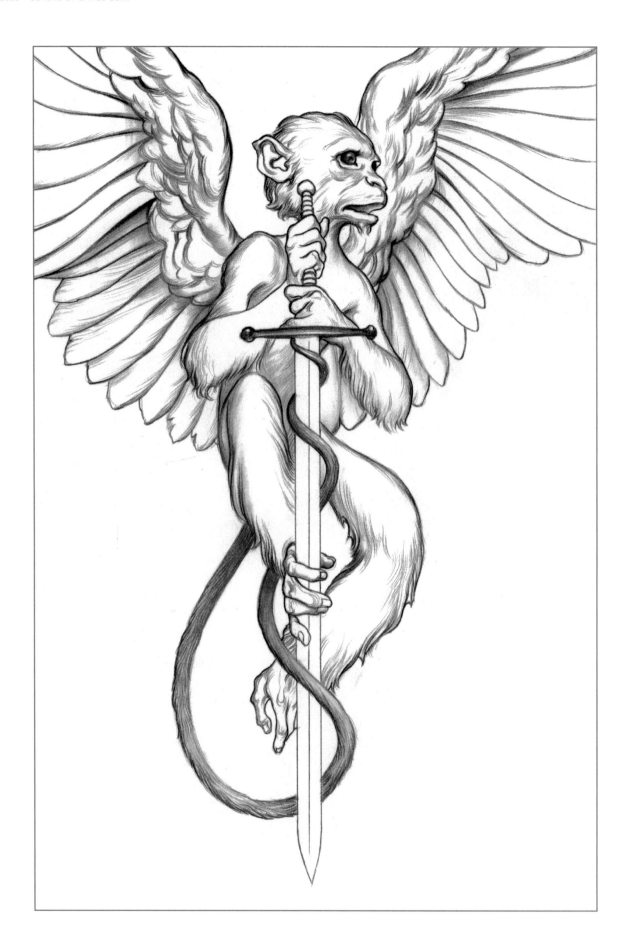

FABLES: COVERS BY JAMES JEAN

FIRST EDITION CASE ART

MEDIA: GRAPHITE.

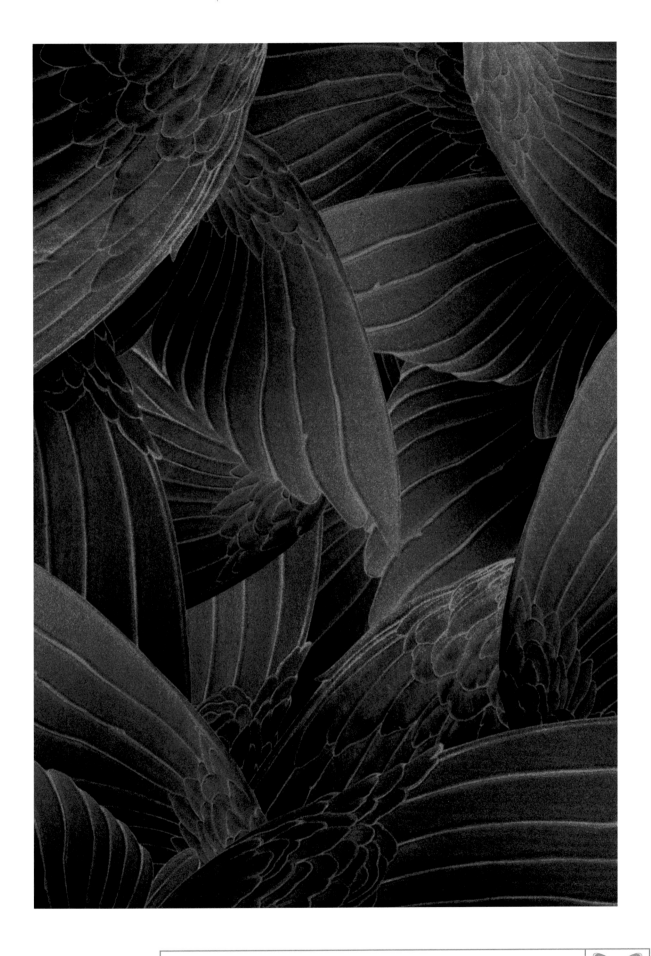

FABLES: THE COMPLETE COVERS BY JAMES JEAN

NEW EDITION CASE ART

MEDIA: GRAPHITE, DIGITAL.

James Jean was born in Taiwan in 1979. Raised in New Jersey, he graduated from New York City's School of Visual Arts in 2001. Along with his award-winning cover art for DC Comics, Jean has exhibited his fine art throughout the world and has worked with The New York Times, Wired, Warner Bros., Target, Nike, and Prada among many others. He currently lives and works in Los Angeles.

NOSY QUESTIONS

BY BILL WILLINGHAM

It's become the nature of forewords for the author of said foreword to do more talking about himself than about the purported subject of the book. In this case my foreword has been bumped to the back of the book (for space considerations I am told), which makes it an afterword, which traditionally is more likely to deal more directly with the subject of the book. It's just one of life's odd facts that afterword writers are (or must be) less ego driven than foreword writers. Since the subject is James Jean and his amazing run of cover paintings for the Fables comic book series, I will endeavor to make my after-foreword about him and his work. But in nearly a half-dozen attempts to write this foreword, in each case I quickly digressed into talking more about myself than about James: what I think about James' work; what my favorite cover is; what having James doing the Fables covers means to me; and so on. As interesting as that might be (and I suspect it would only be interesting to myself) the purpose of this book — of the entire book, afterword-foreword included — should be to reveal as much as possible of the heart and bones and sinew of James Jean's work, and perhaps if only by extrapolation, about James himself. With that in mind, and in order to keep this introductory/closing note from being hijacked by my ego, I've decided the best thing to do is to turn it into an interview. Here then are a few nosy questions for James Jean, which will, I hope, reveal something of the mind behind the remarkable art.

Q Bill Willingham: No doubt you've often heard the stories about an artist or writer or performer whose work is finally discovered — meaning recognized by the masses — after years of toiling in obscurity. It's so common an occurrence in fact that the horribly cli-chéd joke is always the same: "Yes, it only took me twelve years to become an overnight success." Of course the number of years varies, depending on who's saying it, but the crux is the same: overnight successes don't actually happen. Except that you might be the exception that proves the rule. If I understand the chronology correctly, you landed the job illustrating the Fables covers right out of art school — within a day or two of graduating, in fact. And it's the Fables gig that quickly brought you widespread attention. Is that true? Are you the first real example of an overnight success? If so, let's have the details. If I'm wrong, what's the real James Jean origin story?

A James Jean: During the summer of 2001, I visited DC with my friend Farel Dalrymple, who knew Heidi MacDonald when she was an editor there at Vertigo. I left my card with her, and Mark Chiarello eventually saw my website and recommended me to Shelly Bond. I actually got the call to create covers for Fables in October of 2001, a month after the twin towers fell.

Q Bill: Are you a fine artist, a designer, or an illustrator, or maybe even a storyteller? Or are these distinctions that should even matter? Are these distinctions that really even exist? What do you call yourself when you have to introduce yourself to someone?

A James: Increasingly, these distinctions don't really matter — I'm merely an artist. Sometimes it's comforting to live within the confines of a title, but I'm not limited to a certain category.

Bill: In addition to your work illustrating comic book covers, Fables covers primarily, you've landed many jobs outside of the comic book business for a truly diverse range of clients, far removed from our funnybook pastures. Assuming I'm recalling it correctly, Prada, Playboy and Nike come to mind as just a few of your other clients. In fact, I believe I recently read that you are about to have a line of Prada clothes based on your designs. Is that true? One doesn't usually imagine a comic illustration career leading to such a wide array of other work. In fact, I find it hard to imagine the outside world being so aware of the notoriously insular comic book world to make these connections. So, to my question: Did your Fables covers lead you to these gigs, or did they come about in some other way?

James: Everything's related. The painter, Eric White, recommended me to Prada. But in the beginning, my covers for Fables led to editorial jobs, which in turn led to advertising, music, and film jobs.

Bill: In light of the wide diversity of your career, mentioned above, it's entirely likely that some readers have picked up this book strictly because they know of you from your work outside of comic books. They may in fact have no idea that you do comics-related work. What do you have to say to those readers about this book? What will they discover here that they don't already know about you?

James: When I started Fables after art school, I was trying desperately to figure things out. I was also in over my head. But I think the readers will see me trying to solve problems in a unique way, with quiet revelations along the way.

Bill: And to turn that question around, there are going to be readers who know you strictly from your comic book work and have no idea about your vast amount of work outside of comics — or at least no familiarity with it. This isn't a comprehensive The Art of James Jean book. It's a fairly specialized examination of one segment of what's quickly becoming an impressively varied career. What do you have to say to those readers about this book and maybe even about what they won't find in these pages?

James: I hope this book will introduce them to the variety of disciplines I'm engaged in, from my sketchbooks and figure drawings to my personal painting.

Bill: I recall one afternoon at the San Diego Comic Convention when we were having lunch outside of the hotel — if memory serves, this would have been the second Comic Con since Fables began publication — when I had to practically twist your arm to convince you to come to the DC/Vertigo booth just for an hour to sign issues of Fables. You were convinced at the time (or at least you claimed) that no one would know who you are, and no one could possibly want you to sign their books. I trust you'll recall that I was vindicated when the line of fans waiting for you went around the (figurative, since this was an indoor event in a very big room) block. Are you still that humble? Do you know you're famous yet? And not just famous inside comic book circles, but you seem to be one of the rare examples of a comics guy becoming big "F" Famous.

James: My physical body is divorced from my body of work. The association between the two is uncomfortable for me.

Bill: Please tell us the cover — one of the ones that appears in this book — that you're most proud of and why.

James: The wraparound cover to the second trade paperback, Animal Farm, remains one of my favorites. Shere Kahn seems powerful on the cover — the profile of his face and the tiger stripes are graphically interesting. The mix of traditional and digital techniques helps to bring the composition to life — the softness of the charcoal is a nice counterpoint to the slickness of the vector drawings of the frames and flowers.

Bill: And what piece of work are you most proud of that doesn't appear in this book? And where should we go to seek it out?

James: I can't single out one piece of work, but readers might be interested in my sketchbooks, collected in Process Recess vol. 1, and the "greatest hits" of my commercial illustrations, collected in Process Recess vol. 2.

Bill: Okay, we've talked about the wide range of your career so far, but you're still young and your career's not even a dozen years old, which still qualifies as infancy in most cases. What are your vaulting ambitions? What have you not yet accomplished that you intend to?

James: At the moment, I just want to paint for myself. It's a simple goal, but somehow hard to reach.

Bill: Julius Schwartz, one of the most famous DC editors of the past few decades, used to commission comic book covers from various artists, with no story in mind. He'd tell the artist, "Just come up with something visually amazing and intriguing, and I'll find someone to write a story based upon the cover." Let's say you're about to do your very last Fables cover — your farewell cover. If you had the chance to do that for the Fables series, creating the cover first, without any input from me or the editors, and only then we'd have to devise the story that goes with it, what would that cover be?

James: It's impossible for me to say. I don't know if I could do that. It's always very important for me to work from a text when I'm creating covers. Also, the cover image doesn't reveal itself to me until I've done a bit of research and exploratory sketching. Even though my personal work is very narrative, the stories they tell are usually ambiguous and full of unfathomable mystery.

As you can see I've quite failed to draw out James in any substantial way. He quite simply is far too humble to talk about himself in any but the most cursory detail. So it looks like I need to talk about him after all, at least enough to give you my opinion of the man and his Fables-related work. As you've just seen for yourself — assuming you're reading this after reading the rest of this book — James is a phenomenal artist and illustrator. But in my book he's much more than that. If you'll look again at any given Fables cover (take your pick, as it's true with all of them), in addition to being a compelling illustration that makes you want to read the story inside, it's a story in itself. In sometimes subtle and always charming ways, James' covers tell it all. And that leads us to the highest compliment I can make about the man, which is what I'll leave you with: James Jean is a storyteller and, in my world, that's the best thing one can be.

<div align="right">
Bill Willingham

Las Vegas, 2008
</div>

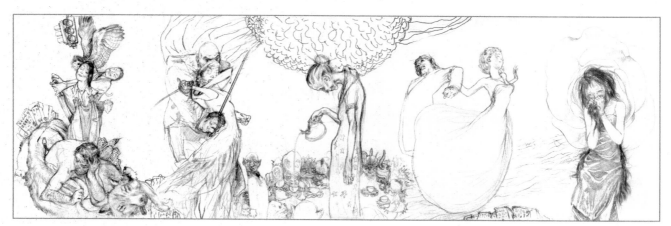

PANORAMIC COVER CONCEPT FOR FABLES NO. 1 - 5

THE FOUR-COLOR CON

Along the dry dirt patch of garden I stare while drinking warm green tea, another deadline approaching, another chance to redeem the failings of last month's cover. Redemption, revenge, and lust — perhaps these dark wishes inspire the illustrations that adorn these comic books. But I'm an impostor. There's no brooding, only the excitement of solving a new puzzle each month, assembling plot, characters, composition and Photoshop layers, interjecting allusions to art history and personal neuroses. Each cover is a template for that month's obsessions, a petri dish for graphic experimentation and hybrid cultures.

This book represents seven years of fraud — the readers have been swindled by the illusions erected before them, seduced with coded avatars and clues to the story within. It is only with so deft a con of words and pictures that Fables has survived for all these years. The artifice in the preceding pages expresses progress. There was once green grass planted in that dry patch of dirt in my backyard, but the progress of climate change has erased each blade. The progress of machines has eased the creation of images and increased our addiction to virtual interfaces. And on the face of each Fables is an ever-changing countenance, progressing towards an internet of wisdom.

James Jean
Santa Monica, 2008

BEHIND THE CURTAIN

ABOVE: EASEL, PERSONAL PIECE, COVER TO FABLES NO. 3, ANATOMICAL PRINT OF A PIGEON.
BELOW: PAINTING PALETTES, SPRAY BOTTLE, ACRYLIC PAINT, ACRYLIC INKS, VINTAGE TYPEWRITER.

ABOVE: WORKSTATION, STUDIO, HEAVY METAL, PROJECTOR WITH OIL PAINTING OF ELDERLY MAN.
BELOW: SANCTUARY/FORTRESS OF SOLITUDE.

FABLES THE COMPLETE COVERS BY JAMES JEAN

Published by DC Comics. Compilation, commentary and afterword Copyright © 2008 Bill Willingham and DC Comics.
Cover and pages 198-247 compilation Copyright © 2014 Bill Willingham and DC Comics. All Rights Reserved.

Originally published in FABLES #1-10, 12-81, JACK OF FABLES #1-11, FABLES: 1001 NIGHTS OF SNOWFALL, FABLES:
LEGENDS IN EXILE TPB, FABLES: ANIMAL FARM TPB, FABLES: STORYBOOK LOVE TPB, FABLES: MARCH OF THE WOODEN
SOLDIERS TPB, FABLES: THE MEAN SEASONS TPB, FABLES: HOMELANDS TPB, FABLES: ARABIAN NIGHTS (AND DAYS) TPB,
FABLES: WOLVES TPB, FABLES: SONS OF EMPIRE TPB, FABLES: THE GOOD PRINCE TPB, FABLES: WAR AND PIECES TPB
Copyright © 2001, 2002, 2003, 2004, 2005, 2006, 2007, 2008, 2009 Bill Willingham and DC Comics. All Rights Reserved.
All characters, their distinctive likenesses and related elements featured in this publication are trademarks of Bill
Willingham and DC Comics. VERTIGO is a trademark of DC Comics. The stories, characters and incidents featured in this
publication are entirely fictional. DC Comics does not read or accept unsolicited ideas, stories or artwork.

FABLES #11 cover (not represented) was painted by Aron Wiesenfeld.

Original logo design by Brainchild Studios/NYC
Designed and compiled by James Jean with production assistance by Chris Pitzer
Design assistance by Amelia Grohman and Curtis King Jr.
("Bullet casing" endpapers extracted from FABLES VOL. 4 TPB)

DC Comics, 1700 Broadway, New York, NY 10019
A Warner Bros. Entertainment Company.
Printed in the USA. First Printing.
ISBN: 978-1-4012-5281-6

SUSTAINABLE FORESTRY INITIATIVE
Certified Chain of Custody
20% Certified Forest Content,
80% Certified Sourcing
www.sfiprogram.org
SFI-01042
APPLIES TO TEXT STOCK ONLY

Library of Congress Cataloging-in-Publication Data

Jean, James, 1979-
Fables covers : the art of James Jean / James Jean, [Bill Willingham]. — New edition.
pages cm
ISBN 978-1-4012-5281-6 (hardback)
1. Comic books, strips, etc.—Illustrations. 2. Book covers. 3. Willingham, Bill. Fables—Illustrations. I. Title.
PN6727.J43F33 2014
741.5'973—dc23
 2014034114